# ART WORK

## Artists in the New England Labor Market

by
Gregory Wassall
Neil Alper
Rebecca Davison

The New England Foundation
for the Arts

Cambridge, Massachusetts

1983

This book is published by:

**New England Foundation for the Arts**
25 Mount Auburn Street,
Cambridge,
Massachusetts 02138

Library of Congress Cataloging in Publication Data

Wassall, Gregory H.
 Art work, artists in the New England labor market.

 1. Art—New England—Marketing. 2. Artists—
New England—Economic conditions. I. Alper, Neil,
1949- . II. Davison, Rebecca, 1946- .
III. New England Foundation for the Arts. IV. Title.
N6515.W37   1983   330.974'043'0887   83-17459

Funding for this study was provided by:
 Connecticut Commission on the Arts
 Maine State Commission on the Arts and Humanities
 Massachusetts Council on the Arts and Humanities
 New Hampshire Commission on the Arts
 Rhode Island State Council on the Arts
 Vermont Council on the Arts
 and the National Endowment for the Arts

ISBN 0-915400-46-4

Additional copies of this book are available from:

**American Council for the Arts**
570 Seventh Avenue
New York, New York 10018
(212) 354-6655

Design: The Laughing Bear Associates
Illustrations: Barbara Carter

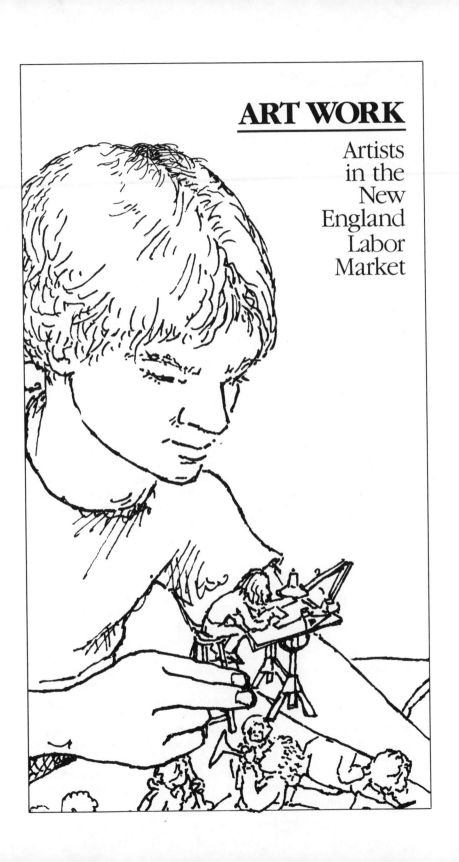

# ART WORK

Artists
in the
New
England
Labor
Market

# Preface

*"Oh, you are an artist? How nice.
And do you also work?"*

This book presents findings from the first comprehensive regional study of the labor market experiences of individual artists. The study was initiated by the six New England state arts agencies and was carried out over a two year period from 1980 to 1982. A survey collected data on creative and performing artists of all ages working in every artistic discipline in New England. The statistical findings are further amplified with comments from artists who participated in personal interview sessions conducted in each state in the region. The study reveals how artists are trained, how much they earn, how much it costs to work as artists, how often they are unemployed, and what other jobs they have to hold in order to carry on as artists.

Why do this research? Why publish this book? The question was asked over and over again by artists who participated in the study and by others who heard about it. Said one performer, "Everyone knows that most of us aren't making it. But since so few people seem to care very much, I can't see the rationale for a study. Don't you know that all of us are supposed to be happy, even if we are poor. We get 'psychic income' (I think that's the term people use). If we wanted to make money, we are supposed to go out and get a real job." And it was another artist who reported the classic "cocktail party" question, "When we tell people we are artists," he explains, "they immediately want to know what we do for a living. It's as if the arts and jobs are a contradiction in terms."

Perhaps these artists are right about people's perceptions of them. After all, aren't artists supposed to have fun doing what they do? If artists aren't going to *work* like the rest of us, why should they get *paid* like the rest of us? This attitude is at least as old as Balzac's tongue-in-cheek assertion in *Cousin Pons* that the poverty "suffered by poets, artists, actors, and musicians, derives some cheer from the joviality natural to the Arts, from the irresponsibility of the Bohemian life on which genius embarks before retiring into creative solitude."

If many people really believe that the artist's life is one of joviality and "psychic satisfaction," then there is a great need for a book like this one to set the record straight. For many artists, the jovial life is a cruel fiction. They have neither the time nor the energy to be jovial. They are holding down too many other jobs. Or they are unemployed. Or they are dealing with unrealistic employment and tax policy developed by the U.S. Department of Labor and the Internal Revenue Service. Or they find that lending institutions, landlords, and the telephone company consider them poor credit risks. The picture is hardly one of "joviality."

This is probably why an old Russian violinist at the Curtis Institute of Music in Philadelphia has always advised his students against a career in music. "You will not only be poor, but no one will feel particularly sorry for you. If you can think rationally about a career in the arts, you do not belong in the arts." To a large extent the following pages are confirmation of the old violinist's point of view. Reading them, and considering the question of a career in the arts coldly, one wonders why any person would choose to be a professional performer, visual artist, writer, or any other kind of artist. The financial sacrifices are so great. The periods of uncertainty about unemployment are too common.

Part of the problem is that we live in a society that defines productivity very narrowly. An auto worker is productive. A self-employed painter is not, unless, of course, his paintings happen to make their way into a sales cycle that produces taxable revenue. Yet is it sensible to say that the artist is less productive than the auto worker? The auto worker makes a car. The painter makes a painting. We do not demand that the car be sold in order to call the auto worker "productive" nor are we less concerned when he is laid off and needs unemployment protection. The very definition of unemployment discriminates against artists. As we shall see in the following pages, artists may go for long periods without any sources of income, but many are not considered legally unemployed nor are they eligible for unemployment benefits.

To some extent we have insulated ourselves against the harsh realities surrounding the labor market experiences of artists, their incomes, and the ways in which they make a living. Times have changed. Artists no longer die of starvation or tuberculosis in cold garrets. Most work. Most make a decent living. The problem is that much of the work they do is unrelated to

their art. They are teachers, or administrators, or editors, or computer programmers. They are "productive" in the narrow sense but unproductive in the artistic sense. We lose immeasurably by the underutilization of their talents, by the diversion of these talents into areas where they are wasted. We celebrate the ninth symphony of Beethoven but fail to ask ourselves how our lives would have been different if Beethoven had been a full-time computer programmer and had had only enough time and energy to write only eight symphonies. How many "ninth symphonies" in our own generation are not being written because composers (or writers or painters or filmmakers) are too occupied with the important business of being "productive" and earning a living?

How much do artists really earn? In New England in 1981, the average artist's income was $15,644 (median income, $11,800) of which only $6,420 was earned from artistic work. This is a shocking figure for a group which had, on average, almost 17 years of formal education and in which fully 80 percent had received at least a bachelor's degree. Nor is this all the bad news. The average New England artist incurred $3,554 in arts-related expenses. For every $2 earned as an artist, more than $1 was spent. So the artist, and others in the household, had to find ways to subsidize the artistic occupation. Is it any wonder that 75 percent of the artists surveyed held jobs outside of their artistic profession?

Somewhere something is wrong. The programs that are designed to help the artist—in whatever discipline—are largely ineffective. And the value society places on the artist's well-being is very low indeed. While government and privately funded programs attempt to assist the artist in this country, that assistance has been overwhelmingly institutional. We have become very skilled at helping *organizations,* and we have thought, somewhat naively, that artists would be the ultimate beneficiaries of this help. But it has not worked out that way. The artist still does not make an acceptable living based on income from artistic activities. And, consequently, it is clear that we must begin to look for alternatives. We must look for ways to help individual artists directly.

Ultimately, then, this is the reason for the study. To demonstrate to those who formulate policy that they must help us find new ways to help artists directly. We must help artists earn more from their art so they can spend additional time being artistically productive. We must help them with the crushing costs of artistic professions. We must help them market their works and their talents. We must help them fight employment, tax, and credit discrimination. We must help women artists, particularly, to reach parity with their male counterparts, for the disturbing truth is that, once again, women find themselves earning far less than men in artistic professions.

But most important, we must provide a focus for the assistance we provide. We must help artists—whether writers, composers, musicians, painters, craft artists, photographers, film-

makers, or whoever— to do what they were trained to do. Not to teach. Not to administer. Not to solve problems. But to paint, perform, take pictures, and to generally extend the creative potential that is inside them. This is the challenge that we can no longer ignore.

Thomas Wolf, *Executive Director*

New England Foundation for the Arts
May, 1983

# Acknowledgements

This regionwide study of artists could not have been accomplished without the support and advice of numerous individuals and organizations. A central role in the initiation and funding of this study was played by the executive directors of the six New England state arts agencies: John Coe, Anne Hawley, Ellen McCulloch Lovell, Christine White, Alden Wilson, Gary Young. We wish to express our gratitude to these individuals and their staffs for assistance they provided. We would also like to thank Anthony Turney, of the National Endowment for the Arts, for providing financial assistance. We particularly appreciate the central coordinating role played by Thomas Wolf, Executive Director of the New England Foundation for the Arts who stayed very much involved with all aspects of the project from the idea stage to its completion.

The study could not have been completed without the assistance of three very hardworking people. Herbert Sprouse of Economic Research Associates assisted in the development of the questionnaire and was responsible for interviewing artists throughout New England. Both Paula McCabe, who was responsible for five of the six states in the region, and Paul Cleary, who was responsible for Massachusetts, did an excellent job developing the mailing lists and supervising the mailing of the questionnaires.

We would like to express our appreciation to those individuals in all the organizations listed in Appendix C that provided the mailing lists used in sampling for this study.

The support of several individuals in particular is noteworthy. Cathy Balshone of the Boston Conservatory of Music and Dance, Deborah Dluhy and Dean Bruce MacDonald of the School of the Museum of Fine Arts, Kathryn Gonzalez and Linda Novak of the New England Conservatory of Music, Judith Kidd of Boston University School for the Arts, and Bob Ringe of Emerson College were all most helpful in arranging for lists of their institutions' arts graduates.

Robert M. Segal, New England Counsel for the American Federation of Television and Radio Artists and the Screen Actors Guild, and Howard Garniss and Maryann Miller of the Boston Musicians' Association, Local 9-535 of the American Federation of Musicians, were instrumental in providing the names and addresses of union artists for this study. Jacqueline French, Gareth May and Guy Pace of Actors' Equity were equally cooperative in this area, arranging for a mailing list of their New England membership.

John Duffy and Andrea Rockower of "Meet the Composer" were highly supportive of our effort, compiling a list of New England composers expressly for use in our survey.

John Mahlman of the National Art Education Association freely offered his organization's list of members for sampling and made many helpful suggestions for obtaining additional lists of New England artists, especially those involved in New England arts education. Dr. Margie Hanson of the National Dance Association contributed not only her organization's mailing list of members for the survey but also directed us to many other sources of New England dance artists.

Cassandra Denny of the National Academy of Design and Jean Passanante of the National Playwrights Conference were very supportive, especially in the early stages of the list-gathering process.

Paul Desaulniers of the Boston Film Video Foundation, Inc. was most cooperative, quickly compiling a list of regional film and video artists for our use.

Jonathan Bruce of the CRT's Craftery Gallery was also very helpful, especially in suggesting sources for locating minority artists within the region, as were Joseph Celli of Real Artways, Harriet Kennedy of the National Center for Afro-American Artists, and Rose Weil of the American College Art Association.

We are grateful to Rudy Nashan, New England representative of the National Endowment for the Arts, for his interest and support and suggestions for locating artists in New England for the survey. We would also like to acknowledge the directors and staff members of each of the state departments of education within the New England region for their contribution. Don McCafferty, Chief of Secondary Education for the state of Vermont, in particular, was most helpful, providing us with his department-sponsored directory of Vermont artists.

Additional thanks go to Sandi Bagley of the Elma Lewis School of Fine Arts and to Rosemary Bourquet of the Boston

Shakespeare Company. Robert Lynch of the University of Massachusetts Arts Extension Service, Mary Kay Hoffman of the Franklin County Arts Council, and Diane M. Hovenesian of the Worcester County Craft Center were instrumental in arranging interviews with artists. Other persons who helped arrange interviews with artists were Nancy Hotchkiss, Piano Factory, Boston; Steve Kokolis, Worcester Office of Cultural Affairs; Barbara Schaffer Bacon, Arts Extension Service; Ann Backus, New Hampshire Commission on the Arts; Richard Fitzgerald, League of New Hampshire Craftsmen; Iona Dobbins, Rhode Island State Council on the Arts; Evelyn Smith, Connecticut Commission on the Arts; and Janet Ressler, Vermont Council on the Arts.

Finally, we would like to thank some very hardworking people. We want to thank Cherie Langer, the secretary for the Vermont Nature Conservancy, for her patience, flexibility, and skill in putting the final manuscript into the word processor—saving us many hours of retyping. Typists in the Department of Economics at Northeastern University, who were supervised by Sylvia Goldberg, did an excellent job interpreting our writing and transferring it to paper. They are Cheryl Noakes, Marjorie Blanch, David Agdern, Margaret Carr, Lisa DeAngelis, and Elizabeth Fiekers who transcribed the artists' interviews; and the many graduate students who spent endless hours stuffing, addressing, and sealing the thousands of envelopes containing questionnaires that made this study possible.

Neil O. Alper
Gregory H. Wassall
Rebecca Davison

May 20, 1983

# Table of Contents

# Chapter One

## An Exchange of Letters

## The Working Artist: Some Issues

# An Exchange
of Letters

*Hinesburg, Vermont*
*October 6, 19--*

Dear Will,

I've just finished reading an editorial in the newspaper that has made me quite angry. It's entitled "Funding for the Arts or Funneling Money Down a Drain." Essentially, the guy complains that most of the money being used to "subsidize" artists goes to programs of "questionable value." He argues that "today's artists lack the spirit of survival." You know, the old struggle creates art notion. He says we've "grown fat, lazy, and complacent with spoonfeeding from government's largess." He goes on to say that "artists are producing art that reflects a bureaucratic turn of mind rather than an inspired spirit." His solution, of course, is turn us all out into the marketplace, "where only those who have the will, dedication, and talent will survive." Sort of a cultural survival of the fittest theory. I feel like an endangered species already.

Besides the fact that very few artists receive large sustaining grants, I don't know any who aren't already out in the marketplace hustling like mad to make ends meet. In fact, most of them are in several marketplaces because most of them have to hold down more than one job. Even artists who have financial support from mates have to earn something just to keep the family afloat.

It *is* odd how artists are both revered and looked down upon in our society. I found this kind of contradiction very disturbing the other day when I met a woman who was both enthralled and appalled that I was an artist. She pummeled me with questions. First she asked what I did for a living. I told her I was a painter and ceramist. She found that hard to believe, so she asked what I did for work. I told her that *was* my work. Then she asked if I could actually make a living doing this. I told her no. She was truly baffled by this time. She couldn't understand why I did what I did

if I couldn't make a living at it. I threw up my hands and told her it was because I was a social misfit who believed in art more than money. She said I didn't seem like a misfit. I said that's because I was disguised as a teacher.

Speaking of misfits. I just got a letter from Jake P. You remember him? He's the choreographer I met a few years ago who was with a dance company in Concord. It was a good group, but I guess he felt stifled. He is very talented, has bundles of energy, and felt he could accomplish greater things in dance. He left the troupe, which was doing very well financially, and sought training with a dancer/choreographer who is making some waves in the dance world. This woman gave Jack no assurances about anything. She did not promise him a job or even that she could give him anything artistically. He went anyway. Surviving on lentils and orange juice, he worked with her for six months. He is now in Portland with his own company and doing some very exciting things, including teaching a very successful children's dance workshop.

Anyway enough of this. How are you? Have you finished the opera yet? Are you still balancing jobs? And how's Sam?

Stephanie is standing here with her boots on, a splitting mall in her hand, and a determined look on her face. She's waiting for me to come help with the wood. So I suppose I best go. Please write soon.

Love,
*Anna*

*Boston Massachusetts*
*October 20, 19--*

Dear Anna,

It was good to hear from you. News from the hinterlands is always refreshing. The editorial you mentioned is disturbing. Commentators here also take periodic pot shots at arts funding. Some of the criticism is valid, some of it isn't. If art had a ready market, if Americans clamored after art like they do computer games, then perhaps we could go it alone.

I guess what irks me the most is people's attitudes about how art is produced. They just can't understand that it is not a mass produced commodity, that it can't be put through an assembly line. They seem to have no conception of how long it takes to create a work of art or to be able to perform well. I've spent the last five years trying to write this opera. I'm sure our editor friend would probably say that if it takes me that long to write one opera, I should give it up. Little does he know that I am a single parent who is not independently wealthy. I'm holding myself and my kid up just above the poverty line with three jobs. Finding time

and mental energy to compose music is rare indeed. I don't think that I'm unusual either. Most of the artists I know hold down more than one job. Unfortunately the only way many of us can capture some time is to apply for a grant to finish a work or take some training.

I'm sure our friend would make some disparaging remark if he knew that I have joined the line at the government trough. I've applied for a grant from the National Endowment for the Arts for money to finish the opera. The chances are slim. If I don't get the money, I'm going to finagle some other way of setting aside the time I need. But I AM going to do it. I hope Sam likes orange juice and lentils.

My commute back and forth from Maynard is getting better. I only go in three days a week now to work at the Computer Center and ride in a car pool. They've got me doing some mindless programming. I can't decide whether it's good or bad. I feel less drained when I get home, but I'm bored silly for eight hours. My carpentry work is going well too. It has been mostly on weekends. Fortunately, the people I do work for are very patient. I still have five students I'm teaching piano, and I still, amazingly enough, find it enjoyable. My musical engagements, however, have been falling off sharply. I just can't seem to find the time to sit down and make some phone calls or get a mailing together. I guess I should have been a businessman before becoming a musician.

I guess I'd better go and fix supper. Oh, Sam says hi and wants to come and see you. Just what you need— a five year old.

Much love,
*Will*

P.S. How's your battle with the IRS coming?

<p style="text-align: right"><em>Hinesburg, Vermont<br>November 3, 19--</em></p>

Dear Will,

We got our first snowfall yesterday. Did you get any down your way?

You asked in your last letter about how my encounter with the IRS was coming. Funny you should ask. This is the fourth month of our "negotiations." They are saying that I can't deduct some of my painting supplies. I can only deduct the amount of paint that is on a painting that is sold. Pretty outrageous. I tried to explain that this is not how things work. I told them that if I have a show, I scrape together enough cash to do the framing, which can cost up to $2,000 or more if it is a big show. If I'm lucky, I'll sell one painting out of the 30 or so being exhibited. Depending on the painting, I could get between $250 to $500. They

said that if I can figure out how much paint is on the painting I sold— that's how much I can deduct. I told them that was ridiculous. An artist sometimes has to do 15 bad paintings— ones he or she would never show— to get one good one. These bad paintings are not marketable.

I've learned a great many things from this little episode with the tax collector, but probably the biggest thing is that tax laws— specifically loopholes— are really made for people who are working to make a profit. Artists have to show the IRS that they too intend to make money from their labor, that they are not just doing this as a hobby and using it as a tax shelter. That's fair enough. I don't doubt that we all want to make money from our art, but I question whether that is or should be the primary motive for art. Lord save us if it is. But so long as we work at art for reasons other than profit, our profession will be considered a hobby. I think part of the problem is that we don't work in conventional ways— our "products" don't necessarily meet some "market demand," we don't mass produce things, and we sometimes take years (even lifetimes) to finish a work. (The IRS requires someone to have earned an income within five years of being in "business" to be able to take a loss or a deduction.) Essentially what I'm trying to say without getting too bogged down in the intricacies of the U.S. tax code is that the law as it stands seems to militate against someone trying to create a work of art or become an artist.

My work is going quite well despite my not finding much in the way of exhibiting space. I have finished the series of four landscapes. After the slew of rejections I've had lately from galleries, it takes all of my will power to go into my studio and face those blank canvases.

The kids have been truly wonderful. They seem to even enjoy playing parent to their parent. They protect me from the coffee-klatching neighbors, telephone calls, and bill collectors. They even fix dinner. I have, I confess, become somewhat of a recluse these days. I hoard my time like an old miser.

Stephanie will be off to college next fall and Michael in two years. I shudder to think of life without them, but it will be good for them to get away and be kids again. Stephanie says she is going to be an investment banker so that she can buy me a gallery of my very own. I told her that by the time she's graduated, I'll be rich and famous enough to buy her her own bank. Such are our dreams these days.

Please send news from the outside.

Always,

*Anna*

Dear Anna,

Well, I didn't get the grant from the Endowment. They praised my work and lamented that they were unable to help me out. Budget cuts, funding priorities, and such were given as the reasons.

On the brighter side, the Computer Center wants to give me a small raise and partial benefits. They are exceptionally understanding. (I think my boss secretly likes the idea of having an "artist" on his staff.) The benefits, especially health insurance, are the most important part of the deal. Ever since Sam broke his arm last summer I've been worried about what would happen if either of us got really sick. I couldn't afford the premiums by myself.

I've decided to stop all of my carpentry work and probably cut down on the number of students I teach. This will plunge our income to about $11,000 a year, and this figure depends on how much I perform. But I have to do this. I have to finish the opera this year so I can go on to other things. We will scrape by somehow. It'll be the roughest on Sam.

Did I tell you about Meredith F? Universal Studios in Los Angeles wants to make a movie based on her novel. She called me the other day to tell me her agent had just received a call from some producer in Hollywood who had been given her book for his birthday, and he loved it. If things go according to plan, they want her to come to California in January to help write the script. As you might imagine she's feeling a little overwhelmed and, I think, somewhat ambivalent. Why is it so hard for us to accept success? We've struggled so long without it. Just a few months ago Meri couldn't even get credit at the local stationery store to buy a ream of paper. Now she'll be able to buy a whole paper mill (or more likely a word processor).

Speaking of credit, another friend of mind has run into a kind of curious thing. He is an actor and doing pretty well here. He moved recently to a new apartment. When he went to get a phone, the phone company said he had to put down some enormous deposit, and when he asked why, they said that it was because he was a bad credit risk. He told them that if he couldn't get a phone, he wouldn't be able to work. He has had a phone for ten years, always paid his bills, but they wouldn't budge. So he has had to borrow money from his girlfriend to get the phone. Odd how disreputable we are.

We're giving Meri a going away party the first week in January. Do you think you can come down?

Lunch is over—have to run.

Always,

*Will*

Dear Will,

I was sorry to hear about the Endowment grant. Is it too late to apply to the state arts council?

The reason I haven't written to you in ages is because I've had quite a bout with my female plumbing. I had a hysterectomy about three weeks ago. I swore I'd never do this, but there was very little choice in this case. It's strange that you should have mentioned health benefits in your last letter, just when this mess toppled down on me. I know only too well now how necessary insurance is. I've had to borrow a large sum of money to get me through this ordeal. I feel so vulnerable, like some small mouse cornered by a large bird of prey.

I keep telling myself that if I would just get a *real* job as a *real* employee all of this uncertainty would disappear. I would be secure. But I know that financial security is false too because I would also lose a large chunk of meaning in my life and become a much less productive person.

I've talked with the University about teaching full-time but I would have to get a Master's and even then they couldn't guarantee me a job. There are a very few positions and many people more qualified than I. Besides I don't want to be a teacher, I want to be a painter. But finding a job as a painter is like trying to find work as a shepherd—there's not a lot of demand.

In order to get myself out of this hole I have taken on some illustration work for a friend of mine who has a graphic arts business. There won't be a lot of work but he pays pretty well. This means of course that the painting must be put off some.

That's wonderful news about Meredith. I wonder if she feels like she's leaving a sinking ship? She does have an odd sense of loyalty to New England and its artists. I will try to get down to see her off, but I can't promise, what with kids and the classes I have to prepare for.

Sometimes I think maybe I should leave this desolate place and dig my heels into a city—New York specifically. Then I think about the land, my neighbors, the rhythm of life in this tiny town. I am inspired here and receive, in many intangible ways, sustenance. But I am terribly isolated from other artists, from new ideas, and from opportunities to sell my work.

Trying to make it as an artist in the country is tough. My friend Ira and his partner have a wonderful mime show (truly wonderful), but they are really having a hard time. One of their desires when they decided to settle in Vermont was to play to people who live in remote villages and towns tucked way up in places like the Northeast Kingdom. But there's no way they can charge realistic ticket prices in East Corinth or Derby Line. In the past they got some help from the state arts council, but that seems to be drying up somewhat. They can get good ticket prices in the larger towns and, of course, Burlington but you can't play

Burlington twenty times a year. They have had to book an increasing number of shows outside the state, even outside New England. I don't know what made me get on this topic, except maybe thinking about Meredith and her flight out of New England and obscurity. She shouldn't feel guilty, if she does.

It's 5:00. I guess I'd better drag myself up to fix dinner. Michael has a basketball game and Stephanie a play rehearsal.

Give my love to Sam.

*Anna*

*Boston, Massachusetts*
*January 8, 19--*

Dear Anna,

Why didn't you let me know you were so sick? I could have taken a week or two off and come up. I hope things are better. Please let me know if you could use some help.

I began my new regime on January 1. It feels wonderful. On Saturday Sam goes over to a friend's house until 12:00 and goes to school on the weekdays so I have four whole mornings a week to work. I may actually finish by March and then on to the string quartets.

You know these last two years that I have had custody of Sam have made me realize the strain many women must feel in trying to be an artist and a mother at the same time. There are at least three women musicians I know who have virtually stopped performing because of family pressures. Some men I know have also curtailed their work, but none have quit altogether. I think this is a very tough problem. Do you think it is a very subtle form of discrimination?

Well, we saw Meri off yesterday. About ten of us took her to the airport and pushed her onto the plane. It was a strange scene. All of us, I think, feeling a little envious and Meredith feeling scared to death. I think you're right about her sense of loyalty to New England. She thinks Hollywood will ruin her provincialism. She says she'll be back. All New England has given her is a cold apartment and bleak images. Though now that I think about it, she is going to make a bundle off those bleak images.

Oh, I almost forgot to tell you I've been asked to perform and do a series of workshops in Connecticut this spring. I'm very excited but I have a lot of practicing to catch up on.

Got to run, my friend. Sam is hollering about the cat or something. *Please* write and tell me how you are.

Always,

*Will*

Dear Will,

Life is looking up. I am slowly regaining my strength, and I feel a thousand times better. I returned to teaching this week and have been painting every day. More graphics work has come my way too. One intriguing job is a brochure for a friend of mine who is a fiber artist. We're working on a design that incorporates fabric.

This woman is pretty interesting. She has been weaving for more than 15 years and has been able to secure some expensive shops in New York that will buy exclusively from her on a regular basis. It seems like she has reached the perfect balance. She produces enough useful, inexpensive clothing to sell and still has time to do her sculptures. (Note: She has no children.) She also does a lot of trading for goods and services. One summer she got all of her fruit and vegetables from a farmer down the road for two shirts and a shawl. She said she's never had to pay a dentist. This bartering idea sounds like a good one.

In the last couple of months I've had a lot of time to reflect on what I'm doing and how I'm doing it. Since Jack's death I've had to deal with a lot of things I never gave a thought to when he was alive. I've realized just how much I depended on him—emotionally and financially. I used to think I was doing so well when I'd sell a couple of paintings a year. Ha! That didn't even cover the cost of my paints. I guess I was just extremely fortunate to have someone like Jack who enjoyed his work and enjoyed me enjoying mine. We were lucky, too, that we always felt we had enough, that we didn't crave new cars, shad roe, or mink coats. (We did love asparagus, tho'.) Many, no most, of the artists I know depend on their mates for some kind of support from time to time. It's like all of these people, the artists' mates, are subsidizing the arts. Without them, society would indeed be the poorer. Many people would simply have to give up trying to be artists, especially if they had a family to support. It has never been so clear to me that behind every work of art there is a bowl of soup.

Write soon.

Much love,

*Anna*

# The Working Artist: Some Issues

In most labor market studies, artists are rarely visible. They appear in the statistics as teachers and computer programmers but not as artists. The reason for this is because artists are usually not asked questions that pertain to their work as artists. This study, on the other hand, was designed to uncover the conditions that specifically govern artists' working lives; the survey questions dealt directly with the artists' economic existence. But the statistical findings, which are discussed in chapters 2 and 3, do not tell the whole story. Several issues emerged from the study that do not boil down into neat statistical statements.

Anna and Will's exchange of letters explicitly and implicitly reveal some of these issues. The letters, which are based on both the statistics and the remarks made by artists on questionnaires and in interview sessions, illustrate some of the problems artists in New England are facing. The following discussion further elaborates (and speculates) on these problems. The discussion falls into three broad categories:

- Income
- Employment versus Work
- Education and Training

More specifically, the issues include problems stemming from inadequate income from art work, inequities between men's and women's earnings and work time, the value of education and training for artists who wish to live by their art alone, and the competing demands placed on artists' time and the effect this has on their ability to create and perform.

## Income

Neither Will nor Anna fits the stereotype of the poor starving artist huddled in some cold garret. Anna's part-time job teaching at a university gives her an income of about $10,000 a year. In addition to this, she receives about $5,000 a year from her husband's pension fund and other nonlabor sources. Will's sundry occupations yield a fluctuating yearly income of between $18,000 and $20,000 a year. When you consider that the average household in New England has an income of $18,900, Will and Anna's financial picture does not seem particularly bleak. But if some of the financial layers of their lives are stripped away, we find that while they can make a decent living— it is not because they

are artists but in spite of it.

In a good year, Will makes approximately $6,500 a year as a pianist and composer. With $3,000 in expenses, mostly for travel, he nets about $3,500 a year as an artist. Anna, like many women artists, earns even less. The sale of her paintings, drawings, and illustrations earns her about $6,000, but her materials and exhibit expenses total more than $4,000, thus making her net art income less than $2,000. When the artist's income is broken down by hourly wage rates, things don't look any better. The average hourly wage for all New England artists is $6.08. (The average worker in New England makes $7.05 per hour.) Women again don't fare very well. Men artists make an average of $7.76 per hour while women make $4.33. Clearly, Will and Anna must either hold other jobs or depend on others for financial support... or both.

Most artists in this study would probably agree with Anna's assessment that artists would have to pack up their artistic visions if they did not have the financial support from a mate or friend. "Faith in my abilities and perseverance in achieving goals has been important," noted a ceramist during one of the interview sessions, "but the initial years of establishing a studio, perfecting technical skills, and learning how and where to market would have been impossible without the spiritual and financial support of my partner and family." The necessity for this type of financial assistance is easily seen in the survey statistics as well: The average artist in New England made approximately $15,600 in 1981, but his or her total household income was over $27,000. This hefty $11,000 difference came from another member of the artist's household.

But financial help from others only accounts for the artist's total household income. It does not account for the difference between the artist's total personal income and the income from art work. Looking again at the $15,600 the average artist made, we find a large portion—about $9,000—of this total is from *nonart work*. Artists teach, build houses, write computer programs, so that they can live, support their families, *and* work as artists. The survey statistics show that most artists, over 75 percent, have jobs other than their art work. The reasons artists give for holding outside jobs are overwhelmingly economic: better pay, job security, and no art work available were the top three. These economic factors shape much of the New England artist's working life.

## Employment versus Work

The poet John Ciardi once observed that employment is what one does to earn a living, work is what one does to live. For a very few artists work and employment are the same thing. For the majority of New England artists work and employment are two quite separate and distinct activities that are constantly being weighed against each other. Because most artists cannot

make a living from their art work, they must have employment to give them some kind of financial stability. This, of course, leaves very little time for an artist to work on or promote his or her art—a perfect Catch-22.

If we look at the number of weeks artists worked in 1981, it is easy to imagine this double-time bind. In New England the average artist worked about 36 weeks as an artist, over 17 weeks in an arts-related job, and 12 weeks in a nonarts-related job. This adds up to a total of 65 weeks. Obviously many artists must have worked more than one job at a time. They also probably worked overtime. The statistics show that the average artist worked over 32 hours a week on his or her art. Now even if the artist had only just one part-time job of 20 hours per week, it would mean he or she would have put in a 52 hour work week.

From this vantage point, Will's complaint about not having enough time to promote himself as a performer is more than understandable. Artists must spend a good portion of each week looking for work or for outlets for their work. But depending on how tight their financial situation is, the time needed for this promotion may be very limited. The more time artists must spend earning an income, the less time they have for "marketing" their art.

Some artists find outside work stimulating. Some 39 percent of the artists surveyed said they thought their other job complemented their art work. On the other hand, only 3.4 percent said that they preferred their nonart work to their art work. Most artists it seems would agree with Anna and Will that outside employment cuts deeply into creative work time. Will's struggle to carve out a block of time in which he could concentrate on composing music and Anna's reclusive existence are not farfetched situations. In interview sessions and in the remarks on the questionnaires, artists repeatedly lamented their lack of creative time. One painter stated emphatically that her view of "a nonart job as grist for the mill had changed to seeing non-art work as a gross imposition on my painting time."

When we look more closely at the problem of competing demands on artists' time, women again seem more affected than men. Will commented that most of the women musicians he knew were having to either give up entirely or severely curtail their work because of family obligations. While the statistical survey did not directly address this issue, the data give a strong indication that women artists *are* still struggling with their roles as mothers and artists. This is apparent when we examine the data for those artists who left the labor force in 1981. Thirty-six percent of the women surveyed left the labor force at one time or another during the year as opposed to only 17 percent of the men. Over 42 percent of the women said they left because of family obligations. Only 12 percent of the men gave that reason.

Parenting patterns are changing in our society, as exemplified by Will's single parenthood, but for the most part women, whether by choice or necessity, are still devoting more time to

childrearing than men. In interview sessions and on the questionnaires, women artists repeatedly made comments such as, "I can work more now because my children are older," or "I hope someday to devote more time to my art as my children grow older." For some women even pregnancy can prevent them from carrying on with their art work. A stained glass designer offers one example. She explained, "In preparation for a prospective pregnancy, much of my work process had to stop because of hazardous chemicals and fumes." She added laconically, "This has slowed production down quite a bit."

The competing demands of time and family are just two aspects of the artist's working life that often impede work in progress. There are several other ways artists are working at a disadvantage. Both Anna and Will have good part-time jobs that afford them at least some modicum of financial stability, but let us say for a moment that they do not have these jobs, that they are both working just as artists.

Like most artists, Anna and Will would then be considered self-employed workers and as such they would lack some very important financial benefits that give workers who are employed some degree of security. Health insurance is one benefit. Many self-employed people cannot afford the cost of health insurance. These people either have to depend on a spouse's employment to provide the insurance or go without it and pray they and their family stay well. The other benefit is unemployment insurance. To receive this, a worker must have been employed by an employer who pays into the insurance fund, have been employed for a certain minimum length of time, and then laid off (as opposed to quit.) As self-employed people, artists rarely meet these qualifications. Even performers who work for someone else often do not work long enough to be able to collect unemployment insurance.

The artist in this case is no different than any other self-employed person. But the artist is very different in some other ways, mostly having to do with the very nature of art and how it is created.

Conventional ways of thinking about productivity, about selling one's product, and even about compensation do not necessarily apply to art work. Selling art, in other words, is not like selling cars. As one artist put it, "...we don't work in anticipation of selling. Art can't anticipate what will sell, or it will quickly become a commercial pursuit rather than a creative one." Artists in this respect are very unlike most self-employed workers: they produce regardless of the demand for their product. An abstract painter, for example, is not going to turn to realism just because it happens to be the current rage. A jazz pianist isn't going to begin playing Mozart just because there seems to be more work for chamber music groups. Artists work according to their vision, their predilections. They must interpret the world as they see it. This is what makes art art. The driving force behind producing cars, toothpaste, or any other consumer oriented product must

be profit; the driving force behind producing art must be creativity.

Not only is the impetus for art different but so is the way in which it is produced. A singer does not sing the same song the same way twice, nor does a fiber artist create the same work over and over again. Art is simply not something that can be turned out on an assembly line. An artist's "product" by definition is unique. This requires very different kinds of work behavior and expectations. When Will sits down on those mornings that he has set aside to work on his music, he has no guarantee that he will be able to write even one note that is worthwhile. Anna said, as well, that sometimes it takes fifteen paintings to make one good one. This is not the principle on which most businesses are run. If someone is in the bagel business, for example, he or she must produce a lot of good quality bagels quickly. With some degree of quality control and a lot of hard work, the person has a good chance of succeeding in turning out bagels people will buy. No such assurance exists for the artist. Artists produce without any set way, method, procedure, process, or formula for achieving their end—often they don't even know what the end will be. They can go down many an artistic blind alley before finding a way out—a journey that can take months, years, even a lifetime. In the meantime, artists must feed, clothe, and house themselves and their families. No easy task for anyone, but for many artists, especially those who wish to devote all their energy to art, it is virtually impossible.

## Education and Training

By conventional standards, New England artists are very well educated. Eighty percent of the artists studied here had college degrees, and 64 percent of these either went to art school or majored in their artistic field in college. But the old axiom—a good college education will lead to a good paying job—does not seem to hold true for artists, at least for those people who want to work solely as artists.

Will and Anna have good educations. Anna, who has a bachelor's degree, has four more years of schooling than the average Vermonter. Will who has a master's degree is much better educated than the average citizen in Massachusetts who has only a high school diploma. While Will's and Anna's educations probably help them get jobs that pay well, teaching and computer programming, it has not necessarily furthered their artistic careers.

As a teacher, Anna has come closer than Will to matching her degree in art to a job. She is not alone. Almost 80 percent of the artists who participated in this study and who had jobs outside their art were involved in art education in some way, mostly teaching. For some artists this is a perfect marriage, but for others it is only a necessity. The question many artists asked in this survey was, "If I don't teach, how necessary is my degree?" For some the answer was obvious. As one writer put it, "Since I don't teach, my degree is worthless."

The statistics presented in chapters 2 and 3 actually show a negative relationship between education and artistic income. In Vermont, where Anna lives, an artist who has graduated from high school earns more money as an artist than someone who has a doctorate degree. This same relationship between degree and artistic income was found throughout the region.

In weighing whether she should go back and get a master's degree in art, Anna has to ponder this dilemma: should she try to increase her earnings, or should she conserve the time she has to work on her art? It is a question of investment of both time and money.

A simple comparison between artists and other workers with equivalent years of schooling might help her make up her mind. For example, engineers have 16.6 years of schooling, roughly the same as the average New England artist. But the average engineer's personal income from his or her engineering work was $27,797 in 1981; the average New England artist's income from his or her art work was $6,500.

It is likely that if Anna and Will are more committed to becoming better artists than they are to increasing their income, they may not pursue higher college degrees but rather seek out special training from others in their fields. Specialized training is vitally important to artists. In many disciplines, artists begin this training when they are very young. This is especially true for performers. (Athletes are probably the only other professional group that starts specialized occupational training at an early age.) As a typical musician, Will would have begun learning how to play the piano at around the age of nine. This means that by the time he was 25, he would have had sixteen years of musical training and probably spent several thousand dollars on instruments, music, and lessons.

Also unlike many other professionals, artists do not get trained and then commence work. There is no clear line between work and training, and certainly training is never really completed. Training can take the form of a writer attempting to emulate another writer's style or a media artist taking an acting class. Training and time for study and practice are so critical to the artist that many leave the labor force (that is, they choose not to be employed nor do they seek work) to improve themselves. Anna's friend Jake felt no hesitancy in leaving his job so that he could work under another dancer. Approximately 42 percent of the artists in this study who had dropped out of the labor force in 1981, in fact, felt as Jake did and left the labor force to improve their artistic skills.

# Art and Society

Brewster Ghiselin's description of creativity in his book *The Creative Process* could serve just as well as a description of the artist in the New England labor market. Ghiselin writes, "This casting loose the ties of security requires courage and understanding. It requires courage to move alone, often counter to popular prepossessions and toward uncertainties."

There is one difference, however, between an artist's creative life and his or her working life. With creativity the artist actually seeks out the unknown, the uncertainty. With work, at least as it relates to financial matters, the artist obviously strives to diminish the uncertainty. The irony, of course, is that in the attempt to pursue their creativity, artists often increase their financial uncertainty.

Society will be the ultimate loser if the artist fails to gain some measure of financial certainty. As we have seen here, and will see even more clearly in the following chapters, artists are subsidizing themselves. Should the economic realities become too harsh, the artist will have no choice but to give up his or her art work. If this should happen, what will society lose? A symphony? An exquisite hand-blown vase? A great novel or film? A violin virtuoso? It does not really matter what it is. What is important is that society will lose creativity, beauty, and insight.

# Chapter Two

## Survey Findings:

## An Overview of New England

# Survey Findings:
# An Overview
# of New England

How artists survive economically has not been well understood in the past. As a group, they seem to slip the noose of pat categorization. Even the United States Census Bureau, the ultimate classifier and tabulator, does not really treat artists as a separate and distinct occupational group. The following profile of New England artists attempts to uncover more information about artists and the nature of their economic existence within this region.

The major source of information for this profile was a mail questionnaire that was completed and returned by 3,027 artists in the six New England states.[1] Responses of Massachusetts artists are for the calendar year 1980; those for artists in the other five states are for 1981. The questions in this survey were specifically directed toward the artists' work situation and factors likely to affect it.[2] The statistics gathered from the questionnaire responses were supplemented with personal interviews with about 100 artists from each of the six states. Work issues that could not be quantified, such as career paths, techniques of selling one's art, and tax deductibility of artistic costs, formed the principal focus of the interviews. The combination of the data from the questionnaires and the additional insights from the interviews has produced a clearer picture of New England artists and their place in the work force.

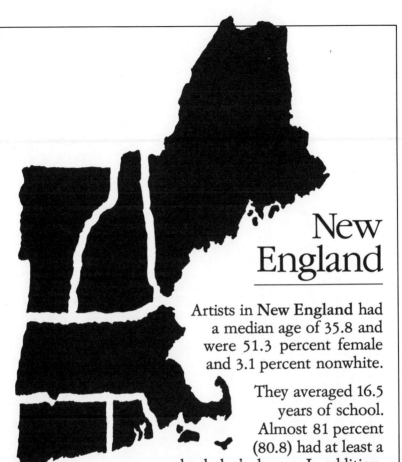

# New England

Artists in **New England** had a median age of 35.8 and were 51.3 percent female and 3.1 percent nonwhite.

They averaged 16.5 years of school. Almost 81 percent (80.8) had at least a bachelor's degree. In addition, 84.4 percent received specialized artistic training in school, and 74.4 percent outside of school.

They worked 36.1 weeks as artists in 1981. In addition to their work as artists, 53.9 percent held jobs related to their art for an average of 32.5 weeks and 36.1 percent held jobs not related to their art for 33.5 weeks. Holding more than one job at a time was common. Nevertheless, 20.8 percent were unemployed and 26.9 percent dropped out of the labor force during the year.

They earned $15,644 in income from all sources in 1981. Their household income (including earnings of other household members) was $27,297. However, the income they earned as artists was $6,420. In earning their artistic income, they incurred nonreimbursed costs of $3,554.

# New England / Table 1

## Demographic Characteristics of the Artists

| | Percent by Occupation | Median Age | Percent Who Are: | | Percent Who Are: | | | | | Percent Who Are: |
|---|---|---|---|---|---|---|---|---|---|---|
| | | | Male | Female | Amer. Indian | Asian | Black | White | Other | Hispanic* |
| **All Artists** | 100% (n = 3,027) | 35.8 | 48.7% | 51.3% | 0.7% | 0.8% | 1.3% | 96.9% | 0.3% | 1.7% |
| **By Occupation:** | | | | | | | | | | |
| Dancers | 1.5 | 31.8 | 29.6 | 70.4 | 0.0 | 0.0 | 4.7 | 95.3 | 0.0 | 5.3 |
| Musicians | 15.6 | 35.8 | 64.9 | 35.1 | 0.4 | 0.7 | 1.1 | 97.6 | 0.2 | 0.9 |
| Actors | 3.5 | 36.2 | 53.3 | 46.7 | 1.0 | 0.0 | 1.9 | 92.1 | 0.0 | 2.0 |
| Theater Production Personnel | 4.0 | 36.2 | 56.8 | 43.2 | 0.0 | 0.0 | 2.6 | 96.5 | 0.9 | 2.6 |
| Writers and Poets | 11.5 | 40.0 | 48.5 | 51.5 | 0.6 | 0.9 | 0.6 | 97.6 | 0.3 | 0.3 |
| Choreographers, Composers, and Playwrights | 3.1 | 40.9 | 53.2 | 46.8 | 0.0 | 2.2 | 1.1 | 95.5 | 1.1 | 3.4 |
| Visual Artists | 33.0 | 37.0 | 44.4 | 55.6 | 0.9 | 0.7 | 1.9 | 96.0 | 0.4 | 2.0 |
| Media Artists | 7.9 | 34.3 | 71.7 | 28.3 | 0.4 | 0.9 | 0.9 | 97.8 | 0.0 | 1.4 |
| Craft Artists | 19.9 | 36.0 | 32.0 | 68.0 | 0.9 | 0.9 | 0.5 | 97.8 | 0.0 | 2.2 |

*Hispanics are not counted as a separate race and therefore are an entirely separate category.

# Demographics and Educational Characteristics

To ensure a representative sample and to make the presentation of data more meaningful, the artists were grouped into nine occupational classes: dancers, musicians, actors, theater production personnel, writers and poets, choreographers, composers, and playwrights, visual artists, media artists, and craft artists. Each artist identified his or her artistic occupation on the questionnaire. When an artist indicated more than one artistic occupation, the one ranked first in income was used.

In most classes, suboccupations can also be identified. The number of artists in each suboccupation can affect the overall characteristics of the entire group. In addition, 44 percent reported more than one artistic occupation. Because multiple occupation combinations were not random, these also could influence the characteristics of each occupational group.[3]

The number of artists in each occupational class is far from equal, reflecting their relative proportions among all artists in New England. If any breakdown of the data includes groups of five artists or less, no information is reported. This is because averages based on very small samples are not statistically reliable, and all artists who responded to the survey were promised anonymity. Individual attributes can be estimated from averages of very small samples. Sample sizes of five or less are not a problem in this chapter but occur occasionally in the following chapter on the individual states.

## Age, Sex, and Race

The occupation with the largest representation, visual arts, contains roughly 22 times as many people as the smallest, dance. (Since a few artists did not identify their occupations, the sum of responses by occupation in Table 1 is less than the total number of artists reported in column 1.)

The median age of members of the nine occupational classes does not vary widely. It is not surprising that dancers, with their dependence on physical capability, have the youngest median age. Choreographers, composers, and playwrights, who often switch to these careers from performing, have the oldest median age. Writers and poets are close behind. Although 35.8 may appear to be a low median age in the labor force, it is in fact one year older than the median age of all workers in New England.[4] The average artist, however, is more educated than the average member of New England's labor force. This could mean the artist postpones entry into the labor force until a later age.

Artists are not typical of workers in general in their composition by sex. Women compose 44.5 percent of the labor force in New England, but made up 51.3 percent of the artists who

## Age at which Artistic Training Began

| Occupation | Starting Age |
|---|---|
| All Artists | 15.0 |
| Males | 15.3 |
| Females | 14.8 |
| Dancers | 11.5 |
| Males | 15.7 |
| Females | 9.9 |
| Musicians | 9.4 |
| Males | 9.9 |
| Females | 8.4 |
| Actors | 16.9 |
| Males | 17.5 |
| Females | 16.2 |
| Theater Production Personnel | 14.1 |
| Males | 15.9 |
| Females | 11.6 |
| Writers and Poets | 16.4 |
| Males | 15.7 |
| Females | 17.1 |
| Choreographers, Composers, and Playwrights | 10.3 |
| Males | 15.7 |
| Females | 9.3 |
| Visual Artists | 15.3 |
| Males | 16.0 |
| Females | 14.8 |
| Media Artists | 18.3 |
| Males | 18.1 |
| Females | 19.0 |
| Craft Artists | 18.8 |
| Males | 20.7 |
| Females | 17.8 |

responded to the survey.[5] The representation of women among the nine occupations is exceedingly variable, ranging from 28.3 percent in the media arts to 70.4 percent in dance. Other than dance, the performing arts occupations were dominated by men. Women formed significant majorities in the two largest occupations, visual arts and craft arts.

New England does not have a high percentage of racial minorities residing within its borders. Whites constitute 96.1 percent of the labor force in the region.[6] Among artists, the representation of whites is slightly higher—96.9 percent. Although information on the racial composition of the labor force is not available in as much detail as in this survey, it can be reported that black artists constitute 1.3 percent of all artists, but blacks in general constitute 3.0 percent of the New England labor force.[7] The relatively low proportion of minorities among surveyed artists occurred despite deliberate efforts to solicit mailing lists known to contain high proportions of minorities.

As with sex, minority representation among occupations is quite variable. Counting Hispanics, minority representation is as high as 10.0 percent among dancers and as low as 2.7 percent among writers and poets. (In accord with Census terminology, Hispanics, while considered to be a minority group, are not considered to be a separate race. Thus adding the percent black and percent Hispanic together is likely to involve some double counting.)

## Education and Training

Education is an important factor in determining the financial success of most members of the labor force. In this survey, questions were asked about the amount of formal (elementary, secondary, and college) education received and the amount of specialized training (training in an artistic field) received. Questions were also asked about artistic training outside the formal educational experience.

One distinguishing characteristic of an artistic career is that it generally begins at an early age. Specific, job-related training for most other occupations does not begin until after high school. Typically, the more years of general education one has, the later in one's educational career specialized job training begins. The average age that the surveyed artists began their artistic training is broken down by occupation and sex in Table 2.

Overall, artists began some form of artistic training at age fifteen, with women starting at a slightly earlier age than men. Starting ages are particularly low among the three performing occupations, and especially among dancers and musicians. The relatively low starting ages for theater production personnel and for choreographers, composers, and playwrights may be due to their initial training as performers.

Artistic training may occur within or outside of the formal educational experience. In Table 3, formal educational attain-

# New England / Table 3

## Educational Attainment of Artists

| | Median Years of Schooling | Percent with Highest Attainment of: | | | | | | | Percent with Specialized Arts Training: | |
|---|---|---|---|---|---|---|---|---|---|---|
| | | Less than High School | High School Diploma | Associate's | Bachelor's | Master's | Doctorate | Other | As Part of Formal Education | Outside Formal Education |
| **All Artists** | 16.5 | 0.5% | 15.0% | 3.1% | 42.2% | 34.1% | 4.5% | 0.5% | 84.4% | 74.4% |
| **By Occupation:** | | | | | | | | | | |
| Dancers | 16.1 | 0.0 | 32.6 | 2.3 | 41.9 | 23.3 | 0.0 | 0.0 | 74.4 | 97.7 |
| Musicians | 16.9 | 0.7 | 15.1 | 1.1 | 41.3 | 37.1 | 4.4 | 0.2 | 89.5 | 77.1 |
| Actors | 16.1 | 1.0 | 21.0 | 2.9 | 53.3 | 19.0 | 2.9 | 0.0 | 82.5 | 87.2 |
| Theater Production Personnel | 17.4 | 0.0 | 9.3 | 2.5 | 40.7 | 42.4 | 5.1 | 0.0 | 95.7 | 71.9 |
| Writers and Poets | 17.6 | 0.9 | 8.9 | 1.8 | 33.5 | 38.0 | 16.9 | 0.0 | 67.8 | 63.6 |
| Choreographers, Composers, and Playwrights | 17.7 | 0.0 | 9.8 | 3.3 | 29.3 | 39.1 | 16.3 | 2.2 | 94.6 | 85.7 |
| Visual Artists | 16.6 | 0.5 | 13.2 | 3.5 | 43.6 | 36.1 | 2.0 | 0.9 | 92.0 | 72.2 |
| Media Artists | 16.2 | 0.4 | 19.6 | 4.4 | 43.2 | 29.7 | 2.2 | 0.4 | 77.4 | 71.6 |
| Craft Artists | 16.3 | 0.5 | 18.7 | 4.5 | 45.9 | 28.5 | 1.4 | 0.5 | 77.3 | 78.0 |

# New England / Table 4

## Specialized Artistic Training as Part of Formal Education

| | Secondary Level | | | Undergraduate Level | | | Graduate Level | | |
|---|---|---|---|---|---|---|---|---|---|
| | Art School | Art Major | Non-Major | Art School | Art Major | Non-Major | Art School | Art Major | Non-Major |
| All Artists | 9.7% | 8.6% | 25.8% | 40.9% | 23.8% | 14.3% | 47.2% | 17.4% | 5.8% |
| By Occupation: Dancers | 18.6 | 0.0 | 16.3 | 35.1 | 13.5 | 27.0 | 50.0 | 16.7 | 5.6 |
| Musicians | 8.8 | 12.9 | 40.6 | 58.2 | 19.7 | 10.8 | 63.7 | 10.6 | 5.5 |
| Actors | 7.8 | 6.9 | 22.6 | 23.7 | 32.3 | 20.4 | 39.0 | 17.1 | 7.3 |
| Theater Production Personnel | 7.8 | 12.1 | 36.2 | 38.4 | 39.3 | 10.7 | 50.7 | 26.0 | 2.7 |
| Writers and Poets | 2.7 | 5.4 | 16.6 | 8.5 | 25.7 | 24.8 | 18.5 | 17.6 | 10.1 |
| Choreographers, Composers, and Playwrights | 9.7 | 8.6 | 30.1 | 23.6 | 40.4 | 24.7 | 47.5 | 34.4 | 3.3 |
| Visual Artists | 14.3 | 9.8 | 24.0 | 53.3 | 24.7 | 9.3 | 59.1 | 15.4 | 3.7 |
| Media Artists | 4.0 | 3.6 | 22.7 | 31.5 | 19.2 | 16.0 | 36.1 | 20.0 | 8.2 |
| Craft Artists | 8.9 | 6.9 | 21.9 | 35.8 | 19.2 | 16.0 | 36.3 | 21.1 | 6.6 |

ment and the extent of specialized training in artistic fields are presented, broken down by occupation. Clearly emerging from this table is the exceptionally high level of educational attainment of artists. For example, the 16.5 median years of school attained by the artists (slightly more than four years of college) far exceed the 12.3 median years of school (slightly more than four years of high school) attained by the average person in the New England labor force. [8] Over 80 percent of the artists have attained at least a bachelor's degree. This is well above the average of 19.3 percent for all adults 25 years old and over in New England. In fact, a higher percentage of artists had graduated from college than New England residents age 25 and over had graduated from high school.[9]

To find members of the labor force with comparable levels of attainment, one has to look at the Bureau of Labor Statistics category of "Professional, Technical, and Kindred Workers." The median years of school completed by people nationwide in this category is 16.6. These people include engineers (16.6 years of schooling), physicians, dentists, and related practitioners (18.4 years), and teachers, excluding college (17.3 years).[10]

The occupations with the most years of education are theater production personnel, writers and poets, choreographers, composers, and playwrights. Dancers and actors have the least formal education but are the most likely to have had specialized training outside the formal educational process. The relationship, however, betweeen the amount of formal education and artistic training outside the formal educational system is not inverse for all occupations. Musicians and theater production personnel rank above average in both years of education and extent of outside specialized training. Media artists rank below average in both. Also, there is no consistent relationship between the extent of specialized training inside and outside the formal education process.

Additional information about specialized training as part of the formal educational process was also requested in the questionnaire. This information, summarized in Table 4, shows the form that the specialized training took and the incidence of the training at different levels of education. For any given level of education, the choices reported in Table 4 are treated as mutually exclusive. For example, anyone reporting having attended a specialized art school[11] was not counted a second time as also having majored in an artistic field, and anyone having majored in an artistic field was not counted additionally as having taken artistic courses as a non-major. Thus the percentage of artists at any level who received no specialized training can also be inferred from this table as the difference between 100 percent and the sum of the percentages for each type of training.

Also, the data for each level reflect only those artists who actually attained that level of education. Therefore, of those artists attaining each level, attendance at a specialized art school is most common at the graduate level, majoring in art is most

## Extent and Amount of Training
## Received by Artists in 1981

| | Percent Participated in 1981* | Hours Per Week** | Weeks** |
|---|---|---|---|
| **All Artists** | 40.8% | 11.4 | 16.8 |
| **By Occupation:** | | | |
| Dancers | 70.7 | 8.7 | 32.4 |
| Musicians | 38.2 | 10.3 | 21.5 |
| Actors | 46.6 | 10.6 | 23.6 |
| Theater Production Personnel | 40.2 | 11.6 | 20.8 |
| Writers and Poets | 34.0 | 7.2 | 20.3 |
| Choreographers, Composers, and Playwrights | 49.4 | 8.6 | 23.5 |
| Visual Artists | 41.1 | 10.0 | 15.8 |
| Media Artists | 41.6 | 17.0 | 9.3 |
| Craft Artists | 40.0 | 16.9 | 9.5 |

*In 1980 for Massachusetts artists.
**These are averages only for those artists who received training.

common at the undergraduate level, and taking artists courses as a nonmajor is most common at the secondary level. The information in Table 4 is not fully consistent with the typical educational profile noted earlier, that specialized training occurs late in one's educational career. Although specialized training overall is much higher at the undergraduate than at the secondary level, it is lower at the graduate level than at the undergraduate level. This may be due to artists using their graduate training to acquire a complementary skill, such as teaching or management.

Among the occupations, musicians, theater production personnel, visual artists, and composers, choreographers, and playwrights tend to receive more than average amounts of specialized artistic training at all levels of education. The artists in the remaining five occupations have less specialized training. Despite the close skill relationships between theater production and composing, choreography, and playwriting, on the one hand, and the three performing arts occupations, on the other, the extent of specialized training differs markedly between these two sets of occupations.

Artists often continue training even after commencing work in their profession. To measure the extent of such training, they were asked whether or not they had received any training or education in artistic fields in 1981.[12] In every occupation, except one, the percentage of artists who participated in some form of training hovers around 40 percent, the average for all artists. The principal exception is dancers of whom almost 71 percent engaged in training. Clearly, the form of training received by dancers is different as well. The number of weeks of training is twice the average of all artists, but the number of hours per week is less. This is typical of the extended ongoing training that is part of one's work in dance. For media artists and craft artists, the training is quite different: more intensive training of a much shorter duration. The training received by artists in other fields falls between these extreme cases.

Of general interest is how women and racial minorities fare as artists. These two groups have lower earnings than men and whites in the general labor market. Although women and minorities often have weaker qualifications for many types of jobs, studies have demonstrated that, even with the same qualifications, they usually earn less.

An important qualification for most occupations is the amount of education that a person has. In Table 6 the average years of schooling attained are broken down by race and sex. (These figures are means, not medians. The mean years of school for all artists is 16.7.) Because of the small size of the racial minority sample in this survey, only one minority class, "nonwhites," is used. Nonwhites consist of Asians, American Indians, blacks, and others. (The relative size of each of these groups can be seen by referring to Table 1.)

The major conclusion to be drawn from these data is that differences in educational attainments between races and sexes

## Average Years of Schooling by Race and Sex

| | Race: | | Sex: | |
|---|---|---|---|---|
| | Whites | Nonwhites | Men | Women |
| All Artists | 16.7 | 16.9 | 16.7 | 16.7 |
| By Occupation: | | | | |
| Dancers | 16.0 | 15.5 | 14.8 | 16.4 |
| Musicians | 16.9 | 16.8 | 16.7 | 17.1 |
| Actors | 16.0 | 15.7 | 16.0 | 16.0 |
| Theater Production Personnel | 17.3 | 19.2 | 17.5 | 17.0 |
| Writers and Poets | 17.4 | 17.6 | 17.6 | 17.2 |
| Choreographers, Composers, and Playwrights | 17.5 | 18.0 | 17.7 | 17.2 |
| Visual Artists | 16.8 | 16.9 | 16.8 | 16.8 |
| Media Artists | 16.3 | 16.0 | 16.2 | 16.5 |
| Craft Artists | 16.3 | 16.2 | 16.2 | 16.3 |

are virtually nonexistent. To the extent that any differences appear, they do so when the sample is grouped by occupations; these differences then appear among the performing occupations. Excluding any differences in quality of education, which would not be discernable from the questions asked in the survey, it would thus appear that male, female, white, and nonwhite artists all possess equivalent educational backgrounds. Whether or not each group can then be expected to earn the same average income depends on a number of other factors, including whether or not more years of formal education enhances income from artistic work.

This educational pattern for artists, especially as it applies to race and sex, is much different than that for the population as a whole. In 1979, the median years of school completed by all Americans over the age of 25 was 12.5 years. It was 12.6 for men and 12.4 for women. For whites it was 12.5; for blacks, 11.9. Differences in years of schooling by race and sex are narrower in the northeastern United States, though they still exist.[13]

# New England / Table 7

## Nonartistic Jobholding Patterns of New England Artists, 1981*

| | No Non-Artistic Job | Percent in Each Occupation With: | | |
| | | Arts-Related Job Only | Nonarts-Related Job Only | Both Arts-Related and Nonarts-Related Jobs |
|---|---|---|---|---|
| **All Artists** | 24.1% | 39.7% | 21.9% | 14.2% |
| **By Occupation:** | | | | |
| Dancers | 15.9 | 43.2 | 18.2 | 22.7 |
| Musicians | 13.7 | 50.7 | 18.7 | 17.0 |
| Actors | 37.1 | 22.9 | 22.9 | 17.1 |
| Theater Production Personnel | 22.0 | 48.3 | 12.7 | 16.9 |
| Writers and Poets | 15.7 | 40.2 | 32.0 | 12.1 |
| Choreographers, Composers, and Playwrights | 10.8 | 61.3 | 10.8 | 17.2 |
| Visual Artists | 27.1 | 38.0 | 21.6 | 13.3 |
| Media Artists | 25.8 | 34.8 | 25.8 | 13.7 |
| Craft Artists | 33.7 | 32.0 | 22.6 | 11.7 |

*1980 for Massachusetts artists.

# Labor Market Characteristics

## Jobholding Patterns

Unlike other professionals, most artists are unable to earn an acceptable living from their work. Many must hold jobs outside their artistic field despite claiming that art is their primary occupation. The necessity of doing this is evident from the number of weeks artists worked annually in other occupations and from the incomes they derive from their art work compared to other forms of employment.

It is unusual for members of most professions, such as medicine, law, education, and accounting, to hold jobs outside their area of expertise. Yet, as Table 7 shows, such jobholding is the rule rather than the exception among artists. *Only one-quarter of the artists in the survey held only artistic jobs in 1981* — three-quarters worked in other jobs as well.[14]

To understand more about this jobholding pattern, artists who filled out the questionnaire were asked to categorize their other jobs as either "arts-related" or "nonarts-related." On the questionnaire, arts-related jobs were defined as teaching or coaching in an artistic discipline, arts administration, and jobs that might be closely connected to the arts, such as management, clerical work, usher, ticket taker, etc. Nonarts-related jobs were defined as any other job other than artistic or arts-related. Additionally, the artists were requested to describe the arts-related and nonarts-related jobs they held during the year.

Almost 40 percent of the artists held arts-related jobs during 1981. Slightly over 20 percent held nonarts-related jobs and 14 percent held both. Among artistic occupations, there is a greater likelihood that those in performing occupations will hold arts-related jobs. Similarly, there is a greater likelihood that artists who are not performers will hold nonarts-related jobs. Neither trend, however, is terribly strong. Although incomes of artists have not yet been discussed, it should be noted that, in general, the more an artist earns from his or her art, the less likely he or she is to work in other jobs.

An obvious reason why arts-related jobs are more commonly held by artists is that they complement art work. This is shown clearly in Table 8. Fully 80 percent of all arts-related jobs consist of teaching in artistic fields. Virtually all of the remainder consist of professional and managerial jobs within artistic organizations. A frequent comment by the artists was that their artistic and arts-related jobs are so interdependent that they have difficulty providing separate data for each.

Nonarts-related jobs are spread more evenly among the traditional occupational classes. Representation in skilled occupational areas and unskilled areas are roughly equal.

There are other factors, too, that warrant examination when looking at artists' jobholding patterns. These factors show the

## Occupational Breakdown of Arts-Related and Nonarts Related Jobs

| Occupation | Arts-Related | Nonarts-Related |
|---|---|---|
| Professional and Technical | 5.6% | 19.0% |
| Art Education | 77.9 | 0.0 |
| Other Education | 0.8 | 14.8 |
| Art Managerial | 9.0 | 0.0 |
| Other Managerial | 1.7 | 11.9 |
| Sales | 1.4 | 11.1 |
| Clerical | 0.6 | 13.4 |
| Craft and Kindred Workers* | 2.2 | 10.4 |
| Operatives and Laborers | 0.2 | 5.3 |
| Service | 0.6 | 13.8 |

*The word "craft" is not used here in the same sense we use it in the text. It is a U.S. Census term that includes various blue collar workers such as carpenters, mechanics, printers, plumbers, and telephone installers.

distinctions between those who did and those who did not declare "artist" to be their principal profession, men and women, and whites and nonwhites. (See Tables 9 and 10.) Distinctions within these groups in *arts-related* jobs turn out to be minimal. Comparisons, particularly within the two largest areas, arts education and arts management, show minimal differences.

Distinctions, however, within these groups are more pronounced in *nonarts-related* job patterns. Those who did *not* declare art as their principal profession are more heavily concentrated in the better-educated, better-paying job areas: the professions, education, and management. Those who *did* declare art as their principal profession are more concentrated in the less-skilled job areas. An obvious interpretation of this pattern is that the more committed and/or successful artist takes *nonarts-related* jobs to supplement his income and provide work during stretches of artistic unemployment. Those not declaring art as their principal profession tended to do so because of the greater prestige, income, and steady employment associated with their nonarts-related profession.

The nonarts-related jobholding patterns of men and women tend toward sexual stereotypes. Men are more prominent in the professions and the blue collar fields. Women are more prominent in education, clerical, and service jobs. Only the greater

# New England / Table 9

## Patterns of Holding Arts-Related Jobs, by Commitment to Artistic Field, Sex and Race

| Occupation | Artist Principal Profession | Artist Not Principal Profession | Men | Women | White | Nonwhite |
|---|---|---|---|---|---|---|
| Professional and Technical | 6.2% | 3.6% | 5.1% | 6.0% | 5.5% | 7.3% |
| Arts Education | 77.1 | 81.1 | 76.3 | 79.4 | 77.8 | 81.8 |
| Other Education | 0.9 | 0.7 | 1.1 | 0.6 | 0.8 | 0.0 |
| Arts Managerial | 9.0 | 8.5 | 10.5 | 7.6 | 9.1 | 7.3 |
| Other Managerial | 1.5 | 2.2 | 1.8 | 1.7 | 1.7 | 1.8 |
| Sales | 1.3 | 1.7 | 1.1 | 1.5 | 1.4 | 0.0 |
| Clerical | 0.5 | 1.0 | 0.4 | 0.8 | 0.6 | 0.0 |
| *Craft and Kindred Workers | 2.6 | 0.7 | 3.2 | 1.3 | 2.3 | 0.0 |
| Operatives and Laborers | 0.3 | 0.3 | 0.2 | 0.3 | 0.2 | 1.8 |
| Service | 0.6 | 0.2 | 0.3 | 0.8 | 0.6 | 0.0 |

*See note on Table 8

# New England / Table 10

## Patterns of Holding of Nonarts-Related Jobs, by Commitment to Artistic Field, Sex and Race

| Occupation | Artist Principal Profession | Artist Not Principal Profession | Men | Women | White | Nonwhite |
|---|---|---|---|---|---|---|
| Professional and Technical | 14.8% | 25.5% | 22.9% | 15.5% | 19.0% | 25.9% |
| Arts Education | – | – | – | – | – | – |
| Other Education | 11.7 | 19.8 | 13.5 | 16.1 | 15.1 | 7.4 |
| Arts Managerial | – | – | – | – | – | – |
| Other Managerial | 8.7 | 16.2 | 9.8 | 13.6 | 11.5 | 11.1 |
| Sales | 13.0 | 9.1 | 10.7 | 12.0 | 11.5 | 14.9 |
| Clerical | 17.9 | 7.3 | 4.8 | 21.2 | 13.7 | 11.1 |
| *Craft and Kindred Workers | 12.1 | 8.1 | 18.5 | 3.1 | 10.5 | 11.1 |
| Operatives and Laborers | 5.5 | 4.4 | 8.7 | 2.2 | 5.0 | 7.4 |
| Service | 16.3 | 9.6 | 11.1 | 16.3 | 13.7 | 11.1 |

*See note on Table 8.

# New England / Table 11

## Reasons For Working in Jobs Outside the Arts

*Percent Checking*

| | Better Pay | Better Job Security | Not Enough Artistic Work | Prefer Nonarts Work | Complements Artistic Work | Other |
|---|---|---|---|---|---|---|
| All Artists | 61.9% | 48.9% | 48.2% | 3.4% | 39.6% | 21.7% |
| By Occupation: | | | | | | |
| Dancers | 64.3 | 53.6 | 57.1 | 0.0 | 46.4 | 25.0 |
| Musicians | 50.4 | 57.1 | 61.7 | 6.5 | 44.1 | 18.8 |
| Actors | 39.6 | 35.8 | 69.8 | 1.9 | 39.6 | 20.8 |
| Theater Production Personnel | 60.9 | 47.8 | 50.0 | 2.2 | 41.3 | 21.7 |
| Writers and Poets | 79.1 | 56.4 | 46.3 | 3.2 | 34.6 | 17.7 |
| Choreographers, Composers, and Playwrights | 61.3 | 44.3 | 59.0 | 1.6 | 54.1 | 13.1 |
| Visual Artists | 65.4 | 47.8 | 43.1 | 1.5 | 38.6 | 23.1 |
| Media Artists | 57.6 | 44.0 | 48.8 | 4.0 | 37.6 | 24.0 |
| Craft Artists | 58.8 | 42.4 | 38.8 | 5.2 | 38.0 | 25.5 |

## Reasons for Working in Jobs Outside the Arts, by Type of Job

| | Percent Checking Reason: | | |
|---|---|---|---|
| Reason | Had Arts-Related Job Only | Had Non-arts-Related Job Only | Had Both Jobs |
| Better Pay | 62.6% | 65.7% | 56.3% |
| Better Job Security | 55.7 | 45.2 | 45.5 |
| Not Enough Artistic Work | 43.1 | 48.3 | 57.2 |
| Prefer Nonarts Work | 4.4 | 3.0 | 2.2 |
| Complements Artistic Work | 64.4 | 20.5 | 33.7 |
| Other | 15.4 | 26.1 | 23.6 |

proportion of women in managerial jobs violates this stereotype. Distinctions between whites and nonwhites do not reinforce stereotypes. Nonwhites are more prominent in the professions but less prominent in education. Differences are minimal in other occupational areas.

It is obvious that holding a job outside of art is a widespread trait among artists in this survey. To probe this issue more deeply, artists were asked to check one or more of the six possible reasons why they held nonart (either arts-related or nonarts-related) jobs. (See Table 11.) Economic factors predominated the responses. Over half the artists checked "better pay," while almost half checked "better job security" and "not enough artistic work." Often noted were irregular or seasonal work and pay as artists, inability to sell one's artistic services or products, and lack of health insurance and pension benefits. Only 3.4 percent claimed to prefer their nonartistic job, but almost 40 percent noted that their nonartistic (and probably arts-related) job complemented their artistic work.

More information on why artists held these jobs is revealed when the reasons for holding them are tabulated separately for those who held arts-related, nonarts-related, and both jobs (Table 12). The most frequently checked reason, "better pay," was checked equally often by holders of arts-related and nonarts-related jobs. This reason was checked less often by holders of both jobs. Apparently this group's nonart jobs did not pay as

# New England / Table 13

## Weeks Employed in 1981

| | Overall | As an Artist | In Arts Related Jobs* | In Nonarts Related Jobs* |
|---|---|---|---|---|
| All Artists | 46.0 | 36.1 | 17.3 (32.5) | 11.8 (33.5) |
| By Occupation:<br>Dancers | 43.1 | 27.3 | 23.5 (34.9) | 11.3 (29.6) |
| Musicians | 46.1 | 32.9 | 26.3 (38.5) | 12.8 (36.6) |
| Actors | 38.5 | 27.4 | 12.3 (28.6) | 10.6 (27.0) |
| Theater Production Personnel | 46.0 | 34.7 | 23.7 (37.1) | 9.1 (31.2) |
| Writers and Poets | 46.2 | 33.6 | 16.6 (32.2) | 15.5 (35.6) |
| Choreographers, Composers, and Playwrights | 44.7 | 26.9 | 27.8 (35.7) | 8.1 (29.6) |
| Visual Artists | 46.8 | 39.7 | 15.6 (30.8) | 11.5 (33.7) |
| Media Artists | 46.2 | 37.7 | 13.8 (28.9) | 13.0 (34.0) |
| Craft Artists | 46.1 | 37.6 | 12.3 (28.4) | 10.6 (31.4) |

*Numbers in parentheses are weeks worked only for those who held such jobs. The data refer to 1980 for Massachusetts artists.

well, and thus they needed to hold more than one type of job throughout the year. This is reinforced by the very low frequency with which those who held both jobs claimed they did so because they preferred them to art work. However, those holding both jobs also checked "not enough artistic work" more often, indicating that their lack of artistic work was particularly acute, forcing them to seek out several kinds of jobs to make ends meet.

"Job security" was more frequently chosen as a reason for holding arts-related jobs. The vast majority of these jobs are in teaching, where greater job security in the form of tenure is usually granted. The existence of tenure apparently outweighs, in the artists' minds, the currently precarious nature of arts education, especially in the public schools. Many public school arts teachers expressed a concern over job stability, particularly in Massachusetts, where Proposition 2½ legislation has adversely affected jobs in public education. Also, those who held arts-related jobs not surprisingly checked "complements artistic work" much more often than those holding other jobs.

## Employment, Unemployment, Out of the Labor Force

### Definitions

This description of the types of jobs artists hold and the reasons why they hold them draws only a partial picture of how artists fare in the labor market. An examination of employment and unemployment patterns offers further details and insights into the working lives of New England artists.

In interpreting the employment and unemployment data it is important to understand the precise manner in which the terms "employment" and "unemployment" are being used. To collect data from the survey comparable to the U.S. Labor Department reports, the Department's definitions were carefully spelled out in the questionnaire. Briefly, members of the labor force must be either employed or unemployed. To be employed in any given week, a person must work at least one hour for pay or in anticipation of pay. Thus, one who is paid by an employer, as a performing artist typically is, must be both working for and receiving pay from that employer to be counted as employed. A self-employed person, such as a visual or craft artist, need only be working in anticipation of pay to be counted as employed. In fact, it is rare when a self-employed person at work can be counted as unemployed, using the government's definition. It is not surprising, then, that artists in occupations dominated by self-employment reported less unemployment. Another complicating factor is the large number of artists holding nonartistic jobs. A person unable to find work such as a dancer, for example, would correctly indicate that he or she is employed if working steadily as a dance instructor or waiter.

To be unemployed, a person must not be working (as defined

# New England / Table 14

## Weeks Employed in 1981, by Race and Sex*

|  | Overall | As Artist | In Arts-Related Jobs | In Nonarts Related Jobs |
|---|---|---|---|---|
| **Men** | 47.7 | 38.4 | 18.0 | 12.2 |
| **Women** | 44.2 | 33.4 | 17.1 | 11.7 |
| **Whites** | 46.0 | 35.8 | 17.4 | 11.9 |
| **Nonwhites** | 45.4 | 37.0 | 22.3 | 10.0 |

*1980 in Massachusetts.

above) but actively seeking work. A person not working and not actively seeking work is considered out of the labor force. In the survey, questions were asked to probe the incidence of all three forms of labor market behavior— employed, unemployed, and not in the labor force.

## Employment

One of the ways to assess an artist's employment pattern is to examine the amount of time he spends working. This was done in two ways: by looking at the number of weeks worked at all jobs *and* as artists, and by looking at the number of hours worked solely as artists.[15]

The data in Table 13 clearly show that artists not only held more than one job but frequently held them simultaneously. By adding the number of weeks artists worked in all three job categories and comparing that sum to the total number of weeks worked overall, we see that not only does the sum exceed the number of weeks worked overall, but it exceeds the number of weeks in a year. This is easily seen when the sum of the weeks worked in each of the three job categories are added together. This totals sixty-five weeks. But since artists reported working only an average of 46 weeks per year, they must have worked more than one job at a time. This, in turn, implies less than full-time work in at least one of the two or more jobs jointly held. The pattern suggests less than full-time work at other times as well, since it is unlikely that a part-time job could be converted to a full-time one as soon as one job was dropped or lost.

As noted above, nonperforming artists generally report a greater number of weeks worked as artists. In general, the fewer weeks worked as an artist, the more weeks worked in other fields. The one exception is actors, with a low number of weeks worked both inside and outside their artistic field.

For all artists, the same data on weeks worked are broken down by race and sex in Table 14. The major difference highlighted in this table is that men artists worked more weeks overall in each type of job than women artists. The total number of weeks worked overall by whites and nonwhites is virtually the same, though nonwhites worked more weeks in artistic and arts-related jobs.

How artists allocated their work time is another piece of this employment pattern. Each artist was asked how many hours in a "typical week" were devoted to different aspects of his or her work as an artist (Table 15). For performing artists, estimates of time spent performing, rehearsing, practicing, and looking for work were requested. Nonperforming artists were asked to estimate the time spent creating their art, receiving artistic training, and marketing their art.

To keep the tabulated results meaningful, only performing hours are reported for performing artists and only nonperforming hours are reported for nonperforming artists. In reality, an artist who is both a performer and a nonperformer was not restricted to report only one or the other. Artists could and did log work hours in both categories whenever they possessed skills in both areas. The tabulations were merely made separately to simplify interpretation of the data. The extent to which performing artists logged hours in nonperforming arts, and vice versa, can be seen by comparing total hours, which includes time spent on all artistic work, to the sum of hours reported by function. For example, dancers worked 29.0 artistic hours of which 26.7 were spent as performing artists. The other 2.3 hours must have been spent as nonperforming artists. This also implies that the entire 26.7 hours worked as performing artists were not necessarily spent working as a dancer if one occasionally performs, for example, as a musician or actor.

The total weekly hours worked as an artist in all but two of the occupations is less than 40. This is not an indication of artists being less devoted to their work than people in other professions, but rather it is a sign that artists worked many hours in nonarts jobs trying to make a living. Since over 75 percent of those surveyed held nonarts jobs, it may be more surprising that the average artist managed to devote as many hours per week to his or her art as he or she did. Not so surprising is that occupations that had higher percentages of artists holding only an artistic job showed more hours per week worked as artists. More generally, those occupations reporting the least weeks worked in nonartistic jobs also reported more hours worked per week as artists.

## Unemployment and Out of the Labor Force

The other side of the employment coin is, of course, unemployment. The unemployment figures that emerge from this study tell us several things about how the artist functions economically. The first column in Table 16 shows the percentage

# New England / Table 15

## Hours Working as an Artist in a Typical Week in 1981*

| | Total | Performing Artists: | | | | Nonperforming Artists: | | |
| | | Performing | Rehearsing | Practicing | Looking For Work | Creating | Training | Marketing |
|---|---|---|---|---|---|---|---|---|
| **All Artists** | 32.8 | | | | | | | |
| **By Occupation:** | | | | | | | | |
| Dancers | 29.0 | 4.0 | 10.6 | 10.2 | 1.9 | — | — | — |
| Musicians | 26.8 | 7.2 | 6.5 | 10.8 | 1.4 | — | — | — |
| Actors | 43.8 | 14.9 | 12.8 | 8.2 | 5.5 | — | — | — |
| Theater Production Personnel | 41.0 | 7.6 | 17.6 | 6.7 | 1.5 | — | — | — |
| Writers and Poets | 26.5 | — | — | — | — | 22.2 | 0.9 | 3.0 |
| Choreographers, Composers, and Playwrights | 23.2 | — | — | — | — | 16.4 | 0.5 | 2.6 |
| Visual Artists | 34.6 | — | — | — | — | 28.6 | 1.3 | 4.5 |
| Media Artists | 35.7 | — | — | — | — | 26.2 | 2.0 | 7.5 |
| Craft Artists | 36.0 | — | — | — | — | 28.6 | 1.0 | 6.3 |

*1980 for Massachusetts artists.

of artists, overall and by occupation, who experienced unemployment during the year. The 20.8 percent of all artists who experienced some unemployment during 1981[16] is only slightly above the corresponding rate for the United States labor force of 19.5 percent.[17] The number of weeks of unemployment for artists who were unemployed in 1981, however, is considerably less than the corresponding number for the entire labor force. In this case it is necessary to compare median weeks of unemployment for the two groups, as only this statistic is available for all workers. (The 13.4 weeks of unemployment for all unemployed artists in Table 16 is the mean, or average, amount.) The median length of unemployment of 13.3 weeks for all workers, therefore, is above the 10.0 weeks for New England artists.[18]

Major differences in the percent unemployed during the year exist among the occupations. Because of the nature of the official definition of unemployment, it is not surprising that performing artists were much more likely to have been employed during the year than other types of artists. The number of times artists were unemployed may not necessarily translate into differences in time spent working, as someone can be dancing full-time but be "unemployed" if not paid. But a painter is "employed" if he or she is painting a watercolor in anticipation of selling it.

The average artist who experienced unemployment was unemployed 1.8 times during the year. Again, it is possible to draw comparisons with national data by looking at a slightly different statistic. During 1981, 31.7 percent of those unemployed throughout the U.S. experienced two or more spells of unemployment, and 14.9 percent suffered three or more spells.[19] Among unemployed New England artists, 42.5 percent suffered two or more spells of unemployment and 20.9 percent suffered three or more. It therefore may be concluded that artists were unemployed more frequently but that each spell of unemployment was of shorter duration. Although this conclusion is consistent with the stereotype of artists changing jobs frequently, it must be noted that the extensive holding of nonartistic jobs by the artists may also exert a strong influence on the nature of unemployment. For example, it cannot be determined from *which job* an artist is unemployed, or to what extent holding other jobs masks artistic unemployment. Unemployment, particularly among self-employed artists, is quite likely to reflect their unemployment experience with nonartistic jobs.

Such diverse factors may also help explain levels and differences in receiving of unemployment benefits (Table 17). The percent receiving unemployment insurance was calculated by dividing the number of times artists were unemployed into the number of times they collected unemployment benefits. The 22.2 percent figure for all artists appears to be quite low. However, many artists in the survey may not have been eligible to collect benefits. In order for a worker to receive unemployment insurance, he or she must work for an employer in an industry

# New England / Table 16

## Unemployment Status of Artists in 1981*

| | Percent Unemployed During the Year | Number of Weeks Unemployed | Number of Times Unemployed | Percent Receiving Unemployment Insurance | Percent Out of the Labor Force |
|---|---|---|---|---|---|
| All Artists | 20.8% | 13.4 | 1.8 | 22.2% | 26.9 |
| By Occupation: | | | | | |
| Dancers | 46.5 | 13.2 | 2.0 | 55.0 | 27.9 |
| Musicians | 22.4 | 11.9 | 2.2 | 13.6 | 24.8 |
| Actors | 50.0 | 17.6 | 1.9 | 42.1 | 34.6 |
| Theater Production Personnel | 24.6 | 12.8 | 1.4 | 21.4 | 24.6 |
| Writers and Poets | 20.5 | 12.6 | 1.9 | 21.1 | 25.2 |
| Choreographers, Composers, and Playwrights | 29.1 | 10.7 | 1.6 | 31.3 | 22.5 |
| Visual Artists | 17.9 | 14.4 | 1.8 | 16.7 | 28.0 |
| Media Artists | 26.4 | 12.9 | 1.8 | 16.7 | 18.9 |
| Craft Artists | 12.9 | 12.4 | 1.5 | 20.0 | 30.8 |

*1980 for Massachusetts artists.

that is required to participate in the unemployment insurance program within the state (there are differences in coverage among them). Also, the artist must meet the eligibility requirements, which are based on earnings from his or her present job, recent earnings history, and reason for losing the job. Self-employed workers, the status of many artists, are not eligible for unemployment compensation.

The relevance of working as an artist in an unemployment insurance-covered occupation is evident in the vast differences in percent receiving compensation among artistic occupations. The percentage of dancers collecting unemployment insurance is about three times as great as that among the typically self-employed visual, media, and craft artists. An anomaly is the musician occupation, with a lower rate of success at collecting unemployment benefits than any other occupation. A contributing factor may be the relatively short duration of the unemployed period among musicians of 5.4 weeks.

When broken down by race and sex, the unemployment of artists parallels the labor force as a whole. More women than men were unemployed during the year, and more nonwhites than whites were unemployed.[20] Women were also unemployed more weeks and had fewer but longer spells of unemployment. They were also less likely to collect unemployment insurance. The higher rates of unemployment for women are particularly significant when one recalls that women formed majorities in the writing, visual arts, and craft categories (Table 1). Nonwhites, too, were more prone to unemployment. They had longer and more frequent spells of unemployment and were less likely to collect unemployment insurance.

Besides being unemployed, people often drop out of the labor force altogether. This means they stop looking for work. Such a move may be by choice, for example, to return to school or raise a family. It may also be out of discouragement, as when a job search becomes so futile that one stops seeking work. *In this study the percentage of artists who dropped out of the labor force was higher than the percentage who were unemployed during the year.* Drop-out rates among occupations are less variable than unemployment rates. Dancers and actors, already shown to be more frequently unemployed, were also more likely to drop out of the labor force. On the other hand, visual and craft artists, with low unemployment experiences, have the second and third highest drop-out rates.

This contrast in unemployment and drop-out rates for visual and craft artists may be the result of several factors. First, underemployment can discourage workers and cause them to leave the labor force. Since self-employed artists cannot by definition be unemployed if they are working at their art for at least one hour per week, they may move directly from an "employed" status to an "out of the labor force" status, unless they are unemployed from a nonartistic job. That so many of these artists dropped out of the labor force during the year suggests that a

# New England / Table 17

## Unemployment Status, by Race and Sex

|  | Percent Unemployed | No. of weeks Unemployed | No. of times Unemployed | Percent Receiving Unemployment Insurance | Percent Out of the Labor Force |
|---|---|---|---|---|---|
| Men | 18.9% | 12.9 | 2.0 | 23.0% | 17.0% |
| Women | 22.6% | 13.6 | 1.6 | 16.6% | 36.2% |
| White | 20.4% | 13.2 | 1.8 | 19.3% | 27.0% |
| Non-white | 28.9% | 16.0 | 2.1 | 8.7% | 25.0% |

# New England / Table 18

## Reasons for Being Out of the Labor Force, by Sex

| | *Percent Checking Reason:* | | |
|---|---|---|---|
| Reason Given | Both Sexes | Men | Women |
| Believed no work available | 8.3% | 10.6% | 7.3% |
| Family obligations | 33.2 | 12.2 | 42.4 |
| In school | 13.0 | 10.6 | 14.0 |
| Ill health | 11.8 | 11.4 | 12.0 |
| Improving artistic skills voluntarily | 42.4 | 44.3 | 41.5 |
| Other | 35.4 | 46.4 | 30.5 |

significant number were barely able to find or create enough work for themselves at one point or another. Second, there is a low rate of nonartistic job-holding among visual and craft artists, lower than all other artists except actors, that indicates that these artists are less likely (or able) to substitute nonartistic jobs when their art work dwindles or temporarily stops. Third, these two occupations are heavily populated by women, and as can be seen in Table 17, women were twice as likely to drop out of the labor force overall as men.

These speculations can be compared to the data in Table 18, which shows the frequency with which various reasons for being out of the labor force were checked. Artists could check as many reasons as they felt were applicable. Surprisingly, lack of work was checked by less than 10 percent of those out of the labor force and was the least frequently checked reason. Among the specific reasons checked most often in the survey were "improving artistic skills" (42.4 percent) and "family obligations" (33.2 percent). While most reasons were checked by both sexes with about the same frequency, "family obligations" was checked by women over three times more often than by men, and "other" was checked about half again more often by men. The reasons for the sex difference in checking "other" and the frequency with which it was checked are not clear.

The percentage of nonwhites who dropped out of the labor force is very close to the drop-out percentage of whites. The responses of nonwhites to the reasons for dropping out of the labor force are essentially identical to the white responses.

## Searching for Work

An important aspect of a career in the arts is how one seeks work. Performing artists generally do not retain the same job for long periods of time, thereby necessitating frequent job searches. Many nonperforming artists face a similar problem in marketing their artworks, unless they are fortunate enough to have a gallery or agent providing them a steady outlet for their work. Also, frequent entry into the nonartistic job market is a fact of life for those artists who supplement their artistic income with other jobs.

For these reasons, the way artists look for work does not resemble the way other members of the labor force look for work. Unfortunately, job search methods are not well documented for professions that might bear the greatest similarity to artistic job search. A broad comparison can be made with 1976 data collected by the Bureau of the Census that describes the methods used by unemployed workers receiving unemployment insurance.[20] While the correspondence between artists looking for work and other unemployed persons is not exact, a comparison of the two groups provides some insights into the similarities and differences between the artistic professions and a more diverse group of job seekers.

# New England / Table 19

## Employment Methods Used When Seeking Artistic Jobs

*Percent in Each Occupation Using:*

| | Booking Agent | Want Ads | Private Employment Agency | Friends or Relatives | Business Associates | Student Placement Office | Public Employment Office | Other |
|---|---|---|---|---|---|---|---|---|
| **All Artists** | 10.0% | 23.4% | 4.4% | 37.9% | 38.9% | 5.7% | 4.1% | 22.7% |
| **By Occupation:** | | | | | | | | |
| Dancers | 11.4 | 31.8 | 2.3 | 45.5 | 56.8 | 6.8 | 6.8 | 38.6 |
| Musicians | 31.5 | 23.1 | 0.9 | 46.3 | 52.7 | 7.3 | 3.7 | 19.9 |
| Actors | 39.4 | 37.5 | 7.7 | 48.1 | 44.2 | 2.9 | 1.9 | 38.5 |
| Theater Production Personnel | 10.4 | 22.6 | 3.5 | 44.3 | 51.3 | 5.2 | 2.6 | 31.3 |
| Writers and Poets | 6.3 | 17.4 | 5.3 | 28.9 | 24.5 | 2.8 | 4.4 | 23.6 |
| Choreographers, Composers, and Playwrights | 17.0 | 29.5 | 4.5 | 39.8 | 42.0 | 9.1 | 3.4 | 30.7 |
| Visual Artists | 2.9 | 27.3 | 6.1 | 39.8 | 38.7 | 8.1 | 6.3 | 22.6 |
| Media Artists | 5.0 | 23.6 | 2.7 | 41.8 | 51.4 | 4.5 | 3.6 | 22.7 |
| Craft Artists | 1.6 | 14.9 | 2.0 | 27.7 | 26.4 | 2.9 | 3.3 | 17.9 |

The figures in Table 19 show the distribution of common methods used by artists in their quest for employment in artistic fields. It is not surprising to discover that there are important differences in job hunting methods used by performing versus nonperforming artists. Employment for dancers, musicians, actors, and other theater personnel is more likely to require an employer, while artistic "employment" for nonperforming artists usually consists of creating and marketing finished work. Exceptions to these generalizations are frequent, however, because of the wide variety of ways in which artists received monetary compensation for their artistic endeavors. Seemingly anomalous results, such as craft artists who indicated that they use booking agents, can probably be explained by the fact that many artists reported participation in more than one artistic occupation.

Booking agents are cited most frequently by musicians and actors. Other theater-related professions, such as dancers, theater production personnel, and choreographers, composers, and playwrights, also use booking agents to secure jobs.

Want ads in general and trade publications are useful in all occupations. Only about 15 percent of craft artists use want ads, the lowest incidence of this method of seeking employment. On the other hand, 37.5 percent of the actors and 31.8 percent of the dancers use want ads. Among the more general group of job seekers surveyed by the Bureau of the Census, about 59 percent use want ads to seek jobs.

Friends and relatives play an important role in the artist's job search. In this respect, artists are similar to members of the labor force at large. For all occupations except craft artists, between one-third and one-half of the artists use friends and relatives in a job search. In comparison about 84 percent of the unemployed persons sampled by the Bureau of the Census use friends and relatives.

Using business associates is the remaining significant method of searching for work within an artist's occupation. Slightly over half of all media artists and theater production personnel seek work in this way. Among all artists, this job search method was checked most often. There is no method in the Bureau of the Census study that is directly comparable to this category.

Student placement offices are used less frequently, with about 16 percent of the unemployed population using this method. Artists use placement offices even less, with no more than 10 percent of any occupation using this source for employment. Public employment services are used by half of the unemployed persons surveyed by the Bureau of the Census, and private employment offices are used by nearly one-third of these people. Less than 10 percent of the artists in all occupations use these services. Interviews with artists confirm that artistic jobs are not routinely listed with these types of agencies.

Artists interviewed during the course of this study also spoke frequently of their desire for better methods of finding employment in their artistic fields. Performing artists made many refer-

# New England / Table 20

## Employment Methods Used When Seeking Nonartistic Jobs

*Percent in Each Occupation Using:*

| | Want Ads | Private Employment Agency | Friends or Relatives | Business Associates | Student Placement Office | Public Employment Office | Other |
|---|---|---|---|---|---|---|---|
| **All Artists** | 28.7% | 7.6% | 29.2% | 19.0% | 5.9% | 8.1% | 7.0% |
| **By Occupation:** | | | | | | | |
| Dancers | 19.5 | 2.4 | 39.0 | 26.8 | 2.4 | 12.2 | 7.3 |
| Musicians | 25.9 | 6.8 | 27.1 | 17.1 | 7.9 | 6.1 | 3.7 |
| Actors | 30.1 | 8.7 | 28.2 | 16.5 | 3.9 | 6.8 | 5.8 |
| Theater Production Personnel | 25.5 | 10.9 | 30.0 | 22.7 | 3.6 | 7.3 | 9.0 |
| Writers and Poets | 34.1 | 11.1 | 35.1 | 24.6 | 7.9 | 14.1 | 13.4 |
| Choreographers, Composers, and Playwrights | 34.9 | 8.1 | 25.6 | 24.4 | 5.8 | 9.3 | 7.0 |
| Visual Artists | 30.1 | 7.1 | 28.1 | 17.4 | 6.5 | 8.2 | 7.3 |
| Media Artists | 28.8 | 8.2 | 34.1 | 26.0 | 3.8 | 6.7 | 6.3 |
| Craft Artists | 23.7 | 6.1 | 27.2 | 15.6 | 4.1 | 6.3 | 5.4 |

ences to the difficulty they experience in finding out about openings and auditions and the heavy reliance that they have on "connections" and the "grapevine."

The data in Table 20 show similar information about the methods used by artists to seek employment in nonartistic fields. When searching for such jobs, the surveyed artists show less reliance on friends and relatives and on business associates than they reported when searching for jobs in their art fields. For all artists except dancers and actors, want ads are more frequently used when looking for nonart jobs than when looking for artistic work. Private employment agencies, public employment offices, and student placement offices are more frequently used by artists when seeking nonartistic jobs. The frequency of use of these methods is still well below that reported by the Bureau of the Census study.

For nonperforming artists, tangible finished products usually have to be marketed (Table 21). Artists who responded to the survey reported that shows and fairs and consignments in showrooms or shops are the most important means of marketing works of art. Shows and fairs are used heavily by visual, media, and craft artists. They apparently are most important to craft artists, with more than 66 percent citing them as a method of selling their finished works. The same percentage of craft artists use consignment sales in showrooms and shops. This method is also frequently used by visual and media artists.

Owning or sharing a showroom or shop is not as common. It is used most frequently by craft artists, of whom 28 percent indicated that they participate in this form of marketing. About 17 percent of visual artists and 14 percent of media artists reported that they own or share these types of spaces as well.

A representative or agent is the most commonly checked medium by writers and poets (about one out of every three) and choreographers, composers, and playwrights (21.8 percent). Visual, media, and craft artists also frequently sell their works this way. Advertisements are also used most frequently by media artists (17.6 percent), followed by craft artists (16.4 percent) and visual artists (10.2 percent).

During the interviews, the frustrations of marketing artworks were frequently mentioned. Some artists indicated that their work is not salable; others noted that the effort required is greater than is justified by the monetary return. A common complaint is that the mark-up added by agents or galleries impede the sale of artworks and constitute unjustifiable profits at the expense of the artists' efforts. Craft artists and visual artists also complain of high entrance fees for fairs and shows, citing experiences in which sales made at a show did not cover the cost of showing work there.

Table 15 describes the hours per week, on the average, artists spend searching for work. Those in dance, music, and theater production spend between one and two hours a week. Actors spend 5.5 hours per week seeking work. Data in this table also

# New England / Table 21

## Marketing Methods For Tangible Art Works

*Percent in Each Occupation Using:*

| | Shows and Fairs | Consignment in showroom/ shop | Own or Share Showroom/ Shop | Representative/ Agent | Advertisements | Other |
|---|---|---|---|---|---|---|
| **All Artists** | 36.2% | 36.3% | 12.9% | 19.4% | 10.0% | 14.7% |
| **By Occupation:** | | | | | | |
| Dancers | 11.6 | 2.3 | 4.7 | 2.3 | 7.0 | 2.3 |
| Musicians | 3.2 | 1.8 | 0.2 | 2.5 | 3.0 | 1.1 |
| Actors | 5.8 | 3.8 | 1.0 | 2.9 | 5.8 | 4.8 |
| Theater Production Personnel | 7.9 | 8.8 | 3.5 | 6.1 | 7.9 | 6.1 |
| Writers and Poets | 8.5 | 9.8 | 1.6 | 32.9 | 5.9 | 30.1 |
| Choreographers, Composers, and Playwrights | 5.7 | 3.4 | 2.3 | 21.8 | 8.0 | 14.4 |
| Visual Artists | 52.0 | 56.3 | 17.0 | 28.9 | 10.2 | 14.3 |
| Media Artists | 42.3 | 33.3 | 14.0 | 20.3 | 17.6 | 17.5 |
| Craft Artists | 66.3 | 66.0 | 28.0 | 17.3 | 16.4 | 21.2 |

describe the hours per week artists in each occupation spend marketing their art. Choreographers, composers, and playwrights spend just under three hours per week, while media artists spend over seven hours. Though comparable data on job search time for other nonart occupations are not available, these figures intuitively seem to be much greater than average.

# Income

In our society one of the strongest measures of a worker's employment success as well as the relative attractiveness of a particular occupation is income. This measurement seems to break down, however, when considering art work; unlike other workers, the artist must work extensively outside his or her profession in order to survive financially. Although all artists in the survey worked as artists during the year, only 80.4 percent of them earned artistic income. Over 50 percent earned income from arts-related jobs, and 34.9 percent earned income from nonarts related jobs. Furthermore, 30 percent received nonlabor income, such as interest, dividends, alimony, welfare, and retirement benefits. Only 1.2 percent of the artists earned no income from any source during the year. These artists, however, belong to households where other household members earn income. Overall, 69.8 percent are part of a household unit of two or more members (a household unit was loosely defined to include persons with whom income and living expenses are shared). Out of all the artists, 60.9 percent have other household members contributing to household income.

Table 22 shows the average income of New England artists by occupation[22] The estimated market value of artistic goods and services bartered and the total costs of earning one's artistic income are also included. Though it is not explicitly shown in this table, the income earned by other household members can be computed by subtracting the artist's total income from the total household income. For total household and total artist's income, the median as well as the mean is reported. This enables a comparison with Census data.[23]

When this comparison is made, it is seen that artists seem to fare about the same or slightly better than the median member of the New England labor force. Median household income in New England in 1980 was $18,900; the median personal income of a labor force member was $11,480. The median labor income was $10,800.[24] This last figure corresponds to total personal income minus nonlabor income. At the time of this writing, 1981 income figures were not yet available.

Though artists' incomes compare favorably with those of other members of the labor force, Table 22 shows that art work contributes relatively little to an artist's finances. Artistic income constitutes 41.0 percent of the average artist's personal income and 23.5 percent of his or her household income. Not only did

# New England / Table 22

## Income and Artistic Costs, 1981

| | Total Household Income | Total Income | Artistic Income | Arts Related Income | Nonarts-Related Income | Non-Labor | Value of Artistic Goods Bartered | Costs of Earning Artistic Income |
|---|---|---|---|---|---|---|---|---|
| All Artists | $27,297 (21,981) | $15,644 (11,800) | $6,420 | $4,743 | $2,916 | $1,572 | $199 | $3,554 |
| **By Occupation:** | | | | | | | | |
| Dancers | 21,636 (16,000) | 11,445 (10,991) | 5,249 | 3,214 | 2,942 | 273 | 47 | 2,333 |
| Musicians | 26,151 (22,000) | 16,934 (14,068) | 6,453 | 6,000 | 3,515 | 1,033 | 107 | 2,772 |
| Actors | 32,912 (18,008) | 22,032 (10,082) | 15,597 | 1,632 | 2,433 | 2,510 | 143 | 3,133 |
| Theater Production Personnel | 26,870 (21,986) | 18,681 (16,745) | 9,127 | 6,102 | 1,997 | 1,605 | 194 | 2,402 |
| Writers and Poets | 29,196 (25,002) | 16,501 (12,090) | 3,947 | 5,828 | 4,182 | 2,198 | 114 | 1,869 |
| Choreographers, Composers, and Playwrights | 31,429 (24,989) | 18,495 (14,855) | 4,053 | 10,763 | 2,230 | 1,540 | 111 | 1,952 |
| Visual Artists | 27,229 (21,981) | 14,588 (10,440) | 6,037 | 4,632 | 2,444 | 1,530 | 211 | 3,961 |
| Media Artists | 27,017 (20,007) | 18,137 (12,999) | 8,691 | 3,420 | 3,949 | 2,070 | 289 | 5,571 |
| Craft Artists | 26,460 (21,001) | 12,820 (10,000) | 6,166 | 2,839 | 2,403 | 1,425 | 311 | 4,527 |

Note: Numbers in parentheses are medians. Sum of components may not add to total artist's income because of different numbers of artists reporting each component of income.

# New England / Table 23

## Type of Income By Occupation and Sex

| | Artist's Total Income | | Artistic Income | | Arts-Related Income | | Nonarts-Related Income | | Nonlabor Income | |
|---|---|---|---|---|---|---|---|---|---|---|
| | Men | Women | Men | Women | Men | Women | Men | Women | Men | Women |
| All Artists | $20,418 | $10,935 | $9,288 | $3,546 | $5,809 | $3,692 | $3,659 | $2,169 | $1,704 | $1,451 |
| By Occupation: | | | | | | | | | | |
| Dancers | 12,422 | 10,991 | 4,146 | 5,780 | 3,172 | 3,234 | 5,034 | 1,896 | 70 | 371 |
| Musicians | 20,643 | 10,404 | 8,176 | 3,366 | 6,764 | 4,637 | 4,559 | 1,644 | 1,154 | 813 |
| Actors | 30,471 | 12,094 | 22,794 | 6,928 | 1,467 | 1,830 | 3,358 | 1,318 | 2,851 | 2,100 |
| Theater Production Personnel | 22,288 | 13,353 | 11,870 | 5,046 | 7,562 | 3,931 | 2,028 | 1,951 | 1,124 | 2,304 |
| Writers and Poets | 20,009 | 12,754 | 6,263 | 1,404 | 7,417 | 4,095 | 4,810 | 3,501 | 1,577 | 2,875 |
| Choreographers, Composers, and Playwrights | 22,273 | 14,533 | 5,938 | 2,027 | 12,554 | 8,837 | 2,403 | 2,044 | 1,378 | 1,714 |
| Visual Artists | 20,107 | 10,012 | 9,290 | 3,341 | 5,880 | 3,567 | 3,051 | 1,952 | 1,967 | 1,174 |
| Media Artists | 20,173 | 13,017 | 9,734 | 6,064 | 3,638 | 2,873 | 4,437 | 2,721 | 2,353 | 1,358 |
| Craft Artists | 17,633 | 10,166 | 10,122 | 3,948 | 3,161 | 2,705 | 2,725 | 2,164 | 1,624 | 1,338 |

almost 20 percent of all surveyed artists earn no artistic income in 1981, but 47.4 percent incurred artistic costs which exceeded their artistic income. In order to function as artists, many members of this survey have to depend on income from other jobs and from other household members.

Artistic incomes vary widely among occupations, with actors at the top and writers and poets at the bottom. The percent deviation from the average of all artists is less for total artists' income and less yet for total household income. These numbers indicate that low artistic income in occupations are partly offset by higher nonartistic and other household incomes. The occupations with the most arts-related income were generally those associated with teaching. The low overall incomes earned by dancers can be explained in part by their younger ages. The highest barter incomes and artistic costs were found among media, visual, and craft artists. Though bartering for goods and services is reputed to be common among artists, reported barter income was less than 5 percent of artistic income and less than 3 percent of total income for craft artists, the group reporting the highest barter income.

## Sex and Race and Income

Interesting results arise when incomes are broken down by sex and race (Tables 23 and 24). In these tables, only income earned by the artists themselves (excluding barter) is reported. When broken down by sex, major income differences emerge. Women earned less income. Their total income was slightly more than half that of men, and their artistic earnings were less than 40 percent of men's artistic earnings. Within the occupations, only women dancers earned more artistic income than men. This pattern continued in other forms of income as well. Nonlabor income was the only category where women made more money than men.

These income differences by sex cannot be easily rationalized by differences in age or formal education, essentially because they do not exist, but they can be related to the amount of time spent working. For example, in Table 14 it was seen that men worked more weeks than women, both as artists and in other jobs. Since information was also collected on the number of hours spent per week working at one's art (Table 15), it is possible to estimate an hourly artistic "wage rate" (Table 25). Looking at the breakdown of these wage rates by sex only narrows the disparities. The artistic wage rate of men exceeded that of women overall and in seven of the nine occupations. It is not possible to adjust nonartistic labor income for hours worked, but after adjusting for weeks worked, women's "weekly wage" still lay well below that of men.

These differences in income by sex parallel those found in the work force as a whole where women's income has consistently hovered around 60 percent of men's income. These general

# New England / Table 24

## Type of Income by Occupation and Race

| | Artist's Total Income | | Artistic Income | | Arts-Related Income | | Nonarts-Related Income | | Nonlabor Income | |
|---|---|---|---|---|---|---|---|---|---|---|
| | White | Nonwhite | White | Nonwhite | White | Nonwhite | White | Nonwhite | White | Nonwhite |
| All Artists | $15,546 | $16,863 | $ 6,298 | $6,988 | $ 4,727 | $6,840 | $2,890 | $2,534 | $1,622 | $ 501 |
| By Occupation: | | | | | | | | | | |
| Dancers | 11,513 | IS | 5,663 | IS | 3,532 | IS | 2,549 | IS | 292 | IS |
| Musicians | 17,097 | 15,330 | 6,516 | 4,569 | 5,968 | 9,072 | 3,578 | 1,668 | 1,065 | 21 |
| Actors | 19,125 | IS | 12,402 | IS | 1,679 | IS | 2,512 | IS | 2,647 | IS |
| Theater Production Personnel | 18,543 | IS | 8,931 | IS | 5,988 | IS | 2,081 | IS | 1,698 | IS |
| Writers and Poets | 16,534 | 7,115 | 3,934 | 1,770 | 5,960 | 3,872 | 3,992 | 1,439 | 2,289 | 33 |
| Choreographers, Composers, and Playwrights | 18,413 | IS | 3,876 | IS | 11,194 | IS | 1,760 | IS | 1,682 | IS |
| Visual Artists | 14,507 | 18,409 | 6,012 | 7,034 | 4,504 | 8,767 | 2,449 | 2,111 | 1,575 | 496 |
| Media Artists | 18,247 | IS | 8,780 | IS | 3,503 | IS | 3,856 | IS | 2,099 | IS |
| Craft Artists | 12,793 | 11,560 | 6,138 | 4,240 | 2,843 | 4,098 | 2,388 | 1,560 | 1,438 | 1,622 |

IS = insufficient sample

work force income differences though can be attributed in part to higher educational attainment of men and a relatively greater concentration of men in the traditionally higher-paying occupations—neither reason applies here.

One interpretation of the data would be to attribute the lower incomes earned by women to discrimination. In using this interpretation, what may appear surprising is that artistic income disparities by sex also persist in occupations where the artist is typically self-employed and where a tangible product, not a service, is produced. In the interview sessions, some artists noted that discrimination in forms other than hiring, promotion, and compensation can happen to female artists. Examples given included difficulties in obtaining a good agent, having one's work accepted by a gallery or publisher, and simply convention or historical practice.

An alternative interpretation can be advanced by comparing the total household income received by male and female artists. Though the income earned by men artists exceeds that of women by almost $10,000, the household income of men artists exceeds that of women by only $628. Obviously some member of the household, husband or other mate possibly, contributes more to the household income than the average woman artist. Having this family member earn enough to satisfy the basic household needs could free a woman artist to concentrate on less marketable but more artistically satisfying forms of work or simply require less aggressive efforts in marketing her art. Unfortunately, the evidence presented here does not conclusively prove or disprove the existence of sex discrimination within the art community.

Differences in income by race have been extensively documented in the U.S. labor force. Like male-female wage differentials, some of the wage gap can be attributed to differences in characteristics of whites and nonwhites, such as unequal amounts of education. Nevertheless, much of the income disparities that exist between white and minority races is attributed to labor market discrimination. The nonwhite artists responding to this survey reported receiving slightly *more* formal education than whites, 16.9 vs. 16.7 years. Nonwhites work virtually the same number of weeks as whites, and report more time spent working in artistic and arts-related jobs and less time working in nonarts-related jobs.

In fact, the total income earned by nonwhite artists *exceeds* that of white artists. Also, artistic income and arts-related income of nonwhites is higher. Nonarts-related and nonlabor income are lower, but these are lesser in magnitude. The total household income of nonwhites also lies above that of whites. Reducing artistic income to an hourly "wage rate" leads to the same result: the nonwhite hourly "wage" is higher. When arts-related and nonarts-related "weekly wage" becomes higher for both types of income.

Though this evidence is consistent with the hypothesis that

## Artistic "Wage Rates," by Occupation, Race and Sex

|  | Overall: | By Sex: | | By Race: | |
|---|---|---|---|---|---|
|  |  | Men | Women | White | Non-white |
| **All Artists** | $ 6.08 | $ 7.76 | $ 4.33 | $ 5.90 | $8.95 |
| **By Occupation:** |  |  |  |  |  |
| Dancers | 4.90 | 3.45 | 5.62 | 4.92 | IS |
| Musicians | 9.04 | 10.98 | 5.33 | 9.16 | 5.37 |
| Actors | 14.51 | 13.74 | 15.51 | 9.68 | IS |
| Theater Production Personnel | 12.41 | 16.77 | 5.65 | 12.94 | IS |
| Writers and Poets | 3.56 | 4.63 | 2.35 | 3.36 | IS |
| Choreographers, Composers, and Playwrights | 8.69 | 10.26 | 6.22 | 6.91 | IS |
| Visual Artists | 4.15 | 5.43 | 3.10 | 4.18 | 3.87 |
| Media Artists | 6.72 | 7.40 | 4.76 | 6.83 | IS |
| Craft Artists | 5.10 | 5.73 | 4.64 | 5.12 | 1.96 |

race discrimination among these artists does not exist, one cannot jump to that conclusion unless *all* factors affecting incomes of white and nonwhite artists were accounted for. As with sex discrimination, further research is needed before a definite conclusion can be reached.

An additional difficulty in interpreting the income data of nonwhites is their relatively small sample size. Of the 85 nonwhites who responded to the survey, 79 answered the questions pertaining to income. In five of the nine occupational categories there are five or fewer nonwhite artists. Consequently the responses in those categories are not reported.

## Education and Age and Income

Education typically leads to higher incomes. Table 26 compares all forms of income earned by the artist with the number of years of school; Table 27 shows income in comparison with highest degree earned. Both tables show essentially the same results. While total income tends to rise with higher educational attainment, artistic income does not. Arts-related income rises with educational attainment, while nonarts-related and nonlabor income do not show such a pattern.

It appears that the main advantage that more formal education has for artists is the ability to command higher incomes in arts-related work. Recall that the bulk of arts-related jobs are professional in nature, with the majority in teaching. The majority of nonartistic jobs are in clerical and blue-collar fields, where there is less reward for more formal education. Does this mean that marketable artistic skills cannot be taught? An alternative hypothesis, also consistent with the data, is that the more attractive arts-related incomes that well-educated artists earn, the less important the marketing of their art works and/or performances becomes. Neither hypothesis can be said to be valid without further investigation.

Age is also often thought to lead to higher income. It is often viewed as a proxy for experience and seniority. In Table 28, incomes are compared with age, grouped into intervals of ten years. Here, both total and artistic income do tend to rise with increased age. Nonlabor income rises most strongly with age, and arts-related income rises to ages 50-59. One normally expects to see higher labor incomes in higher age brackets, at least until retirement, and this pattern is borne out with the artists.

Two factors contribute to the phenomenon of continuously rising artistic income and rising nonartistic income only up to age 60. One is that most jobs in which one works for an employer have a customary or mandatory retirement age. But artists appear to continue their artwork beyond normal retirement age and reduce or eliminate their nonart employment. Complementing this behavior is the jump in nonlabor income at the 60-69 age bracket, reflecting social security and other pension income, which helps to free artists from dependence on nonartistic jobs.

Findings such as these, while revealing, can also mask underlying data patterns. For example, in Table 28, there are 58 artists whose incomes are represented in the over 70 age bracket, and 1,128 in the 30-39 age bracket. Yet when reading the table, one tends to treat the numbers reported as equally important. The numbers of artists at each level of educational attainment are also far from equal. To compensate for inequities, each person's data was weighted equally when deriving summary statistics.

One can accomplish this by constructing Pearson correlation coefficients for the data. These coefficients measure the extent to which two series of numbers tend to move together in a pattern. A perfect positive correlation yields a coefficient of 1.0; a perfect negative correlation yields a −1.0 coefficient. If the series are not related to each other the coefficient is zero. In the "real world," number series tend to have coefficients not at any of these extreme values, so it is necessary to provide a measure of the degree of association, referred to as a level of significance.

All this can be seen more readily in Table 29 where correlation coefficients are shown for years of school and then age vs. the various incomes that have been reported. A larger correlation coefficient (farther from zero in either a positive or a negative

## Type of Income versus Years of School

| Years of School | Artist's Total Income | Artistic Income | Arts-Related Income | Nonarts-Related Income | Nonlabor Income |
|---|---|---|---|---|---|
| 11 or less | $15,115 | $5,797 | $ 0 | $3,538 | $5,780 |
| 12 | 17,604 | 9,657 | 2,486 | 2,620 | 2,152 |
| 13 | 12,007 | 6,939 | 766 | 2,788 | 1,749 |
| 14 | 13,314 | 7,024 | 1,052 | 3,797 | 1,432 |
| 15 | 14,330 | 8,970 | 1,293 | 3,120 | 1,145 |
| 16 | 13,424 | 7,129 | 2,343 | 2,564 | 1,371 |
| 17 | 14,912 | 5,490 | 4,382 | 3,000 | 2,122 |
| 18 | 15,295 | 4,687 | 6,528 | 2,566 | 1,520 |
| 19 | 19,393 | 6,888 | 7,750 | 3,057 | 1,782 |
| 20 or more | 21,141 | 5,185 | 10,831 | 3,981 | 1,312 |

## New England / Table 27

### Type of Income versus Highest Degree Earned

| Educational Attainment | Artist's Total Income | Artistic Income | Arts-Related Income | Nonarts-Related Income | Nonlabor Income |
|---|---|---|---|---|---|
| Did not Graduate high school | $20,397 | $10,465 | $ 0 | $3,574 | $6,358 |
| High school diploma | 14,805 | 8,390 | 1,572 | 3,009 | 1,634 |
| Associate's degree | 13,303 | 7,634 | 1,095 | 3,495 | 1,202 |
| Bachelor's degree | 13,450 | 6,509 | 2,897 | 2,629 | 1,486 |
| Master's degree | 17,541 | 5,600 | 7,715 | 2,742 | 1,569 |
| Ph.D. degree | 25,020 | 4,497 | 12,392 | 6,540 | 1,711 |

## Type of Income versus Age of Artist

| Age Bracket | Artist's Total Income | Artistic Income | Arts-Related Income | Nonarts-Related Income | Nonlabor Income |
|---|---|---|---|---|---|
| 20 to 29 | $ 9,603 | $3,757 | $2,718 | $2,742 | $ 382 |
| 30 to 39 | 13,653 | 5,992 | 3,832 | 3,049 | 828 |
| 40 to 49 | 20,249 | 8,423 | 7,153 | 3,080 | 1,649 |
| 50 to 59 | 20,538 | 7,280 | 7,715 | 2,978 | 2,549 |
| 60 to 69 | 22,386 | 8,485 | 4,954 | 2,648 | 6,056 |
| Over 70 | 20,980 | 9,763 | 2,608 | 210 | 8,563 |

direction) implies a stronger correlation. The level of significance, in parentheses under the coefficients, shows the likelihood that the reported correlation could have occurred simply due to chance. For example, the coefficient for years of schooling vs. arts-related income is much higher than that of schooling vs. nonarts-related income. The significance level of the former, .000, states that the probability that the correlation is due to chance is less than one in a thousand. The significance level of the latter, .080, states that the probability that this correlation is due to chance is 8 in 100. Although one can never say what is really significant and what is not, social scientists usually pick an arbitrary cut-off point, often .05 (five in a hundred), and state that when the odds of chance occurrence are less than this, it is accepted that there is an actual, not random, association between the two number series.

In doing this, we find that the correlations between years of school and total, artistic and arts-related income are statistically significant. (See Tables 30 and 31.) All the age-income correlations are significant, except for nonarts-related income, which barely misses the .05 cut-off. These correlations both formalize and confirm the data in Tables 26 to 28.

Of the evidence on education and income, perhaps the most unsettling is the significant negative relationship between years of education and artistic income. It was explained earlier that since more education led to higher nonartistic labor income, artists with more education may devote more time to nonart work and less effort in selling artistic skills and output. A second explanation consistent with the above is implied by the data in Table 30. Here, years of school are also correlated with artistic wage rates. This correlation is positive but not very strong, implying that more educated artists are more efficient at producing and selling their art. Put another way, more educated artists tend

## Pearson Correlations: Income versus Years of Schooling and Age

|  | Artist's Total Income | Artistic Income | Arts-Related Income | Nonarts-Related Income | Nonlabor Income |
|---|---|---|---|---|---|
| **Years of Schooling** | .0974 (.000) | -.0645 (.001) | .3409 (.000) | .0278 (.080) | -.0217 (.136) |
| **Age** | .2298 (.000) | .0883 (.000) | .1488 (.000) | -.0313 (.053) | .2498 (.000) |

Significance levels are in parenthesis.

to earn more on a hourly basis but work fewer hours as artists. In turn, working fewer hours is compatible with more time spent in nonartistic jobs, where the return on more education is higher.

There is also a mild loss in work efficiency, as reflected by wage rates, with increasing age. Though wage rates are positively correlated with age, the correlation is not quite as strong as that of income with age.

When these correlations are computed for each of the nine occupations, the strength of the correlation is weaker. Many are not statistically significant. The correlations for each occupation, however, generally have the same sign (that is, + or −) as the correlation for all artists when the latter is statistically significant.

Especially because artists are often self-employed or must engage in self-imposed practice, their out-of-pocket expenditures for their artwork may be substantial. The last column of Table 22 shows the total amount of these costs for each occupation, and provides a direct comparison of these costs to artistic income. Because of necessary spending on equipment and supplies, visual, media, and craft artists report the highest costs. Among occupations, artistic costs are not the same proportion of income, ranging from 20 percent for actors to 73 percent for craft artists. It was observed earlier that almost half of the artists in the survey incurred costs exceeding their artistic income.

The total costs in Table 22 were computed by totaling the artists' reported costs in 14 categories provided on the questionnaire. Costs are broken down by category and occupation in Table 31. More money was spent on visual art supplies than any other category, even though the spending was essentially limited to the three visual art occupations. Second in importance was travel, with heaviest spending by performing artists and media artists (who are mostly photographers). The existence of multi-

## Pearson Correlations: Artistic Income and "Wage Rates" versus Years of Schooling and Age

| | Income vs. Years of School | Wage Rate vs. Years of School | Income vs. Age | Wage Rate vs. Age |
|---|---|---|---|---|
| **All Artists** | -.0645 | .0220 | .0883 | .0698 |
| | (.001) | (.164) | (.000) | (.001) |
| **By Occupation:** | | | | |
| Dancers | -.4897 | -.2927 | -.1535 | -.1546 |
| | (.001) | (.099) | (.172) | (.252) |
| Musicians | -.0739 | -.0012 | .0783 | .0997 |
| | (.069) | (.492) | (.055) | (.032) |
| Actors | .0881 | .0887 | .0371 | .1461 |
| | (.202) | (.236) | (.360) | (.110) |
| Theater Production Personnel | -.0873 | .1806 | .0432 | .1342 |
| | (.194) | (.060) | (.329) | (.119) |
| Writers and Poets | .0054 | .0834 | .1663 | .2102 |
| | (.464) | (.109) | (.002) | (.001) |
| Choreographers, Composers, and Playwrights | -.1446 | -.0386 | .3340 | .1149 |
| | (.103) | (.401) | (.001) | (.216) |
| Visual Artists | -.0932 | -.0087 | .1675 | .0848 |
| | (.004) | (.413) | (.000) | (.015) |
| Media Artists | -.1510 | -.0994 | .1011 | -.0044 |
| | (.016) | (.108) | (.072) | (.478) |
| Craft Artists | -.0540 | .0623 | -.0067 | .0090 |
| | (.114) | (.105) | (.440) | (.427) |

# New England / Table 31

## Breakdown of Artistic Costs, by Occupation

| | Study | Travel | Publicity | Duplication | Insurance | Rent | Fees and Commissions | Musical Inst. Purchase and Repair | Costumes | Copyright Fees | Music and Books | Visual Art Supplies | Artistic Tools | Other |
|---|---|---|---|---|---|---|---|---|---|---|---|---|---|---|
| All Artists | $174 | $537 | $194 | $139 | $85 | $354 | $283 | $119 | $46 | $5 | $125 | $759 | $275 | $240 |
| **By Occupation:** | | | | | | | | | | | | | | |
| Dancers | 443 | 856 | 152 | 66 | 3 | 141 | 19 | 47 | 280 | 1 | 120 | 45 | 65 | 96 |
| Musicians | 306 | 703 | 75 | 60 | 88 | 90 | 131 | 571 | 110 | 5 | 203 | 10 | 70 | 85 |
| Actors | 222 | 739 | 189 | 89 | 24 | 87 | 993 | 38 | 278 | 2 | 130 | 30 | 36 | 277 |
| Theater Production Personnel | 182 | 515 | 188 | 284 | 56 | 341 | 29 | 108 | 75 | 9 | 191 | 184 | 173 | 72 |
| Writers and Poets | 68 | 391 | 137 | 167 | 16 | 151 | 268 | 17 | 12 | 12 | 198 | 57 | 109 | 150 |
| Choreographers, Composers, and Playwrights | 176 | 502 | 164 | 182 | 44 | 89 | 199 | 123 | 91 | 11 | 177 | 22 | 57 | 76 |
| Visual Artists | 146 | 425 | 191 | 152 | 84 | 582 | 355 | 25 | 12 | 3 | 30 | 1,102 | 276 | 259 |
| Media Artists | 149 | 873 | 408 | 266 | 160 | 359 | 297 | 18 | 13 | 6 | 105 | 1,638 | 805 | 314 |
| Craft Artists | 134 | 510 | 273 | 101 | 131 | 436 | 271 | 16 | 8 | 5 | 83 | 1,347 | 47 | 402 |

ple occupational skills among artists probably explains small amounts of otherwise anomalous spending, such as craft artists purchasing musical instruments and musicians purchasing visual art supplies.

There was some discussion among the interviewed artists about the difficulty of convincing the Internal Revenue Service of the tax-deductibility of these costs. In theory, unreimbursed costs of earning a living are deductible from income before estimating tax liability. However, the IRS must be persuaded that the artist is truly engaged in a business and not pursuing art as a hobby. Regular and continuous activity and the ability to show a profit seem to be important in this regard. The latter criterion obviously could not be met by many artists in this survey. Another problem seems to be the unfamiliarity that IRS auditors have with the process of creating art. For example, an artist in one of the interview sessions stated that the IRS was quarreling with her deduction of the cost of materials used in preliminary versions of a painting, and allowing a deduction for material costs of only the final product.

# Chapter 2 — Endnotes

[1] Details of the survey methodology may be found in Appendix A.

[2] A copy of the questionnaire is in Appendix B.

[3] A breakdown of multiple job-holding patterns is found in Appendix A.

[4] Information tabulated from special tabulations of the U.S. Bureau of the Census, 1981 Current Population Survey data tapes.

[5] Ibid.

[6] Ibid.

[7] Ibid.

[8] Ibid.

[9] From Table 6 it can be seen that adding together those people with bachelor's, master's, and doctoral degrees yields 80.8 percent of all artists with at least a bachelor's degree. By comparison, 71.0 percent of New England residents 25 years older and over are at least high school graduates. U.S. Department of Commerce, Bureau of the Census, *1980 Census of Population and Housing: Provisional Estimates of Social, Economic, and Housing Characteristics.* (Washington D.C.: 1982), Table P-2, p. 14.

[10] U.S. Department of Labor, Bureau of Labor Statistics, "Educational Attainment of Workers," for March 1979. January 1981, Table E, p. A-13.

[11] It is assumed that a "specialized arts school" may be either a school solely devoted to artistic training or a college within a university also solely devoted to artistic training. Artists filling out the questionnaire defined this term as they saw fit.

[12]Because the survey was made in Massachusetts in 1981, the responses of Massachusetts artists refer to training undergone in 1980. This is not, however, likely to bias the overall response to the questions about training in any way. This is not necessarily true about responses to questions in other areas though, and adjustments to the Massachusetts data were made when required.

[13]United States Bureau of the Census. "Educational Attainment in the United States: March 1979 and 1978," *Current Population Reports,* Series P-20, No. 356, 1981, p. 48.

[14]Again, in this and following tables, the 1981 data include 1980 data for Massachusetts artists.

[15]Data were not collected on the number of hours artists worked at other jobs.

[16]These data reflect the 1980 unemployment experiences of Massachusetts artists. Using 1980 instead of 1981 data should not significantly affect overall conclusions about employment and unemployment. The difference in Massachusetts unemployment rates between the two years is small: 5.6 percent in 1980 versus 6.4 percent in 1981.

[17]U.S. Department of Labor, Bureau of Labor Statistics, Release 82-255.

[18]Ibid.

[19]Ibid.

[20]It has traditionally been true that the unemployment rate of women has exceeded that of men. Only during part of the 1981-83 recession has the unemployment rate of men been higher.

[21]Ann MacDougall Young, "Job Search of Recipients of Unemployment Insurance," *Monthly Labor Review,* February, 1979, pp. 49-54.

[22]The 1980 income figures in Massachusetts were adjusted upward to reflect 1981 income data by multiplying 1980 incomes by the percentage growth rate of Massachusetts per capita personal income between 1980 and 1981. Similarly, 1980 artistic cost data were adjusted upward by the Boston area inflation rate between 1980 and 1981.

[23]Medians are not reported for other components of artists' income because they are misleading. The median is defined as the numerical observation that lies halfway between the highest and lowest when all observations are ranked. For example, less than half the artists received nonarts-related income. Thus the median amount for this would be zero, as it would for some other components of income.

[24]These figures were obtained from special tabulations of the U.S. Bureau of the Census, 1981 Current Population Survey data tapes for New England.

# Chapter Three

## Survey Findings:
## The Six
## New England States

Connecticut
Maine
Massachusetts
New Hampshire
Rhode Island
Vermont

# Connecticut

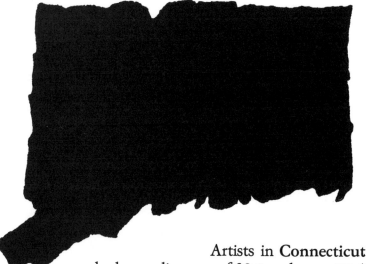

Artists in **Connecticut**
had a median age of 39.5 and were 50.4
percent female and 3.4 percent nonwhite.

They averaged 16.5 years of school. Almost 80 (79.5) percent had at least a bachelor's degree. In addition, 81.5 percent received specialized artistic training in school, and 75.8 percent received such training outside of school.

They worked 35.7 weeks as artists in 1981. In addition to their work as artists, 44.8 percent held jobs related to their art for an average of 33.8 weeks and 32.4 percent held jobs not related to the art for 35.7 weeks. Holding more than one job at a time was common. Nevertheless, 17.3 percent were unemployed and 26.0 percent dropped out of the labor force during the year.

They earned $19,021 in income from all sources in 1981. Their household income (including earnings of other household members) was $34,246. However, the income they earned as artists was $8,818. In earning their artistic income, they incurred nonreimbursed costs of $2,981.

# Demographic and Educational Characteristics

In most respects, the artists surveyed in Connecticut had the same demographic characteristics as artists throughout New England. The composition of the artists by sex, race, and ethnicity was quite similar to the regionwide sample (Table 1). The Connecticut artists' median age of 39.5 years, however, was almost four years greater than the regionwide sample median. Some differences exist within occupations. The representation of men in theater production and choreography, composing, and play writing in in the state was higher, but it was lower among craft artists. Because less than five dancers in Connecticut responded to the survey, information cannot be provided for this occupational group.

The formal educational experiences of Connecticut's artists are strikingly similar to those of artists in other states in the survey (Table 2). The median years of schooling, 16.5 was exactly the same and the distribution by highest degree was also similar. This was true as well for the average educational attainment within occupations. In both Connecticut and the entire region, actors had the lowest educational attainment; choreographers, composers, and playwrights had the highest.

As in the rest of New England, Connecticut artists are much better educated than the average state worker. The median number of years of school for a member of the Connecticut labor force was 12.3.[1] Of all the state residents over age 25, 70.5 percent were high school graduates and 21.2 percent had completed four or more years of college.[2] Of the state artists surveyed, 99.6 percent had a high school diploma and 40.1 percent had attained at least a bachelor's degree.

Where educational attainment was broken down by race and sex, as it was in the region as a whole, nonwhites had more years of formal education than whites. The average number of years of schooling for nonwhites was 17.0; for whites the average was 16.7. For men artists in Connecticut, average attainment was 16.8; for women, it was 16.6. Regionwide, both men and women had an average of 16.7 years.

Artists in Connecticut took specialized arts training about as frequently as artists elsewhere in the region. They received specialized arts training as part of their formal education slightly less often than other New England artists. Particularly, musicians, writers and poets, and choreographers, composers, and playwrights living elsewhere in the region received more of this type of training than their counterparts in Connecticut. Connecticut artists had specialized training outside the formal educational process slightly more often than their counterparts in the rest of the region. In this case, however, differences among occupations are not as great.

The data showing the extent of specialized arts training as part of one's formal education do not exhibit any new or un-

# Connecticut/Table 1

## Demographic Characteristics of the Artists

| | Percent by Occupation | Median Age | Percent Who Are: | | Percent Who Are: | | | | | Percent Who Are: |
|---|---|---|---|---|---|---|---|---|---|---|
| | | | Male | Female | Amer. Indian | Asian | Black | White | Other | Hispanic |
| All Artists | 100.0% (n = 786) | 39.5 | 49.6% | 50.4% | 0.5% | 0.8% | 1.9% | 96.6% | 0.1% | 2.5% |
| By Occupation: Dancers | IS | IS | IS | IS | IS | IS | IS | IS | IS | IS |
| Musicians | 10.9 | 36.7 | 65.9 | 34.1 | 0.0 | 0.0 | 3.5 | 96.5 | 0.0 | 1.2 |
| Actors | 5.9 | 40.5 | 56.5 | 43.5 | 2.2 | 0.0 | 0.0 | 97.8 | 0.0 | 2.3 |
| Theater Production Personnel | 3.9 | 38.5 | 70.0 | 30.0 | 0.0 | 0.0 | 3.4 | 96.6 | 0.0 | 6.9 |
| Writers and Poets | 12.1 | 45.9 | 54.3 | 45.7 | 1.1 | 1.1 | 1.1 | 96.7 | 0.0 | 1.2 |
| Choreographers, Composers and Playwrights | 3.3 | 45.3 | 68.0 | 32.0 | 0.0 | 0.0 | 0.0 | 96.0 | 4.0 | 4.4 |
| Visual Artists | 33.8 | 39.5 | 50.0 | 50.0 | 0.8 | 0.8 | 2.7 | 95.8 | 0.0 | 3.3 |
| Media Artists | 6.7 | 36.8 | 77.4 | 22.6 | 0.0 | 0.0 | 1.9 | 98.1 | 0.0 | 3.9 |
| Craft Artists | 22.0 | 37.9 | 23.3 | 76.7 | 0.0 | 1.8 | 1.2 | 97.1 | 0.0 | 1.2 |

IS = insufficient sample

# Connecticut / Table 2

## Educational Attainment of Artists

*Percent with Highest Attainment of:*

| | Median Years of Schooling | Less than High School | High School Diploma | Associate's | Bachelor's | Master's | Doctorate | Other | *Percent with Specialized Arts Training:* As Part of Formal Education | Outside of Formal Education |
|---|---|---|---|---|---|---|---|---|---|---|
| **All Artists** | 16.5 | 0.4% | 16.6% | 3.6% | 40.1% | 34.3% | 5.1% | 0.0% | 81.5% | 75.8% |
| **By Occupation:** | | | | | | | | | | |
| Dancers | IS | IS | IS | IS | IS | IS | IS | IS | IS | IS |
| Musicians | 16.4 | 0.0 | 20.2 | 0.0 | 41.7 | 34.5 | 3.6 | 0.0 | 83.3 | 76.1 |
| Actors | 16.0 | 2.2 | 28.3 | 4.3 | 41.3 | 19.6 | 4.3 | 0.0 | 82.6 | 89.1 |
| Theater Production Personnel | 17.0 | 0.0 | 10.0 | 0.0 | 46.7 | 36.7 | 6.7 | 0.0 | 93.3 | 64.3 |
| Writers and Poets | 17.8 | 0.0 | 10.8 | 2.2 | 30.1 | 37.6 | 19.4 | 0.0 | 57.4 | 60.2 |
| Choreographers, Composers, and Playwrights | 18.7 | 0.0 | 7.7 | 3.8 | 26.9 | 38.5 | 23.1 | 0.0 | 84.6 | 76.0 |
| Visual Artists | 16.7 | 0.8 | 16.4 | 3.4 | 40.5 | 36.3 | 2.7 | 0.0 | 92.0 | 74.9 |
| Media Artists | 16.3 | 0.0 | 15.1 | 5.7 | 50.9 | 26.4 | 1.9 | 0.0 | 77.4 | 70.6 |
| Craft Artists | 16.3 | 0.0 | 17.4 | 6.4 | 41.3 | 34.3 | 0.6 | 0.0 | 75.6 | 84.6 |

IS = insufficient sample

usual patterns. Of the artists who attended high school, 51 percent received some form of artistic training at that level, with training outside their major area of study being most common. By comparison, 77.6 percent of those who attended college received some form of specialized training at that level, with attendance at an art school or college the most common form. Attendance at an art school or college was also the most common form of artistic training received by those who went to graduate school. Slightly over 70 percent of all artists with a graduate education received some form of artistic training at that level.

Actors and craft artists, who had the least amount of formal education, were the most likely to have received specialized training outside of their education. In general, those in artistic occupations with more formal education received less amounts of training outside the formal educational process.

# Labor Market Characteristics

As this and other state surveys demonstrate, artists frequently held jobs outside their field of expertise. This was true for many in Connecticut as well, but in this state it was more likely that an artist worked only as an artist than in any other New England state. Among the 786 artists surveyed, 31.7 percent held only artistic jobs in 1981, as opposed to 24.1 percent of the artists in the region. In addition to their artistic occupation, 35.9 percent of the artists held arts-related jobs, 23.5 percent held nonarts-related jobs, and 8.9 percent held both types of jobs. The distribution of arts-related jobs among artists within the state is very similar to that of the region. There is a higher concentration among the professional-managerial categories, as with the nonarts-related jobs, but the difference is slight. Like artists in other states, Connecticut artists who held arts-related jobs were primarily educators (see Table 3). Almost four out of every five arts-related jobs were in the field of artistic education. Nonarts-related jobs were distributed more evenly among the occupations. Four out of every five nonarts-related jobs were in the professional and technical, (nonart) educational, managerial, sales, and clerical fields. Compared to the rest of the region, the distribution of nonarts-related jobs in this state was more oriented toward white-collar occupations and less toward blue-collar and service jobs.

Two factors offer some explanation for why Connecticut artists, on the whole, seem to be less dependent than their regional counterparts on jobs outside their art work. One of these factors is income. Connecticut artists both earned substantially more money as artists and had household members who contributed more money than the average New England artist. This financial stability would obviously give artists more independence. The other factor, one that seems to contradict the above, is that Connecticut artists were more likely than their New England peers to hold nonarts-related jobs. In other states, this situ-

## Distribution of Other Jobs Held by Artists

| Occupation | *Job Type Distribution:* | |
| | Arts-Related | Nonarts-Related |
| --- | --- | --- |
| Professional and Technical | 6.0% | 17.0% |
| Art Educators | 78.6 | 0.0 |
| Other Educators | 1.7 | 19.0 |
| Art Managerial | 8.9 | 0.0 |
| Other Managerial | 1.4 | 15.4 |
| Sales | 0.6 | 14.2 |
| Clerical | 0.6 | 15.0 |
| *Craft and Kindred Workers | 2.3 | 7.3 |
| Operatives and Laborers | 0.0 | 4.0 |
| Service | 0.0 | 8.1 |

*The word "craft" is not used here in the same sense it is used in the text. It is a U.S. Census term that includes various blue collar workers such as carpenters, mechanics, printers, plumbers, and telephone installers.

ation was frequently associated with financial need, but in Connecticut it was more likely that those holding nonarts-related jobs were professionals in other fields who worked part-time as artists and did not consider art to be their principal profession. There are, to be sure, some artists in the state who would have identified themselves as artists and who would not have held nonarts-related jobs if they could have made a living from their art.

How artists in Connecticut allocate their time further defines how they function in the labor force. This "work-time" was calculated in two ways: by the number of weeks worked overall and as an artist, and by the number of hours worked solely as an artist.

Overall, Connecticut artists worked 45 weeks during 1981, one week less than the average New England artist. The major difference between the state and the region was Connecticut artists spent less time on the average in arts-related jobs than other artists did—14.9 weeks as opposed to 17.3.

This average, since it encompasses all artists, including those who did not hold an arts-related job, is less solely because fewer Connecticut artists elected to work in arts-related jobs. For only those who held arts-related jobs, the average weeks worked was actually higher among Connecticut artists—33.9 weeks versus 32.5 regionwide. It is clear from Table 4 that some Connecticut artists not only worked more than one job, but frequently held more than one job simultaneously. When the sums for each of the job types are added together they exceed the overall number of weeks worked and the number of weeks in a year.

The overall weeks worked by occupation in the state and the region are comparable, except for actors. It was surprising to discover that while Connecticut actors worked almost five weeks less than the New England average, they earned more income than any type of artist anywhere in the six states. Connecticut actors are also unusual in that 77.8 percent of their total income was earned by acting, a much higher percentage than that of any other occupation in any other state. Thus the fact that Connecticut actors worked 7.5 weeks less in nonartistic jobs than the regional average seems to result from their greater ability to support themselves as actors. That they also worked 3.5 weeks less as actors than the regional average suggests that while acting work was certainly no more plentiful for them, it was more remunerative when available. This conclusion is reinforced by the data collected on hours worked in a typical week. These data show that Connecticut actors worked essentially the same number of hours per week at their craft as the regional average. Thus salary differentials are not the result of a longer work week.

Looking at the number of weeks worked for only those artists who held nonartistic jobs, one sees some differences, but not patterns. For example, Connecticut writers and poets worked substantially more weeks in arts-related jobs than the regional average, as did Connecticut musicians in nonarts-related jobs.

# Connecticut / Table 4

## Weeks Employed In 1981

| | Overall | As An Artist | In Arts-Related Jobs* | In Nonarts-Related Jobs* |
|---|---|---|---|---|
| **All Artists** | 45.0 | 35.7 | 14.9 (33.9) | 11.3 (35.7) |
| **By Occupation:** | | | | |
| Dancers | IS | IS | IS | IS |
| Musicians | 46.6 | 31.7 | 18.7 (37.4) | 18.8 (42.6) |
| Actors | 33.7 | 23.9 | 7.5 (28.9) | 8.0 (22.4) |
| Theater Production Personnel | 42.7 | 36.5 | 17.4 (37.3) | 8.0 (26.6) |
| Writers and Poets | 46.9 | 36.5 | 16.1 (36.3) | 11.5 (36.8) |
| Choreographers, Composers, and Playwrights | 44.5 | 32.9 | 25.7 (35.7) | 7.2 (23.5) |
| Visual Artists | 46.1 | 39.9 | 14.8 (33.0) | 9.4 (35.6) |
| Media Artists | 47.0 | 36.0 | 11.5 (32.1) | 11.0 (32.4) |
| Craft Artists | 45.2 | 35.3 | 13.0 (31.8) | 13.1 (39.2) |

*Numbers in parentheses are weeks worked in arts-related and nonarts-related jobs for only those artists who held such jobs.

IS = insufficient sample

The sum of the weeks worked exceeds the overall total if artists held two or more jobs at the same time.

Connecticut actors, theater production personnel, and composers, choreographers, and playwrights all worked substantially fewer weeks than the regional average in nonarts-related jobs.

One of the most important findings in this study is that men artists worked more weeks than women. This is true not only for total weeks worked (men worked 47 weeks versus 43 weeks for women), but for weeks worked as an artist (38 versus 34), in arts-related jobs (15 versus 14), and in nonarts-related jobs (12 versus 11). This pattern closely parallels the regional data (see Table 14 in chapter 2).

In a typical week, artists in Connecticut worked 32.9 hours at their art. This and most other figures in Table 5 resemble the work patterns of all New England artists in the survey. Typically, the occupations that showed the longest artistic work weeks were the least likely to involve nonart work. This, more than the nature of the artistic occupation itself, seemed to determine how much artists worked as artists.

In 1981, 17.3 percent of the Connecticut artists who responded to the survey reported being unemployed at some time during the year. Those who were unemployed during 1981 were unemployed for an average of 15.4 weeks. The average unemployed artist was unemployed 1.84 times in 1981 and collected unemployment insurance for only 19 percent of the time unemployment occurred. As noted in chapter 2, an important reason why artists collected unemployment insurance so infrequently is that self-employed persons, as many artists are, are not eligible for it.

The comparison of these statistics with those in Table 16 in chapter 2, shows that a smaller proportion of the artistic labor force in Connecticut was unemployed in 1981 than in New England as a whole. Although some of this difference may suggest that the state's artists have more employment opportunities, it is also true that in 1981 the unemployment rate in Connecticut was lower than the regional average. Connecticut artists who were unemployed in 1981 were unemployed two weeks longer than the regional average, but the number of times they were unemployed and collected unemployment insurance was similar to that of the region.

Though the percent who were unemployed was significantly lower, the percent of artists in the state who dropped out of the labor force was close to the same rate regionwide—26.0 versus 26.9 percent. The reasons for being out of the labor force were ranked similarly. The frequency ranged from a low of 8.3 percent for "believed no work available" to a high of 42.4 percent for "improving artistic skills voluntarily."

# Income

An important distinction between artists in Connecticut and the rest of New England lies in differences in their incomes.

# Connecticut / Table 5

## Hours Working as an Artist in a Typical Week in 1981

| | Total | *Performing Artists:* | | | | *Nonperforming Artists:* | | |
| | | Performing | Rehearsing | Practicing | Looking for Work | Creating | Training | Marketing |
|---|---|---|---|---|---|---|---|---|
| **All Artists** | 32.9 | - | - | - | - | - | - | - |
| **By Occupation:** | | | | | | | | |
| Dancers | IS | IS | IS | IS | IS | | | |
| Musicians | 25.9 | 6.7 | 7.8 | 8.7 | 1.5 | - | - | - |
| Actors | 42.3 | 12.7 | 10.1 | 9.6 | 7.8 | - | - | - |
| Theater Production Personnel | 40.4 | 8.1 | 23.4 | 4.1 | 1.1 | - | - | - |
| Writers and Poets | 27.9 | - | - | - | - | 25.0 | 0.6 | 1.7 |
| Choreographers, Composers, and Playwrights | 23.1 | - | - | - | - | 16.8 | 0.4 | 2.5 |
| Visual Artists | 36.0 | - | - | - | - | 29.3 | 1.8 | 4.8 |
| Media Artists | 34.0 | - | - | - | - | 25.6 | 1.3 | 6.8 |
| Craft Artists | 31.8 | - | - | - | - | 25.1 | 1.3 | 5.2 |

IS = insufficient sample

The average Connecticut artist reported a household income of almost $7,000 higher and a personal income of about $3,400 higher than the regional average. It was also $11,140 higher than the statewide 1980 average household income.[3] Connecticut artists received more money than artists regionwide from all sources of income, but the greatest difference was in the income from art work. Connecticut artists' income was $2,400 higher than the regional average. Ironically, the costs for artists were lower too, making the difference in "net" artistic income even greater. Most striking of all is the income of actors, who earned $25,232 as artists and $32,445 from all sources.

More than artists in other states, artists in Connecticut benefited from the incomes of other family members. Craft artists, the majority of whom were women by more than three to one, had a personal income of $13,334, which was supplemented with income from family members of $19,523. Other artists enjoyed this kind of support as well, though it was not quite as striking.

One might surmise that the Connecticut artists who were surveyed enjoy a good measure of prosperity because they live in the New England state with the highest income level and standard of living. No doubt this helps, but it can hardly comprise the total picture, if for no other reason than this: while the household and personal incomes for all the labor force in Connecticut were, respectively, 7 and 6 percent above the New England average, artists in the state in 1981 had household incomes of 25 percent and personal incomes of 22 percent *above* their fellow artists regionwide. There are some other factors that may help to explain this.

Connecticut's lack of a personal income tax may make it particularly attractive to artists who are financially successful. In fact, many prominent artists do live in the state. But if a lack of income tax were a critical factor, the income of New Hampshire artists would also be well above average. It is not. Perhaps a stronger influence lies in Connecticut's proximity to New York City, with its multitude of theaters, television stations, musical organizations, art galleries, and publishing houses. New York City not only attracts prominent artists but also provides superior job opportunities for artists in all career phases. As a rough test of this hypothesis, household and personal incomes of artists living in Connecticut were sorted by zip code. The state was broken into two parts: a southwest portion (roughly Fairfield County), and the rest of the state. Household incomes of artists in the southwest were $45,289, compared to $32,047 in the rest of the state. The personal incomes (from all sources) of artists living in the southwest were $24,330 compared to $17,626 in the rest of the state. Thus the incomes of artists and other family members were higher in the southwest by about 40 percent; incomes for most artists in the rest of the state, however, remained higher than the New England average. Not all artistic occupations benefited equally from proximity to New York City. Such proximity seemed particularly important in segmenting the job

# Connecticut / Table 6

## Income and Artistic Costs in 1981

| | Total Household Income | Artist's Income: Total* | As Artist | In Arts-Related Work | In Nonarts-Related Work | Nonlabor | Value of Art Work Bartered | Total Artistic Costs |
|---|---|---|---|---|---|---|---|---|
| **All Artists** | $34,246 (29,000) | $19,021 (14,000) | $ 8,818 | $ 4,799 | $3,394 | $2,017 | $187 | $2,981 |
| **By Occupation:** | | | | | | | | |
| Dancers | IS | IS | IS | IS | IS | IS | IS | IS |
| Musicians | 28,192 (25,294) | 18,756 (16,000) | 6,202 | 5,359 | 6,131 | 1,064 | 70 | 2,091 |
| Actors | 47,390 (26,108) | 32,445 (12,040) | 25,232 | 900 | 2,582 | 3,730 | 50 | 4,321 |
| Theater Production Personnel | 27,054 (25,400) | 20,855 (18,230) | 11,910 | 4,621 | 2,021 | 2,304 | 17 | 1,980 |
| Writers and Poets | 34,879 (31,979) | 19,344 (17,143) | 5,651 | 6,997 | 3,892 | 2,521 | 5 | 1,712 |
| Choreographers, Composers, and Playwrights | 39,004 (32,000) | 27,017 (25,050) | 7,383 | 13,908 | 2,261 | 4,193 | 238 | 2,469 |
| Visual Artists | 36,049 (29,999) | 19,116 (14,000) | 10,176 | 4,977 | 2,447 | 1,590 | 235 | 3,693 |
| Media Artists | 30,842 (20,051) | 20,823 (16,510) | 10,723 | 3,272 | 4,052 | 2,777 | 201 | 4,107 |
| Craft Artists | 32,857 (29,008) | 13,334 (11,000) | 4,653 | 3,221 | 3,745 | 1,723 | 332 | 2,604 |

*Components of total artist's income may not add exactly to total because of nonresponses to question requesting breakdown of total income.
IS = insufficient sample

83.

market for actors. Actors living in the southwest corner earned $43,036 in personal income. Those in the rest of the state, ironically, earned $21,535, slightly less than the New England average of $22,032.

In other respects income patterns in Connecticut followed those in the rest of the region. The personal income for men artists in Connecticut was $25,489, more than double the $12,072 that women artists earned. In New England, the artistic income for men was 162 percent higher than that of women. In Connecticut, the differential was 179 percent— $12,762 versus $4,580. In fact, men artists enjoyed more personal income from all sources, roughly to the same extent as men throughout the rest of New England. The only aberration in this pattern is that Connecticut women artists enjoyed a higher total household income than their male counterparts, attributable apparently to the superior earning power of other members of their households.

Converting artistic income into an hourly wage by dividing it by total hours worked does little to alter the conclusions already drawn. Because men on the average worked more hours as artists the percentage artistic wage differential is less than the income differential. But, even on an hourly basis, the earnings gap is still quite significant, $7.61 for men versus $3.44 for women.

The influences exerted on income by education and age worked no differently for Connecticut artists than for artists elsewhere (see Table 7). All forms of income, other than nonarts-related, were positively correlated with age. Total personal income and artistic income rose with age through all age brackets. Arts-related income rose with age until age 60, and then declined. Nonarts-related income rose with age until age 50 and then declined. Artistic income was negatively correlated with years of schooling. This relationship, however, was not as strong as in other states. Total personal and arts-related incomes were significantly greater for those with more years of education. Nonarts-related and nonlabor incomes were only slightly higher for people with more education.

# Connecticut— Endnotes

[1] From a special tabulation of the U.S. Bureau of the Census, 1981. Current Population Survey data tapes for New England.

[2] U.S. Department of Commerce, Bureau of the Census, *1980 Census of Population and Housing, Supplementary Report.* (Washington D.C.: 1982) Table P-2, p.

[3] Current Population Survey data tapes.

# Connecticut / Table 7

## Average 1981 Income by Demographics

| | Total Household Income | Artists' Income: Total | Arts | Arts Related | Nonarts Related | Nonlabor |
|---|---|---|---|---|---|---|
| **Sex:** Female | $34,608 | $12,071 | $ 4,580 | $ 3,380 | $2,348 | $ 1,655 |
| Male | 33,970 | 25,489 | 12,762 | 6,129 | 4,278 | 2,357 |
| **Race:** White | 34,217 | 18,910 | 8,723 | 4,804 | 3,285 | 2,080 |
| Nonwhite | 31,649 | 15,134 | 3,515 | 6,469 | 4,223 | 927 |
| **Age:** 20-29 | 19,331 | 10,583 | 4,970 | 2,484 | 2,512 | 605 |
| 30-39 | 30,654 | 16,106 | 8,199 | 3,272 | 3,998 | 630 |
| 40-49 | 42,597 | 22,891 | 9,928 | 7,422 | 4,427 | 1,316 |
| 50-59 | 43,630 | 21,989 | 8,963 | 7,771 | 2,550 | 2,437 |
| 60-69 | 40,297 | 28,834 | 13,113 | 4,742 | 2,632 | 8,347 |
| 70+ | 38,998 | 32,709 | 16,779 | 5,142 | 36 | 10,753 |
| **Education: Degree:** High School | 30,505 | 16,553 | 10,009 | 1,458 | 3,325 | 1,536 |
| Associate's | 44,860 | 15,518 | 11,998 | 193 | 2,372 | 955 |
| Bachelor's | 31,982 | 16,776 | 9,453 | 1,952 | 3,481 | 1,906 |
| Master's | 36,805 | 22,060 | 8,038 | 8,737 | 3,057 | 2,275 |
| Doctorate | 36,864 | 23,330 | 2,459 | 13,884 | 6,823 | 555 |

# Maine

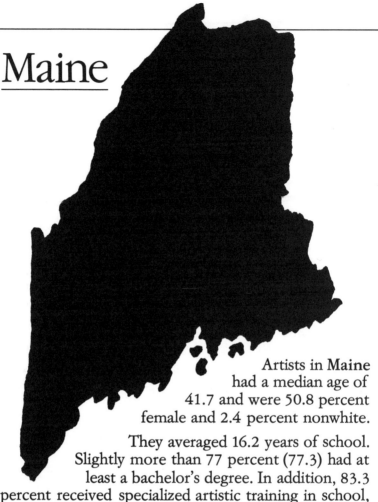

Artists in **Maine** had a median age of 41.7 and were 50.8 percent female and 2.4 percent nonwhite.

They averaged 16.2 years of school. Slightly more than 77 percent (77.3) had at least a bachelor's degree. In addition, 83.3 percent received specialized artistic training in school, and 77.9 percent received training outside of school.

They worked 35.9 weeks as artists in 1981. In addition to their work as artists, 50.3 percent held jobs related to their art for an average of 28.5 weeks and 36.4 percent held jobs not related to their art for 32.0 weeks. Holding more than one job at a time was common. Nevertheless, 15.0 percent were unemployed and 30.0 percent dropped out of the labor force during the year.

They earned $14,558 in income from all sources in 1981. Their household income (including earnings of other household members) was $23,447. However, the income they earned as artists was $6,723. In earning their artistic income, they incurred more reimbursed costs of $3,555.

# Demographic and Educational Characteristics

The occupational distribution of artists in Maine (Table 1) was similar to that of the region. One-third were visual artists, with crafts artists accounting for an additional one-quarter. The major difference between Maine and the other New England states was that this state had 30 percent more craft artists. The state had a slight underrepresentation of musicians, actors, theater production personnel, and choreographers, composers, and playwrights.

The median age of artists in Maine was just under 42, which made them almost six years older, on the average, than region-wide and than Maine's labor force in general.[1] There were more female artists than male artists, which differs markedly from the proportions in the state labor force. Fifty-eight percent of the state labor force was male.[2] The racial-ethnic composition of Maine artists was essentially the same as it was throughout the region. The only differences were a slightly larger proportion of American Indians and a smaller proportion of black artists.

Maine artists had slightly less education than artists in the rest of New England. They completed an average of 16.2 years of schooling while 16.5 years is the regionwide average. This is primarily because a greater proportion of Maine artists did not continue their schooling beyond a bachelor's degree. Even though a direct comparison was not possible, it was apparent that Maine artists were much better educated than the average adult in the state. According to preliminary estimates from the 1980 census, 68.5 percent of the Maine adult population 25 years old and older, graduated from high school (the national average is 66.3 percent,[3]) while all but 0.7 percent of Maine artists 25 years and older, graduated from high school. Almost 80 percent of the Maine artists held at least a bachelor's degree with more than 25 percent having graduate degrees.

Table 2 shows a variation in the formal education of Maine artists according to their artistic occupation. Writers and poets had the greatest amount of education, an average of 17.4 years of schooling; media artists had the least, an average of 15.9 years. The second most highly educated group was actors who were also much more educated than their counterparts in the rest of New England. With an average of 16 years of schooling, they, along with dancers, had the smallest amount of formal education among the artists surveyed throughout the region.

An artist's education was generally not limited to formal schooling however. More than 75 percent of Maine artists, slightly higher than the region, participated in artistic training outside the formal educational system. In Maine the average age for starting this artistic training was almost 16, with the starting age for dancers and musicians much lower than for visual and crafts

# Maine / Table 1

## Demographic Characteristics of the Artists

|  | Percent by Occupation | Median Age | Percent Who Are: | | Percent Who Are: | | | | | Percent Who Are: |
|---|---|---|---|---|---|---|---|---|---|---|
|  |  |  | Male | Female | Amer. Indian | Asian | Black | White | Other | Hispanic |
| All Artists | 100.0% (n = 298) | 41.7 | 49.2% | 50.8% | 1.0% | 0.7% | 0.3% | 97.6% | 0.3% | 1.1% |
| By Occupation: |  |  |  |  |  |  |  |  |  |  |
| Dancers | 2.0 | 36.0 | 16.7 | 83.3 | 0.0 | 0.0 | 0.0 | 100.0 | 0.0 | 0.0 |
| Musicians | 13.7 | 36.3 | 67.5 | 32.5 | 5.0 | 2.5 | 0.0 | 92.5 | 0.0 | 2.6 |
| Actors | 2.4 | 36.0 | 57.1 | 42.9 | 0.0 | 0.0 | 0.0 | 100.0 | 0.0 | 0.0 |
| Theater Production Personnel | 2.0 | 42.0 | 50.0 | 50.0 | 0.0 | 0.0 | 0.0 | 100.0 | 0.0 | 0.0 |
| Writers and Poets | 11.3 | 40.0 | 54.6 | 45.4 | 0.0 | 0.0 | 0.0 | 100.0 | 0.0 | 0.0 |
| Choreographers, Composers, and Playwrights | 1.0 | IS | IS | IS | IS | IS | IS | IS | IS | IS |
| Visual Artists | 33.4 | 37.3 | 41.2 | 58.8 | 0.0 | 0.0 | 0.0 | 99.0 | 1.0 | 1.1 |
| Media Artists | 8.2 | 37.5 | 91.7 | 8.3 | 4.2 | 0.0 | 0.0 | 95.8 | 0.0 | 0.0 |
| Craft Artists | 25.9 | 35.9 | 35.5 | 64.5 | 0.0 | 1.4 | 1.4 | 97.3 | 0.0 | 1.4 |

IS = insufficient sample

artists. All of the dancers in Maine participated in informal train-
ing while very few writers and poets did so. More than 33 per-
cent of Maine artists participated in some form of informal
artistic training during 1981. They averaged almost 15 weeks
and almost 18 hours per week of training. These artists spent
an average of $369 on this training.

A large proportion of Maine artists also received artistic
training as part of their formal education, especially as part of
their college education. Almost 40 percent of the artists received
some artistic training as part of their secondary schooling, with
a little more than 7 percent having attended an arts high school.
Sixty percent of Maine artists majored in their art as undergradu-
ates, with 35 percent having received their schooling at an art
school. Only 32 percent of the artists received specialized art
training in graduate school.

# Labor Market Characteristics

Most Maine artists, like most artists in the rest of New Eng-
land, found it necessary to hold jobs other than art work. Fewer
than 30 percent of the artists in Maine (28.6 percent) were em-
ployed solely as artists, compared to almost 25 percent in New
England. Half of the artists held jobs related to their art at some
time during 1981. More than one-third (36.4 percent) held jobs
unrelated to their art at some time during the year. Fifteen per-
cent held both types of jobs, arts-related and nonarts-related,
during 1981.

The occupational distribution of the arts-related and non-
arts-related jobs held by Maine artists (see Table 3) is similar to
that of all artists in New England. More than 80 percent of the
artists in the state who held arts-related jobs taught in their
artistic field. This is a slightly larger proportion than regionwide.
Most of the other artists held art managerial jobs. The remainder
of the arts-related jobs held by artists in Maine were in art busi-
nesses or organizations and were generally not artistic in nature,
such as a sales clerk in an art supply store or an accountant for
a performing arts group.

In Maine, as well as the rest of New England, the profes-
sional and technical occupations accounted for the largest pro-
portion of nonarts-related jobs held by artists. Twenty-one
percent of Maine artists who held a nonarts-related job worked
as professionals; in New England 19 percent held a professional
job. Managerial and teaching occupations together account for
more than one-quarter of the nonarts-related jobs held by artists
in Maine.

In nonarts-related employment, the major difference be-
tween Maine artists and those in the rest of the region was in the
proportion of low level white-collar occupations, sales and cleri-
cal, and blue-collar occupations. The proportion of artists in
Maine who were employed in sales jobs was 64 percent higher

# Maine / Table 2

## Educational Attainment of Artists

| | Median Years of Schooling | Percent with Highest Attainment of: | | | | | | | Percent with Specialized Arts Training: | |
| --- | --- | --- | --- | --- | --- | --- | --- | --- | --- | --- |
| | | Less than High School | High School Diploma | Associate's | Bachelor's | Master's | Doctorate | Other | As Part of Formal Education | Outside of Formal Education |
| **All Artists** | 16.2 | 0.7% | 19.9% | 2.1% | 50.2% | 23.7% | 3.4% | 0.0 | 83.2% | 77.9% |
| **By Occupation:** | | | | | | | | | | |
| Dancers | IS | IS | IS | IS | IS | IS | IS | IS | 100.0 | 100.0 |
| Musicians | 16.2 | 2.5 | 17.5 | 0.0 | 60.0 | 17.5 | 2.5 | 0.0 | 87.2 | 79.5 |
| Actors | 17.3 | 0.0 | 0.0 | 0.0 | 57.1 | 42.9 | 0.0 | 0.0 | 71.4 | 83.3 |
| Theater Production Personnel | IS | IS | IS | IS | IS | IS | IS | IS | 83.3 | 83.3 |
| Writers and Poets | 17.4 | 0.0 | 15.1 | 0.0 | 48.5 | 27.3 | 9.1 | 0.0 | 71.9 | 60.6 |
| Choreographers, Composers, and Playwrights | IS | IS | IS | IS | IS | IS | IS | IS | IS | IS |
| Visual Artists | 16.2 | 0.0 | 19.2 | 3.2 | 50.0 | 25.5 | 2.1 | 0.0 | 90.7 | 73.4 |
| Media Artists | 15.9 | 4.2 | 37.5 | 4.2 | 37.5 | 16.7 | 0.0 | 0.0 | 73.9 | 78.3 |
| Craft Artists | 16.1 | 0.0 | 21.9 | 1.4 | 52.1 | 21.9 | 2.7 | 0.0 | 78.1 | 85.3 |

IS = insufficient sample

than the proportion in the region. For the operative and laborer occupations, the same difference existed. At the same time, the proportion of artists who held clerical jobs in Maine was approximately one-quarter of what it was regionwide. This may simply be a reflection of differences in the job opportunities available in Maine. There might have been fewer clerical opportunities than there were in other states in the region, especially Massachusetts and Connecticut. Furthermore, a relatively small proportion of artists who held nonarts-related jobs had service jobs. Few artists in Maine supplemented their income working as waitresses or cooks.

Maine artists did not hold nonart jobs because they preferred them. Only 5 percent of the artists with either an arts-related or a nonarts-related job indicated they preferred it to their art work. Artists worked other jobs primarily for economic reasons. Over half the artists said they had other employment because the "pay was better." Almost 45 percent of these artists said that "increased job security" was an important reason for having a job other than relying on their art.[4]

The amount of time artists spent working was another important factor in understanding how they fit into the labor market. This "worktime" was measured in two ways: by the number of weeks artists worked overall and as artists and by the number of hours they worked as artists. Maine artists worked an overall average of 46 weeks in 1981 and an average of 36 weeks as an artist (Table 4). Actors and theater production personnel had the fewest weeks employed as artists. Maine artists were employed an average of almost four fewer weeks in arts-related jobs than artists throughout New England. (This may be because of a lack of employment opportunities in arts-related jobs, especially teaching.) Media artists spent the most time working at their art while theater production personnel worked the least.

Maine artists worked an average of 33 hours per week at their art (Table 5). In estimating the number of hours they worked, performing artists included time spent performing, rehearsing, and looking for work, and nonperforming artists included time spent on creating, training, and marketing their art. There was considerable variation among occupations with dancers spending about 11 hours per week and actors spending 48 hours per week.

These findings tell us several things about the artist's working life. It is clear that many artists in Maine not only held more than one job during 1981 but they held these jobs simultaneously. In all of the occupations where there were sufficient responses, the sum of the weeks worked in the three job categories is greater than the overall weeks worked. For example, the overall total for musicians is 47.1, but if you add up the number of weeks worked for each of the job categories, the total is 79.6. Obviously, jobs must have overlapped. The reasons for this are numerous, but from the evidence that will be presented later, it appears that at least one major reason was simply economic survival.

# Maine / Table 3

## Distribution of Other Jobs Held by Artists

| Occupation | Job Type Distribution: | |
| --- | --- | --- |
| | Arts-Related | Nonarts-Related |
| Professional and Technical | 2.7% | 21.0% |
| Art Educators | 83.3 | 0.0 |
| Other Educators | 0.7 | 13.4 |
| Art Managerial | 8.9 | 0.0 |
| Other Managerial | 1.4 | 13.4 |
| Sales | 0.7 | 18.2 |
| Clerical | 0.7 | 3.8 |
| *Craft and Kindred Workers | 0.0 | 9.6 |
| Operatives and Laborers | 0.0 | 8.7 |
| Service | 2.1 | 12.4 |

*The word "craft" is not used here in the same sense it is used in the text. It is a U.S. Census term that includes various blue collar workers such as carpenters, mechanics, printers, plumbers, and telephone installers.

# Maine / Table 4

## Weeks Employed In 1981

| | Overall | As An Artist | In Arts-Related Jobs* | In Nonarts-Related Jobs* |
|---|---|---|---|---|
| **All Artists** | 46.0 | 35.9 | 13.9 (28.5) | 11.5 (32.0) |
| **By Occupation:** | | | | |
| Dancers | 43.5 | IS | IS | IS |
| Musicians | 47.1 | 34.1 | 27.8 (41.1) | 17.7 (36.4) |
| Actors | 35.0 | 29.4 | 17.0 (IS) | 1.4 (IS) |
| Theater Production Personnel | 48.3 | 29.2 | 13.8 (IS) | 12.0 (IS) |
| Writers and Poets | 46.9 | 35.0 | 16.5 (29.1) | 15.5 (33.0) |
| Choreographers, Composers, and Playwrights | IS | IS | IS | IS |
| Visual Artists | 45.6 | 36.3 | 9.7 (25.3) | 11.3 (33.1) |
| Media Artists | 50.7 | 46.2 | 11.9 (26.2) | 6.0 (IS) |
| Craft Artists | 44.7 | 37.8 | 9.5 (22.4) | 6.5 (23.7) |

*Numbers in parentheses are weeks worked in arts-related and nonarts-related jobs for only those artists who held such jobs.

IS = insufficient sample

The sum of the weeks worked exceeds the overall total if artists held two or more jobs at the same time.

The number of hours artists worked tells us even more. While there were differences among artists in the number of hours they worked per week, this is not a sign that some artists are more dedicated than others. Rather it shows merely that there may be fewer opportunities for some artists in Maine. The number of hours artists work also tells us that they worked "overtime." Writers and poets, for example, worked 26 hours a week in their art. If they had another job, as was likely, and even if it were parttime, it means they probably worked at least a 40-hour week.

When work week figures are broken down for men artists and women artists, a startling pattern emerges. In 1981, men in Maine worked significantly more weeks during the year than women—an average of 48.5 weeks overall for men and an average of 43.4 weeks for women. This five-week overall difference is caused by a five-week difference in the number of weeks men and women worked as artists. Men averaged 38.5 weeks, the same as men throughout New England, and women averaged 33.3 weeks, the same as women regionally.

The reason men artists worked more than women in 1981 may be found in the most frequently cited explanation artists gave for not being in the labor force (that is, neither employed or unemployed). More than 40 percent of the artists who spent some of 1981 out of the labor force said family obligations was an important reason for this occurring. Even in 1981, family obligations, such as raising children, were more likely to fall to women than to men.

These work time differences between men and women artists were not consistently true for all artistic occupations in Maine. It was more common for the craft and media artists than for the other occupations. For writers and poets in the state, the overall pattern was the same, but the primary reason for men working more weeks was different. In this case, men worked more because they were employed more weeks in arts-related jobs—23.6 weeks as opposed to 8.2 for women. (This could also be an indication that fewer women are teachers in Maine.) In the remaining two artistic occupations where there was a sufficient sample, musicians and visual artists, the weeks worked did not show significant differences that could be attributed to the sex of the artist.

Not all Maine artists were employed throughout 1981. Fifteen percent were unemployed at some time during the year. That is, they were not working for themselves or for someone else, but they were looking for work. These people were a smaller proportion, by almost 25 percent, than the proportion of the artists regionally who were unemployed at least once during 1981. Nationally almost 20 percent of the labor force was unemployed at some time during 1981.[5] Maine actors were the most likely to have experienced some unemployment while the media artists were the least likely. Those who were unemployed were out of work for an average of a little more than 14

# Maine / Table 5

## Hours Working as an Artist in a Typical Week in 1981

| | Total | Performing Artists: | | | | Nonperforming Artists: | | |
|---|---|---|---|---|---|---|---|---|
| | | Performing | Rehearsing | Practicing | Looking for Work | Creating | Training | Marketing |
| **All Artists** | 33.2 | - | - | - | - | - | - | - |
| **By Occupation:** | | | | | | | | |
| Dancers | 11.6 | 0.5 | 2.3 | 6.5 | 2.3 | - | - | - |
| Musicians | 22.8 | 4.9 | 5.4 | 10.3 | 1.1 | - | - | - |
| Actors | 48.6 | 18.5 | 10.3 | 9.7 | 4.6 | - | - | - |
| Theater Production Personnel | 39.8 | IS | IS | IS | IS | - | - | - |
| Writers and Poets | 26.0 | - | - | - | - | 18.5 | 1.8 | 5.0 |
| Choreographers, Composers, and Playwrights | IS | - | - | - | - | IS | IS | IS |
| Visual Artists | 31.7 | - | - | - | - | 26.8 | 1.4 | 3.3 |
| Media Artists | 47.5 | - | - | - | - | 31.8 | 2.6 | 13.1 |
| Craft Artists | 38.6 | - | - | - | - | 30.0 | 0.6 | 8.3 |

IS = insufficient sample

weeks over an average of two periods of unemployment. Almost 24 percent received unemployment compensation during these periods, making Maine's unemployed artists slightly worse off than the other artists in the region.

Almost twice as many artists dropped out of the labor force as were unemployed during 1981. Thirty percent of all the artists were out of the labor force at least once during the year. As discussed above, the most frequently cited reason for not being in the labor force was family responsibilities.[6] It was cited by 43 percent of those who found themselves out of the labor force. The next most frequent reason was that the artist voluntarily withdrew from the labor force to practice his or her art (38 percent). This was followed by other, unspecified reasons (also 38 percent), attending school (11 percent), illness (10 percent), and believed there was no work available (9 percent).

Maine artists' labor market experiences do not differ dramatically from the average worker in Maine. Unlike the artist, the average Maine worker does not hold down more than one job at a time and does not spend as much time working for economic survival. How successful artists are at attaining economic stability is examined in the next section.

# Income

The Maine artist was part of a household that in 1981 averaged almost $23,500 in total income (Table 6), labor and non-labor combined. The average 1980 income for Maine households was $17,827.[7] Though some of this difference can be attributed to inflation, the 30 percent increase was greater than the inflation rate for the period, indicating that in 1981 artists came from households with average 1981 incomes higher than the average for the state. This was, however, less than the average for artists' households in the region. Almost 75 percent of the artists' households in Maine had more than one income earner. In over 55 percent of the households, where there was more than one earner, the second earner was working full-time (at least 35 hours per week), and in almost 27 percent the second earner was working part time. There was one earner in only 18 percent of the households with more than one member, compared to 32 percent of the families statewide in 1979.[8]

There was a much larger variation in household income among Maine artists than among artists' households within the region. The ranking of household income by artistic occupation was also different in Maine than it was regionwide. In Maine, actors' households had the lowest average income while media artists' households had the highest average income, averaging almost $25,000 more than actors' households. Regionwide actors' households had the highest average income and dancers' households had the lowest average income with approximately $11,000 less income than the actors.

In Maine, artists brought in 62 percent of their households' income. This is proportionally somewhat higher than the average New England artist. Theater production personnel were responsible for the smallest share of their households' income, only 34 percent, while media artists were responsible for the largest share of their households income (81 percent) and contributed the largest dollar amount, more than $34,200. Actors contributed the least to the household, only $9,100.

The examination of the distribution of artists' incomes by source revealed the necessity of nonartistic work for most artists. In 1981, the average artist in Maine earned 46 percent, or $6,700, of his or her income from working as an artist, slightly higher than the typical New England artist. An additional 25 percent of his or her income came from art-related work, and 17 percent came from working in nonarts-related jobs, a share slightly lower than the average for the region. Nonlabor income from rent, social security, and other sources, accounted for the remaining 10 percent of the artists' total income. More than 40 percent of the artists' 1981 income came from doing something other than working as an artist. Without this income the economic survival of an artist in Maine is in doubt.

Some artists were more successful than others in being able to support themselves from their artwork. Media artists in Maine earned almost 80 percent of their income in 1981 from working in their artistic field. Writers and poets, on the other hand, were the least successful, earning only 13 percent of their income from their art, which was almost half the regionwide proportion.

Another source of income that is becoming more important among artists is barter income. In 1981, the typical Maine artist received a little more than $216 from trading his or her art or artistic services for goods and services. This was slightly larger than the amount received by the typical New England artist. From information gathered in interviews with artists, it appears actors received the most from bartering followed by writers, media artists, and musicians. The least successful artists in Maine, the craft artists and visual artists, were the most successful region-wide in bartering their art for goods and services, often other works of art, art supplies, or art lessons.

Table 6 shows the average total costs incurred by the artists in producing their art. It includes only those costs not reimbursed by an employer or business. Maine artists spent an average of almost $3,600, or almost 53 percent of their artistic income in 1981, producing their art. This was a larger absolute amount but a smaller proportion of their income than artists regionwide. As with the artists in New England, media artists had the highest costs, followed by craft and visual artists. For Maine writers and poets, the income they received from their writing was not even $400 more than their costs. It is clear that many artists are using other financial resources, nonart work, and other household members, to at least partially support themselves and their artistic endeavors.

# Maine / Table 6

## Income and Artistic Costs in 1981

| | Total Household Income | Total* | *Artist's Income:* As Artist | In Arts-Related Work | In Nonarts-Related Work | Nonlabor | Value of Art Work Bartered | Total Artistic Costs |
|---|---|---|---|---|---|---|---|---|
| **All Artists** | $23,447 (19,002) | $14,558 (10,920) | $6,723 | $3,479 | $2,432 | $1,668 | $216 | $3,555 |
| **By Occupation:** Dancers | IS | IS | IS | IS | IS | IS | IS | IS |
| Musicians | 20,974 (19,888) | 12,204 (10,500) | 3,306 | 4,474 | 3,733 | 735 | 309 | 1,791 |
| Actors | 17,257 (11,000) | 9,129 (8,500) | 5,116 | 1,457 | 160 | 2,500 | 833 | 1,638 |
| Theater Production Personnel | 36,697 (22,000) | 12,419 (8,010) | 7,938 | 2,181 | 1,613 | 687 | IS | IS |
| Writers and Poets | 25,314 (22,250) | 14,924 (11,509) | 1,940 | 6,229 | 2,834 | 1,221 | 327 | 1,545 |
| Choreographers, Composers, and Playwrights | IS | IS | IS | IS | IS | IS | IS | IS |
| Visual Artists | 20,733 (18,000) | 12,554 (9,998) | 5,137 | 2,448 | 2,565 | 2,423 | 139 | 2,106 |
| Media Artists | 42,195 (27,250) | 34,202 (16,357) | 26,804 | 4,710 | 2,204 | 408 | 322 | 14,049 |
| Craft Artists | 21,322 (18,003) | 12,637 (9,856) | 7,012 | 2,493 | 942 | 2,190 | 170 | 4,407 |

*Components of total artist's income may not add exactly to total because of nonresponses to question requesting breakdown of total income.
IS = insufficient sample

There were a number of differences in the income of artists in Maine that were related to sex, age, and educational background (see Table 7). One of the most surprising was the difference in income between women and men artists.

In general, women artists in Maine received less income from all sources with the exception of nonlabor income. The average female artist received half the income of the average male artist. The largest portion of this difference came from women's lower artistic earnings. Women's earnings were not even 30 percent of the average male artistic earnings, which were $10,317 in 1981. The disparity in male and female earnings from arts-related and nonarts-related work was not as large. Women earned 54 percent and 61 percent of what men earned, respectively.

The reasons for these income differences are complex. The amount of time female artists spent working, however, offers at least a partial explanation. As discussed above, they spent fewer total weeks working, an average of 43.4 weeks or almost 10 percent less time than the average male artist. Much of this difference can be attributed to women working fewer weeks as artists, about 14 percent fewer weeks than men artists. Female artists in Maine also worked fewer weeks in arts-related jobs and nonarts-related jobs than male artists but not significantly fewer.

In addition to working fewer weeks overall, women artists averaged fewer hours per week working as artists. A 10 percent differential in the number of hours typically worked can be traced to a difference of almost 25 percent between the number of hours female and male visual artists, media artists, and craft artists spent creating their art. (Unfortunately, information on the number of hours spent in activities other than art was not available to determine how it might have affected income.) But the difference in time spent working as an artist cannot fully explain the differences in income for 1981.

Another way of looking at differences in male/female income is through the estimated hourly wage they received for their art work. In 1981, the average artist in Maine worked for $6.60 per hour. In comparison, artists regionwide made $6.08, and production workers in manufacturing in the state made $6.66.[9] In all the artistic occupations, with one exception, male artists had higher wages than female artists. The differences ranged from 500 percent higher for the artists in theater production to 25 percent higher among the writers and poets ($4.82 for male and $3.84 for female). The exception was the female artist working in crafts. The average female craft artist earned almost $12 per hour while the average male craft artist earned almost $5 per hour.

Age was another factor in the income levels for Maine artists. Total household income increased with age until the artists were between 40 and 49 years old, after that it declined. In fact, households with artists age 20 to 29 had average incomes only slightly lower than artists 70 and older, almost $17,000 to almost

# Maine / Table 7

## Average 1981 Income by Demographics

|  | Total Household Income | *Artists' Income:* | | | | |
|---|---|---|---|---|---|---|
|  |  | Total | Arts | Arts Related | Nonarts Related | Nonlabor |
| **Sex:** Female | $22,107 | $ 9,620 | $ 2,935 | $ 2,396 | $1,844 | $1,772 |
| Male | 24,743 | 19,207 | 10,317 | 4,402 | 3,015 | 1,581 |
| **Race:** White | 23,754 | 14,797 | 6,864 | 3,445 | 2,516 | 1,711 |
| Nonwhite | 14,500 | 9,103 | 3,240 | 5,141 | 100 | 621 |
| **Age:** 20-29 | 16,800 | 7,552 | 2,265 | 2,583 | 2,321 | 388 |
| 30-39 | 21,444 | 13,335 | 7,178 | 2,722 | 2,485 | 956 |
| 40-49 | 30,945 | 20,859 | 10,135 | 5,667 | 3,580 | 1,476 |
| 50-59 | 25,021 | 14,465 | 5,848 | 3,319 | 1,617 | 3,895 |
| 60-69 | 28,239 | 18,648 | 6,072 | 4,207 | 1,461 | 3,643 |
| 70+ | 18,987 | 17,320 | 9,135 | 165 | 0 | 9,200 |
| **Education: Degree:** |  |  |  |  |  |  |
| High School | 27,889 | 19,394 | 12,501 | 1,615 | 1,948 | 1,981 |
| Associate's | 23,899 | 10,233 | 5,694 | 77 | 3,880 | 582 |
| Bachelor's | 21,457 | 12,802 | 6,446 | 2,404 | 2,349 | 1,581 |
| Master's | 22,988 | 14,134 | 3,544 | 6,398 | 3,039 | 1,296 |
| Doctorate | 32,180 | 19,835 | 1,320 | 13,712 | 0 | 4,803 |

$19,000. The peak household income was about $31,000.

The pattern was somewhat different for total artistic income earned. Artists 40 to 49 years old earned approximately an average peak income of $21,000. Older artists, over 50, did not have average incomes much lower than this. The average income for artists 70 and older, however, was much lower— $17,300. Young artists, 20 to 29, made an average of $7,500.

The pattern was much the same for income earned from arts-related jobs and nonarts-related jobs except that the differences among the age groups were much smaller. Artists 70 and older had very little income from arts-related work and no earnings from nonarts-related work.

Not so surprising was that the older the artists, the more the nonlabor income (income from property, transfer payments, and so forth). Artists 20 to 29 only received an average of $400 in nonlabor income, while artists 70 and older received an average of $9,200 in nonlabor income.

Maine artists were very well educated, but unlike the labor force in general, there was very little evidence that artist's income increases with education. The households of artists holding doctoral degrees averaged only $5,000 more in total income ($32,200) than the households of artists with only high school degrees ($27,500). Households having artists with bachelor's and master's degrees had lower average incomes ($21,300) than households with only high school degrees ($23,000).

For the artists themselves, the relationship between education and income was essentially the same as for their households except that artists with only high school degrees received the same income on the average, as artists with doctoral degrees ($20,000). The biggest difference was between high school graduates who received the bulk of their income from working in their art (65 percent) and the doctoral graduates who received the bulk of theirs from arts-related work (69 percent).

There was a strong negative relationship between education and artistic earnings. As the artist's education increased, the earnings received from working as an artist decreased. On the other hand, there was a positive relationship between education and arts-related earnings. The earnings from nonarts-related jobs were not strongly related to education, nor was the amount of nonlabor income, except that artists with doctoral degrees had no income from nonarts-related work and the most income from nonlabor sources. The reasons for these differences are complex and related to the amount of time artists spent in each of the various activities and the labor market conditions for each activity in Maine during 1981.

# Maine— Endnotes

[1] These figures were calculated from the *Annual Planning Information,* State of Maine, Fiscal Year 1982, Table 5. Maine Department of Labor, Division of Economic Analysis and Research (Augusta, Maine: 1982) p. 16.

[2] U.S. Department of Commerce, Bureau of the Census. *1980 Census of Population and Housing: Provisional Estimates of Social, Economic, and Housing Characteristics.* (Washington D.C.: 1982) Table P-3, p. 27.

[3] Ibid., Table P-2, pp. 14-16.

[4] Multiple responses to this question were permitted.

[5] U.S. Department of Labor, Bureau of Labor Statistics. *News,* No. 82-255, July 20, 1982.

[6] Multiple responses to this question were permitted.

[7] From special tabulations of the U.S. Bureau of the Census, 1981 Current Population Survey data tapes for New England.

[8] *1980 Census,* Table P3-3, p. 27.

[9] U.S. Department of Labor, Bureau of Labor Statistics. *Employment and Earnings.* Vol. 29, No. 5, May 1982, p. 119.

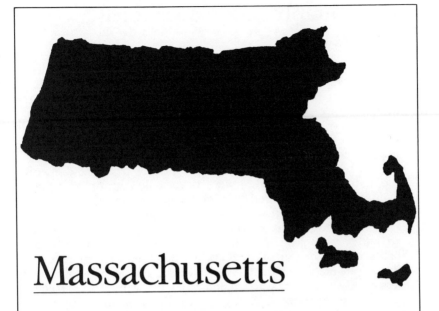

# Massachusetts

Artists in **Massachusetts** had a median age of 34.3 and were 52.3 percent female and 3.5 percent nonwhite.

They averaged 16.7 years of school. Almost 82 percent (81.9) had at least a bachelor's degree. In addition, 85.4 percent received specialized artistic training in school, and 74.4 percent received such training outside of school.

They worked 34.9 weeks as artists in 1980. In addition to their work as artists, 59.5 percent held jobs related to the arts for an average of 33.0 weeks and 39.6 percent held jobs not related to the arts for 33.5 weeks. Holding more than one job at a time was common. Nevertheless, 23.2 percent were unemployed and 26.8 percent dropped out of the labor force during the year.

They earned $13,150 in income from all sources in 1980. their household income (including earnings of other household members) was $22,938. However, the income they earned as artists was $4,552. In earning their artistic income, they incurred nonreimbursed costs of $3,504.

# Demographic and Educational Characteristics

Distribution of artists in Massachusetts who responded to the survey differed from that of the region with an overrepresentation of musicians, 30 percent more, and an underrepresentation of craft artists, 33 percent less. The largest difference was in the number of actors in Massachusetts. Proportionately there were 40 percent fewer actors in the state than there were regionwide. In both the state and the region, the visual artists were the largest group, accounting for more than one-third of the state's artists. Dancers were the smallest group of artists in Massachusetts as well as regionwide, though there was a slightly larger proportion of them in the state.

Massachusetts artists were slightly younger than the typical artist in New England. Their median age was about a year and one-half younger than artists regionwide, but they were more than three years older than the typical state resident.[1] There were more female artists than male artists, indicating that women were somewhat more represented among the artistic labor force than they were in the state's general labor force. They accounted for 45 percent of the general labor force in 1980.[2] Massachusetts artists were overwhelmingly white. The black artists were the largest minority group, followed by artists of Asian descent and native Americans. With 3 percent of the state's 1980 labor force black,[3] blacks were clearly underrepresented. The state's share of minority artists was comparable to regionwide distribution.

Massachusetts artists were as well educated as artists regionwide. They averaged 16.7 years of formal schooling (see Table 2). Almost 82 percent had at least a bachelor's degree with more than one-third holding master's degrees. In comparison, only 20 percent of the state's residents 25 or older had completed four or more years of college in 1980.[4] Relative to the general population, Massachusetts artists were clearly well educated.

There were variations in the amount of formal schooling received by the state's artists. In Massachusetts, the theater personnel averaged the most formal schooling, while regionwide the choreographers, composers, and playwrights had the most formal schooling. The writers and poets were the most likely to have graduate degrees. Well over half of them earned master's and doctoral degrees. This may mean there is a large proportion of teachers among these artists. Dancers in Massachusetts had the least formal schooling, which was also true regionwide, averaging almost one year less schooling than their peers in the region. They also were the largest group, 50 percent, without college degrees suggesting formal schooling may not be important to success in dance.

A large proportion of Massachusetts artists, fully 85 percent, participated in artistic training as part of their formal schooling. The dancers were the least likely to have done so, with only 60

# Massachusetts / Table 1

## Demographic Characteristics of the Artists

| | Percent by Occupation | Median Age | Percent Who Are: | | Percent Who Are: | | | | | Percent Who Are: |
| --- | --- | --- | --- | --- | --- | --- | --- | --- | --- | --- |
| | | | Male | Female | Amer. Indian | Asian | Black | White | Other | Hispanic |
| **All Artists** | 100.0% (n = 1,281) | 34.3 | 47.7% | 52.3% | 0.6% | 1.0% | 1.4% | 96.5% | 0.5% | 1.6% |
| **By Occupation:** | | | | | | | | | | |
| Dancers | 1.8 | 30.8 | 34.8 | 65.2 | 0.0 | 0.0 | 9.1 | 90.9 | 0.0 | 5.3 |
| Musicians | 20.3 | 34.4 | 63.5 | 36.5 | 0.0 | 0.4 | 0.4 | 98.8 | 0.4 | 0.8 |
| Actors | 2.1 | 27.0 | 50.0 | 50.0 | 0.0 | 0.0 | 3.8 | 96.2 | 0.0 | 3.9 |
| Theater Production Personnel | 4.1 | 32.1 | 49.0 | 51.0 | 0.0 | 0.0 | 4.1 | 93.9 | 2.0 | 2.0 |
| Writers and Poets | 4.2 | 36.8 | 45.0 | 55.0 | 0.0 | 1.5 | 0.7 | 97.8 | 0.0 | 0.0 |
| Choreographers, Composers, and Playwrights | 3.1 | 34.0 | 53.9 | 46.1 | 0.0 | 2.7 | 2.7 | 94.6 | 0.0 | 2.7 |
| Visual Artists | 35.0 | 35.5 | 41.9 | 58.1 | 1.4 | 1.2 | 1.9 | 94.9 | 0.7 | 1.7 |
| Media Artists | 8.9 | 31.7 | 64.0 | 36.0 | 0.0 | 1.8 | 0.9 | 97.3 | 0.0 | 0.9 |
| Craft Artists | 13.4 | 34.2 | 30.1 | 69.9 | 1.2 | 0.6 | 0.0 | 98.2 | 0.0 | 2.6 |

# Massachusetts / Table 2

## Educational Attainment of Artists

| | Median Years of Schooling | Percent with Highest Attainment of: | | | | | | | Percent with Specialized Arts Training: | |
| --- | --- | --- | --- | --- | --- | --- | --- | --- | --- | --- |
| | | Less than High School | High School Diploma | Associate's | Bachelor's | Master's | Doctorate | Other | As Part of Formal Education | Outside of Formal Education |
| **All Artists** | 16.7 | 0.7% | 13.4% | 3.3% | 41.4% | 36.0% | 4.5% | 0.7 | 85.4% | 74.4% |
| **By Occupation:** | | | | | | | | | | |
| Dancers | 15.3 | 0.0 | 50.0 | 4.5 | 22.7 | 22.7 | 0.0 | 0.0 | 59.1 | 95.5 |
| Musicians | 17.1 | 0.8 | 12.4 | 1.2 | 41.2 | 39.2 | 4.8 | 0.4 | 90.5 | 78.5 |
| Actors | 16.1 | 0.0 | 15.4 | 3.8 | 61.5 | 19.2 | 0.0 | 0.0 | 87.5 | 88.0 |
| Theater Production Personnel | 17.7 | 0.0 | 7.8 | 2.0 | 41.2 | 43.1 | 5.9 | 0.0 | 96.0 | 73.5 |
| Writers and Poets | 17.5 | 1.4 | 9.3 | 2.1 | 30.7 | 40.0 | 16.4 | 0.0 | 72.6 | 71.2 |
| Choreographers, Composers, and Playwrights | 16.6 | 0.0 | 15.8 | 5.3 | 34.2 | 28.9 | 13.2 | 2.6 | 97.4 | 87.2 |
| Visual Artists | 16.8 | 0.7 | 9.2 | 4.6 | 43.6 | 38.8 | 1.6 | 1.4 | 91.2 | 71.8 |
| Media Artists | 16.1 | 0.0 | 20.7 | 3.6 | 43.2 | 28.8 | 2.7 | 0.9 | 77.8 | 68.5 |
| Craft Artists | 16.3 | 1.2 | 20.5 | 3.6 | 45.8 | 27.7 | 1.2 | 0.0 | 74.8 | 71.3 |

percent participating, while the choreographers, composers, and playwrights were the most likely, with more than 97 percent participation. Almost half the artists who attended high school received some artistic training as part of their schooling. More than 11 percent received it while attending a special arts high school. Two-thirds of the artists who attended college majored in their art, with almost 46 percent doing so while attending an art school. Only 19 percent of the artists with college degrees did not take any art course as part of their undergraduate education. In Massachusetts two-thirds of the artists with graduate educations majored in their art with 53 percent of this training occurring at art schools.

Almost three-quarters of the state's artists participated in artistic training outside the formal schooling environment. This was essentially the same as the regionwide participation level. This training was typically started when the artist was between 14 and 15 years old. The musicians and dancers in the state typically started their training at much younger ages, a little over 9 and 12 years old respectively. The dancers were also the most likely group of artists to participate in this type of training while the media artists were the least likely.

In Massachusetts almost 44 percent of the artists who participated in artistic training outside formal school did so during 1980. These people typically spent almost 20 weeks during the year for an average of 11 hours per week in their artistic training, and on average spent $555 for it.

# Labor Market Characteristics

The overwhelming majority of Massachusetts artists, as well as artists throughout New England, found it necessary to work at jobs other than their artistic occupations. Only 18 percent of the artists in the state worked at nothing but their art while regionwide almost 25 percent of the artists were "pure" artists. Almost 60 percent of the artists in the state worked at jobs related to their art, such as teaching, at some time during 1980. Approximately 40 percent of the artists held a job unrelated to their art, such as working as a secretary, while 16 percent held both arts-related jobs and nonarts-related jobs at some time during 1980. In some cases these jobs were held simultaneously.

The distribution of the state's artists among the arts-related occupations, presented in Table 3, was very similar to the regionwide distribution. The most common arts-related job held was in arts education. Although three-quarters were teachers, Massachusetts artists were slightly less likely to teach their art than their counterparts regionwide. The next most popular arts-related job was arts management, including work as a management consultant. The remainder of the artists with arts-related jobs simply held a job, such as clerical or service, in an arts enterprise like a museum or arts supply store.

## Distribution of Other Jobs Held by Artists

| Occupation | Job Type Distribution: Arts-Related | Nonarts-Related |
|---|---|---|
| Professional and Technical | 6.5% | 20.1% |
| Art Educators | 75.7 | 0.0 |
| Other Educators | 0.4 | 11.5 |
| Art Managerial | 9.4 | 0.0 |
| Other Managerial | 2.2 | 9.8 |
| Sales | 1.9 | 8.6 |
| Clerical | 0.7 | 17.2 |
| *Craft and Kindred Workers | 2.7 | 11.5 |
| Operatives and Laborers | 0.3 | 4.6 |
| Service | 0.1 | 17.2 |

*The word "craft" is not used here in the same sense it is used in the text. It is a U.S. Census term that includes various blue collar workers such as carpenters, mechanics, printers, plumbers, and telephone installers.

The most frequently held nonarts-related jobs were those in the professional and technical occupations. One-fifth of the artists in the state and New England who held nonarts-related jobs worked as professionals or technicians. Next in popularity were the clerical and service occupations, each accounting for more than 17 percent of this type of job. Massachusetts artists were 28 percent more likely to work at these types of jobs than artists regionwide. This may simply be a reflection of greater employment opportunities in clerical and service jobs in the state than in other states, along with fewer opportunities in other nonarts-related occupations. Nonarts teaching and working in building trades occupations, such as carpentry and masonry, were the next most popular jobs. The nonarts teaching occupations were somewhat underrepresented among the state artists relative to the region, while the building trade occupations were over-represented. The remaining nonarts-related occupations, managerial, sales, operative and laborers, were less popular among the Massachusetts artists than they were in the region.

Massachusetts artists generally did not prefer to work at jobs other than their arts. Only 3.4 percent of the artists who worked outside their art indicated they did so because they preferred it, but the vast majority, more than 65 percent of the artists, cited that better pay was why they worked other jobs. More than half of these artists also indicated they held either an arts-related or nonarts-related job because it provided greater job security than working as an artist.[5] An equal proportion cited that there was not enough work available as an artist as another reason for working at jobs other than their art. Despite this reticence, almost 40 percent of the artists who worked outside their art felt their other work complemented their artistic work.

This description of what type of jobs artists held offers only a partial view of the artists' economic circumstances. More information is revealed when we look at the amount of time artists spend working. The artists "work-time" was examined in two ways: by the number of weeks worked overall and as an artist and by the number of hours they worked per week solely as artists. (The number of hours spent working on other jobs was not included on the survey.)

Within the state, theater production personnel worked the most overall, 47.6 weeks, while actors worked the least, 42.0 weeks. (See Table 4.) Regionally this was somewhat different: visual artists worked the largest portion of the year and actors the smallest. Greater variation existed in the number of weeks of art work among artistic occupations. Visual artists spent the most weeks working at their art, 40 weeks. This was 78 percent longer than choreographers, composers, and playwrights. In comparison to the region, Massachusetts artists worked 5 percent fewer weeks at their art work. At the same time, they spent 15 percent more weeks working at arts-related jobs and 11 percent more weeks working at nonarts-related jobs. Massachusetts choreographers, composers, and playwrights averaged more

weeks of work in arts-related jobs than any of the other state artists. Writers and poets, on the average, spent the largest portion of the year working at jobs unrelated to their art. These differences may reflect the kind of employment, both artistic and nonartistic, that was available to artists in Massachusetts.

The artists' work time was also separated into hours worked per week. Massachusetts artists averaged almost half an hour less a week during 1980 than artists regionwide in 1981. (See Table 5). Theater production personnel spent more time than any other state artist working at their art and spent 9 percent more time per week than their regional counterparts. Choreographers, composers, and playwrights in Massachusetts spent 13 percent more time per week than their colleagues throughout the region. Writers and poets in the state averaged the fewest hours per week producing their art and spent 7 percent less time than writers and poets throughout New England.

These statistics suggest that artists in Massachusetts, as in the region, must have held more than one job at a time. Artists averaged 46 weeks of work a year, but if the number of weeks for each type of job are added together, the total is much larger — 67.9 weeks. This is not only 21 more weeks than the overall total, but it is more weeks than are in a year. When limited only to those artists who held arts-related jobs and nonarts-related jobs, the evidence was even stronger. Some of this work, therefore, must have occurred simultaneously, probably much of it part-time. An artist could, for example, have worked as an artist and as a teacher.

Besides breaking down the amount of time artists worked into weeks and hours, work time was also broken down by sex. It was found that in Massachusetts and throughout the region, men artists worked significantly more weeks overall than women artists. Men averaged 47.4 weeks while women averaged 44.7 weeks. Most of the difference was the result of male artists working significantly more weeks as artists, 37.0, than female artists, 32.8 weeks. Men also worked more weeks in arts-related and nonarts-related work than women, 20.5 weeks to 19.5 weeks and 13.3 weeks to 13.1 weeks respectively.

Women artists in Massachusetts not only worked fewer weeks during 1980 than their male peers, but they also worked significantly fewer hours as artists during a typical week. Women artists averaged 31.1 hours per week working in their art while men averaged 33.6 hours. The largest differential was almost 12 hours between actors and actresses. Several groups of women artists averaged more hours working in their art than their male counterparts: theater production personnel (45.5 hours to 43.8 hours), writers and poets (25.0 hours to 24.4 hours), choreographers, composers, and playwrights (26.7 hours to 26.0 hours), and media artists (40.2 hours to 30.8 hours). Men and women dancers worked essentially the same amount of time in a typical week.

Why men artists worked more than women artists is not

110.

# Massachusetts / Table 4

## Weeks Employed In 1980

| | Overall | As An Artist | In Arts-Related Jobs* | In Nonarts-Related Jobs* |
|---|---|---|---|---|
| **All Artists** | 46.0 | 34.9 | 19.9 (33.0) | 13.1 (33.5) |
| **By Occupation:** | | | | |
| Dancers | 43.5 | 32.0 | 19.3 (37.5) | 10.5 (31.6) |
| Musicians | 45.7 | 32.9 | 27.6 (37.9) | 10.6 (33.3) |
| Actors | 42.0 | 28.6 | 17.3 (28.9) | 16.6 (28.8) |
| Theater Production Personnel | 47.6 | 33.5 | 28.0 (39.5) | 10.1 (32.9) |
| Writers and Poets | 45.0 | 28.5 | 16.2 (31.5) | 19.5 (36.8) |
| Choreographers, Composers, and Playwrights | 45.8 | 22.5 | 30.9 (36.4) | 8.3 (35.9) |
| **Visual Artists** | 47.1 | 40.0 | 17.4 (31.0) | 13.3 (33.8) |
| **Media Artists** | 43.9 | 33.8 | 16.8 (28.7) | 16.0 (34.8) |
| **Craft Artists** | 46.2 | 37.5 | 12.6 (27.3) | 11.2 (29.7) |

*Numbers in parentheses are weeks worked in arts-related and nonarts-related jobs for only those artists who held such jobs.

The sum of the weeks worked exceeds the overall total if artists held two or more jobs at the same time.

clear. Nevertheless, some of the reason can be found in the fact that almost 30 percent of Massachusetts artists left the labor force some time during 1980. These artists were neither working nor out of work and looking for a job. The most prevalent reason given for this exodus was family obligations, such as child rearing. Even in Massachusetts, which is a very liberal state that has a female labor force participation rate higher than the national average, family obligations may have affected women more than men artists.[6]

Many Massachusetts artists were not employed for a full year. During 1980 more than 23 percent experienced some unemployment (a period when the artist was not employed but was looking for work). This was a slightly higher proportion than regionwide. Dancers were much more likely to have experienced some unemployment during the year than any of the other artists in the state. Almost 73 percent of the dancers experienced some unemployment. In comparison only 38 percent of the actors were ever unemployed during 1980, the artists next most likely to have been unemployed. The craft artists were the least likely to have been unemployed, with only 14 percent unemployment. The visual artists were the next with 18 percent unemployment. Since most of the craft artists and visual artists were self-employed, rather than having worked for an employer, this is not surprising. The artists who experienced some unemployment averaged 11.3 weeks out of work spaced out over an average of two unemployed periods, and 27 percent of them received unemployment compensation.

An even larger percentage of the state's artists, almost 27 percent, experienced at least one period during 1980 when they were out of the labor force (unemployed and not seeking employment). The actors were the most likely to have been out of the labor force at some time, with 38 percent experiencing such a period. The reason most frequently cited by artists for having left the labor force was to practice their art. Almost 46 percent cited this reason, while 29 percent indicated family obligations forced them to leave. [7] The other reasons cited, in order of decreasing frequency, were illness, school, and the belief that no work was available, so they did not even look.

With Massachusetts artists accounting for more than 42 percent of the region's artists, it was not surprising that the differences between them and artists throughout New England were generally small and few. Those differences that do exist are generally attributed to Massachusetts having a greater concentration of certain artists, such as dancers and musicians, and a smaller concentration of others, such as craft artists. This is likely to be a reflection of the differences in job opportunities present in Boston, a center for certain artistic activities. The effect this had on artists' incomes will be examined in the following section.

## Massachusetts / Table 5

## Hours Working as an Artist in a Typical Week in 1981

| | Total | Performing Artists: | | | Nonperforming Artists: | | | |
| --- | --- | --- | --- | --- | --- | --- | --- | --- |
| | | Performing | Rehearsing | Practicing | Looking for Work | Creating | Training | Marketing |
| **All Artists** | 32.4 | - | - | - | - | - | - | - |
| **By Occupation:** | | | | | | | | |
| Dancers | 30.9 | 5.5 | 14.6 | 8.0 | 1.3 | - | - | - |
| Musicians | 28.1 | 7.9 | 6.3 | 11.7 | 1.2 | - | - | - |
| Actors | 41.5 | 15.9 | 15.7 | 5.1 | 4.3 | - | - | - |
| Theater Production Personnel | 44.7 | 7.8 | 13.7 | 10.5 | 2.7 | - | - | - |
| Writers and Poets | 24.7 | | | | | 20.3 | 1.1 | 2.9 |
| Choreographers, Composers, and Playwrights | 26.3 | | | | | 13.9 | 0.8 | 3.2 |
| Visual Artists | 34.0 | | | | | 28.1 | 1.4 | 4.5 |
| Media Artists | 33.9 | | | | | 24.6 | 2.7 | 6.9 |
| Craft Artists | 37.5 | | | | | 29.6 | 1.0 | 6.8 |

# Income

Massachusetts artists' income came from several sources. They earned money from working as artists, working at arts-related jobs, and working at nonarts-related jobs. They received nonlabor income from returns on investments, interest, dividends, and transfer payments, such as social security, unemployment compensation, and public assistance. Artists also received labor-derived in-kind income through bartering goods or services they produced for something they needed or wanted, such as medical care, art supplies, and art lessons. Table 6 provides information on average 1980 income received by Massachusetts artists from all sources (median values are in the parentheses). The income information for the state differed from that for the region and the individual states since it was a year older and did not reflect the influence of an additional year's inflation. It also reflected different economic conditions that may well have created a different employment climate. Unemployment in the state was lower in 1980 than 1981, and the market conditions for artists' products was better.[8]

Massachusetts artists had an average household income of almost $23,000 for 1980. Even when adjusted for inflation this was below the average for the region. The 1980 average income for all Massachusetts households was $21,905.[9] It appears then that the artists belong to households with incomes near the average for all the households in the state.

The majority of Massachusetts artists (65 percent) were members of households where they shared their income or living expenses with another person. In only 12 percent of these households, the artist was the only one generating income. Almost 66 percent of the households had other members who worked full-time, at least 35 hours per week. An additional 22 percent of the households had other members who worked part-time, less than 35 hours per week. Thirty-one percent of all the families in Massachusetts had two or more workers in 1979.[10] For most of the artists these additional workers apparently provided a necessary source of income to support their artistic work.

There was relatively little variation in artists 1980 household income. Writers' and poets' households had the highest income, approximately $25,000, followed by musicians, choreographers, composers, and playwrights who received $1,000less. The visual and craft artists came from households with income averaging $23,000, while the remainder of the artists' households had income averaging approximately $19,000. In the region, household incomes ranged from less than $22,000 for dancers to almost $33,000 for actors.

In Massachusetts, the average artist was responsible for 57 percent of his or her household's income, the same as region-wide. The average theater production artist was responsible for the largest proportion of his or her household income, almost 75 percent, while the average musician was responsible for the

# Massachusetts / Table 6

## Income and Artistic Costs in 1980

| | Total Household Income | Artist's Income: Total* | As Artist | In Arts-Related Work | In Nonarts-Related Work | Nonlabor | Value of Art Work Bartered | Total Artistic Costs |
|---|---|---|---|---|---|---|---|---|
| **All Artists** | $ 22,938 (20,000) | $ 13,150 (10,000) | $4,552 | $4,725 | $2,706 | $1,208 | $178 | $3,504 |
| **By Occupation:** | | | | | | | | |
| Dancers | 18,554 (14,000) | 11,150 (11,006) | 6,902 | 1,271 | 2,788 | 190 | 69 | 2,502 |
| Musicians | 24,109 (20,000) | 15,726 (13,000) | 6,668 | 5,827 | 2,289 | 1,015 | 62 | 2,978 |
| Actors | 19,050 (12,020) | 9,798 (6,540) | 5,810 | 1,484 | 1,464 | 1,040 | 185 | 1,711 |
| Theater Production Personnel | 20,372 (17,988) | 14,975 (12,005) | 8,117 | 5,444 | 1,360 | 331 | 315 | 2,977 |
| Writers and Poets | 24,915 (20,008) | 13,087 (10,000) | 2,106 | 4,537 | 4,509 | 1,905 | 132 | 1,631 |
| Choreographers, Composers, and Playwrights | 24,144 (20,026) | 15,455 (14,740) | 2,770 | 9,989 | 2,351 | 345 | 28 | 1,164 |
| Visual Artists | 22,901 (19,938) | 11,845 (9,000) | 3,539 | 4,565 | 2,561 | 1,217 | 184 | 4,117 |
| Media Artists | 19,866 (17,988) | 13,246 (10,004) | 3,767 | 3,362 | 3,870 | 2,248 | 299 | 4,096 |
| Craft Artists | 23,053 (19,000) | 11,446 (18,000) | 5,657 | 2,896 | 2,003 | 1,012 | 321 | 5,338 |

*Components of total artist's income may not add exactly to total because of nonresponses to question requesting breakdown of total income.

largest dollar amount, almost $16,000. Craft artists contributed the smallest proportion, only 50 percent, of their household income, while the smallest dollar contribution came from the actors. The actors' total income of almost $9,800 was less than half the income received by actors regionally even after adjusting for inflation.

In Massachusetts the largest source of the average artist's income was his or her earnings from arts-related work. This work accounted for 36 percent of his or her total income. Throughout New England the average artist earned 35 percent more from his or her artistic work than from arts-related work. For some of the artists in Massachusetts, the major source of their income was their art work. It accounted for 62 percent of the dancers' income, almost 60 percent of the actors' income, and 54 percent of the theater production personnel's income. Artistic earnings comprised less than half of a craft artist's income (49 percent) and a musician's income (42 percent), but it was still their largest source. For writers and poets, visual artists, and choreographers, composers, and playwrights, arts-related earnings was the largest source of their income.

Although nonarts-related earnings contributed only 21 percent to the average artist's total income, this source was very important. It was the largest source of income for media artists, accounting for a 29 percent share. The average writer and poet also earned more from his or her nonarts-related work than he or she earned from artistic work.

Nonlabor income constituted only 9 percent of the average Massachusetts artist's income. This was a smaller proportion and a smaller dollar amount than regionwide. Nonlabor income was most important for the media artists in the state. They received $1,217 from nonlabor sources, which was 17 percent of their total earnings. Nonlabor income had the least value in dollars and in relative terms for the dancers, $190 and 2 percent. A major source of nonlabor income was social security. The artists who benefited most from this source of income were obviously the older artists.

Massachusetts artists also received less in-kind income from bartering, $178, than artists throughout New England, even when adjusted for inflation. The craft artists in the state and the region were the most successful in bartering for goods and services. Massachusetts craft artists were actually more successful than their colleagues regionally. The least successful in the state were the choreographers, composers, and playwrights, averaging less than 10 percent of what the craft artists received. Although some artists felt bartering was an important part of their economic survival, the evidence for Massachusetts is that for the average artist it had very little value.

In 1980, Massachusetts artists incurred costs related to creating their art that averaged $3,500 or more than 75 percent of their artistic earnings. In inflation adjusted dollars this was almost $300 more than what the average artists spent regionally in unreimbursed artistic expenses. The average artist in the state earned

## Massachusetts / Table 7

### Average 1981 Income by Demographics

| | Total Household Income | Artists' Income: | | | | |
|---|---|---|---|---|---|---|
| | | Total | Arts | Arts Related | Nonarts Related | Nonlabor |
| **Sex:** Female | $22,792 | $ 9,732 | $2,654 | $ 3,911 | $2,051 | $1,148 |
| Male | 22,989 | 16,745 | 6,456 | 5,599 | 3,410 | 1,278 |
| **Race:** White | 22,803 | 12,968 | 4,367 | 4,698 | 2,682 | 1,250 |
| Nonwhite | 26,171 | 16,728 | 6,790 | 7,209 | 2,388 | 340 |
| **Age:** 20-29 | 14,494 | 8,821 | 3,068 | 2,649 | 2,786 | 319 |
| 30-39 | 21,352 | 12,102 | 4,240 | 4,260 | 2,906 | 777 |
| 40-49 | 31,119 | 17,395 | 6,301 | 6,712 | 2,447 | 1,888 |
| 50-59 | 33,785 | 18,766 | 5,513 | 8,536 | 2,620 | 2,097 |
| 60-69 | 25,906 | 16,852 | 6,140 | 5,030 | 2,514 | 3,467 |
| 70+ | 25,680 | 13,196 | 3,659 | 1,719 | 517 | 7,300 |
| **Education: Degree:** | | | | | | |
| High School | 19,368 | 11,085 | 5,512 | 1,595 | 2,976 | 1,081 |
| Associate's | 19,544 | 11,096 | 4,820 | 1,602 | 4,116 | 782 |
| Bachelor's | 22,094 | 11,326 | 4,448 | 3,200 | 2,295 | 1,346 |
| Master's | 24,709 | 14,812 | 4,129 | 7,068 | 2,563 | 1,137 |
| Doctorate | 31,466 | 23,718 | 5,991 | 10,423 | 6,078 | 1,225 |

barely $1,000 more from his or her art than he or she spent producing it. The majority of the artists, 58 percent, spent more producing their art than they earned from it. Not surprisingly the craft artists spent the most, but they were "lucky" because on average they earned $300 more than they spent. Neither the average visual artist nor media artist, who spent more than $4,000, was as fortunate. The most successful of the artists in terms of net income (the difference between average artistic earnings and costs) were the theater production personnel. Most of the artists in Massachusetts were clearly using other resources, such as nonarts earnings or the earnings of other household members, to support their artistic endeavors.

Table 7 shows income differences that are related to sex, age, and educational background of the artists. One of the most interesting is the difference in the earning power between men artists and women artists. Women artists in Massachusetts received less income from all sources than men artists. Though not statistically significant, women's total household income was $200 less than it was for men artists, $22,790 versus $22,990. The average female artist received 58 percent of the average male artist's total income, $9,732 versus $16,745. For all the artists the difference in earnings between men and women was significant. The $3,800 difference in artistic earnings ($6,456 for the male artists and $2,654 for the female artists) explains a great deal of this overall difference. There were also differences of almost $1,700 in earnings from arts-related work, and a difference of $1,359 in earnings for nonarts-related work. The men artists also received slightly more nonlabor income, $1,278 versus $1,148.

The advantage in income for men did not hold true for all the artistic occupations. Male dancers earned more overall, but female dancers earned more from dancing, $8,048 versus $4,895, and more from arts-related work, $1,919 versus $137. Only the arts-related income difference was statistically significant. Actresses earned more from arts-related work, $2,051 versus $917, and nonarts-related work, $1,763 versus $1,164, but neither difference was significant statistically. Female theater production personnel earned a little more from nonarts-related work, $1,864 to $878, and received more nonlabor income, $602 to $71, than did their male counterparts. Women writers and poets received significantly more nonlabor income, $3,118 versue $613. Women media artists earned a fraction more from their art, $3,907 versus $3,689, and a little more from arts-related work, $3,397 versus $3,343, than men media artists. Female craft artists earned slightly more arts-related income, $3,090 versus $2,567, than males.

The income differences between men and women were influenced by a number of factors, many beyond the scope of this study. But there were at least two factors, related to the amount of time spent working, that help explain the discrepancy. One was that men worked significantly more weeks in 1980 over-

all and significantly more weeks as artists. (They worked more at arts-related and nonarts-related jobs too, but the differences were small.) The other is that women artists in Massachusetts worked many fewer hours in a typical week at their art than did men. The 6 percent difference in total weeks worked and the 7 percent difference in hours spent per week working at their art, however, cannot fully explain the large differential between male income and female income.

But an examination of the estimated hourly wage rate can help further explain this income difference. The average artistic hourly wage for Massachusetts artists (the only one estimable from the information available) was $4.63 in 1980 compared to a 1981 regionwide wage of $6.08 per hour. The average wage for production workers in the state for 1980 was $6.12, or 41 percent higher than the artists' wage.[11] Massachusetts men artists averaged $6.42 per hour for their artistic work while the women artists averaged $2.83 per hour. In all the artistic occupations the men artists earned higher wages than the women artists. The greatest difference was between the men and women theater production personnel, $13.69 versus $2.41, and the smallest difference was between the men and women media artists, $3.50 versus $2.94. When artistic costs are taken into account, the net wage for all the artists becomes $−0.69 per hour. This means that the average artist loses 69 cents for every hour he or she works in his or her art. The average male artist's net wage was $1.53, and the average female artist's was $−4.15.

Massachusetts artists' income also varied with their age. The artist's average total household income and his or her average individual income increased with age, peaking between the ages of 50 to 59 and then declining. The average total income for artists' households in Massachusetts was almost $14,500 for artists 20 to 29 years old, almost $33,800 for 50 to 59 year old artists, and $25,700 for the oldest artists, 70 years and older. Total individual income for the youngest artists averaged almost $8,900, while peak income was almost $18,800 for artists 50 to 59 and $13,200 for the oldest artist.

There really was no clear pattern for artistic earnings alone. The youngest artists earned $3,080, less than half of the earnings of artists 40 to 49 years old who earned $6,300 peak earnings for artistic work. Artists 60 to 69 earned more than $6,100; artists 50 to 59 earned more than $5,500; and the oldest artists earned almost $3,700. Arts-related earnings also followed a peak pattern. The youngest group of artists earned almost $2,700; artists 50 to 59 earned the most, $8,500, and the oldest artists averaged the least with more than $1,700.

Except for the oldest artists who earned less than $900, there was very little variation in nonarts-related earnings. Artists 40 to 49 earned a little more than $2,400, while the artists 30 to 39 earned slightly more than $2,900. Since nonlabor income includes social security and other age-related transfer payments, it is not surprising that nonlabor income increased dramatically

with an artist's age. The youngest artists received only $320 while the oldest artists received $7,300.

As discussed above, artists in Massachusetts and in the region were very well educated relative to the statewide labor force. But it is not clear whether additional formal schooling translates into additional income for the artists as it does for most workers. Total income for the artist did increase with additional formal schooling. This relationship was significant although the increase in income was small. Additional schooling has the greatest effect on arts-related earnings, reflecting the importance of formal schooling on earnings from teaching. Nonarts-related earnings also tend to increase with additional schooling, but the relationship is weak. There is a slight but important relationship between artistic earnings and formal schooling. Ironically this relationship was a negative one: the more formal schooling an artist had the less earnings he or she received from working as an artist. This may simply reflect artists' substituting more lucrative activities, such as working at arts-related jobs for artistic activities as they receive more schooling. Nonlabor income was also negatively related to formal schooling but only weakly.

These same relationships generally held true when comparing income to the highest degree earned by the artists. An artist's total household income increased with each additional degree, from almost $19,300 for artists who did not even complete high school to almost $31,500 for artists with doctorates. The same pattern generally held for the artist's total income though the variation was not as large. Artists who did not complete high school averaged more than $10,800; artists with bachelor's degrees averaged more than $11,300 — only a $500 difference. The difference between artists with bachelor's and master's degrees was almost $3,500 and between artists with master's degrees and doctoral degrees was almost $9,000. Artistic earnings declined by almost 40 percent as the artists obtained additional degrees. Artists without high school diplomas earned almost $10,000 from their art, while artists with doctorate degrees earned almost $6,000.

Arts-related earnings, on the other hand, increased dramatically with each additional degree. Artists without high school degrees had no arts-related earnings. High school graduates had almost $1,700, with artists holding doctoral degrees earning more than $10,400 from arts-related activities. Nonarts-related earnings followed an unusual pattern. Artists without high school degrees earned slightly more than $800; artists with two-year associate's degrees earned approximately $4,100; artists with bachelor's degrees earned $2,300; and artists with doctorates earned almost $6,100 from nonarts-related work. Except for artists without high school degrees, who received only $90 in nonlabor income, there was relatively little difference by degree in nonlabor income received by Massachusetts artists. Artists with associate's degrees received roughly $780, while the artists with bachelor's degrees received almost $1,350 in nonlabor income.

# Massachusetts— Endnotes

[1]Department of Commerce, Bureau of the Census. *1980 Census of Population and Housing: Provisional Estimates of Social, Economic, and Housing Characteristics.* (Washington, D.C.: 1982), Table P-1, p. 5.

[2]Ibid., Table P-3, p. 27.

[3]Ibid., Table P-2, pp. 14-16.

[4]Multiple responses to this question were permitted.

[5]U.S. Department of Labor, Bureau of Labor Statistics. *News*, No. 82-255, July 20, 1982.

[6]Multiple responses to this question were permitted.

[7]*1980 Census.* Table P-4, p. 38.

[8]Ibid., Table P3-3, p. 27.

[9]From special tabulations of the U.S. Bureau of the Census, 1981 Current Population Survey data tapes for New England.

[10]U.S. Department of Labor, Bureau of Labor Statistics. *Employment and Earnings.* Vol. 29, No. 5, May 1982, p. 121.

[11]Ibid., p. 119.

# New Hampshire

Artists in **New Hampshire** had a median age of 38.8 and were 55.1 percent female and 1.7 percent nonwhite.

They averaged 16.4 years of school. Almost 80 percent (78.9) had at least a bachelor's degree. In addition, 81.4 percent received specialized artistic training in school, and 76.2 percent received such training outside of school.

They worked 38.0 weeks as artists in 1981. In addition to their work as artists, 53.4 percent held jobs related to their art for an average of 29.7 weeks and 33.3 percent held jobs not related to their art for 27.8 weeks. Holding more than one job at a time was common. Nevertheless, 19.0 percent were unemployed and 30.0 percent dropped out of the labor force during the year.

They earned $13,706 in income from all sources in 1981. Their household income (including earnings of other household members) was $24,795. However, the income they earned as artists was $6,948. In earning their artistic income, they incurred nonreimbursed costs of $3,942.

# Demographic and Educational Characteristics

The distribution of artistic occupations in New Hampshire differed from the regional distribution. The largest group of artists in the state was craft artists (see Table 1), accounting for more than 37 percent of New Hampshire artists. This was almost twice the regional percentage. With the exception of actors and theater production personnel, all the other artistic occupations were underrepresented in the state compared with the region. New Hampshire, for some inexplicable reason, had slightly more actors and theater production personnel than the region. The largest differences between the state and the region existed in the percentage of dancers, 73 percent less, musical performers, 41 percent less, and visual artists, 26 percent less. An explanation for the first two occupations may be the relative lack of job opportunities within the state or reasonably close by. The reason for the relative shortage of visual artists cannot be as easily explained.

The average New Hampshire artist was almost 39 years old. This is somewhat older than the average artist regionwide who was almost 36 years old and considerably older than the average New Hampshire resident who was about 30 years old.[1] The actors were typically the oldest and media artists were the youngest. There were more women working in the state as artists than men, similar to what was found in the region. In comparison, the state labor force was comprised of 57 percent men and 43 percent women in 1980.[2] Essentially all artists were white with a few American Indians and blacks. There was an underrepresentation of minority artists in New Hampshire relative to New England, though the percentage of American Indians was almost twice that of the region.

The artists in New Hampshire averaged 16.4 years of formal schooling (see Table 2), and were not quite as well educated as artists regionally. Almost 79 percent of them had earned at least a bachelor's degree, which was slightly less than the proportion throughout New England. Only 18 percent of the New Hampshire population, 25 years old or older, had completed four or more years of college[3], so clearly the artists were better educated than the general population.

Not all New Hampshire artists had the same amount of formal schooling. Choreographers, composers, and playwrights had the most schooling in the state and the region. They averaged 19 years of formal schooling in New Hampshire. Not surprisingly, this group also had the largest proportion with degrees beyond the bachelor's, more than 83 percent. The actors in the state, as well as regionwide, had the least amount of formal schooling. They were the most likely to have received bachelor's degrees, and, along with the craft artists, they were the least likely to have earned graduate degrees. This may be a reflection of the

# New Hampshire / Table 1

## Demographic Characteristics of the Artists

| | Percent by Occupation | Median Age | Percent Who Are: | | Percent Who Are: | | | | | Percent Who Are: |
| --- | --- | --- | --- | --- | --- | --- | --- | --- | --- | --- |
| | | | Male | Female | Amer. Indian | Asian | Black* | White | Other | Hispanic |
| All Artists | 100.0% (n = 234) | 38.8 | 44.9% | 55.1% | 1.3% | 0.0% | 0.4% | 98.3% | 0.0% | 1.8% |
| **By Occupation:** | | | | | | | | | | |
| Dancers | 0.4 | IS | IS | IS | IS | IS | IS | IS | IS | IS |
| Musicians | 9.2 | 36.0 | 52.4 | 47.6 | 0.0 | 0.0 | 0.0 | 100.0 | 0.0 | 0.0 |
| Actors | 3.9 | 45.0 | 44.4 | 55.6 | 0.0 | 0.0 | 0.0 | 100.0 | 0.0 | 0.0 |
| Theater Production Personnel | 4.4 | 39.5 | 80.0 | 20.0 | 0.0 | 0.0 | 0.0 | 100.0 | 0.0 | 0.0 |
| Writers and Poets | 11.4 | 40.5 | 30.8 | 69.2 | 0.0 | 0.0 | 0.0 | 100.0 | 0.0 | 0.0 |
| Choreographers, Composers, and Playwrights | 2.6 | 43.5 | 33.3 | 66.7 | 0.0 | 0.0 | 0.0 | 100.0 | 0.0 | 0.0 |
| Visual Artists | 24.6 | 41.6 | 44.6 | 55.4 | 0.0 | 0.0 | 0.0 | 100.0 | 0.0 | 0.0 |
| Media Artists | 6.1 | 35.5 | 71.4 | 28.6 | 0.0 | 0.0 | 0.0 | 100.0 | 0.0 | 0.0 |
| Craft Artists | 37.3 | 36.8 | 42.4 | 57.6 | 3.6 | 0.0 | 0.0 | 96.4 | 0.0 | 3.8 |

IS = insufficient sample    *Artistic occupation unknown.

relative lack of importance of a college degree to actors and craft artists for employment opportunities.

A larger percentage of New Hampshire artists had specialized artistic training outside formal schooling than artists region-wide, 76.2 percent as opposed to 74.6 percent. The average age for starting this training was 16.3. Musicians, and probably dancers (the number of dancers was too small to make an accurate estimate), started their training at a much younger age; 8.8 years old was the average. Actors, musicians, and media artists were much more likely to have this type of training, with more than 85 percent of them having participated. During 1981, 40 percent of the artists in New Hampshire took some kind of artistic training. This training ran for an average period of 8 weeks with 16 hours per week spent in classes at an average cost of $402.

More than 80 percent of New Hampshire artists received artistic training as part of their formal educational programs. Almost 40 percent received some artistic training in high school, with 8 percent having attended a special arts high school. Fifty-three percent of the artists who attended college majored in their field of art. More than one-third of these artists attended an art school. A relatively small percentage of the artists (23 percent) did not take art courses as part of their undergraduate education. Of these artists who attended graduate school, 60 percent majored in their art form, with 37 percent of the artists attending art schools. Fully one-third of the artists did not receive any artistic training in graduate school.

# Labor Market Characteristics

A large number of New Hampshire artists found it necessary to hold jobs outside their art. More than 70 percent worked at something other than their art at some time during 1981. This was a smaller proportion than regionwide where 75 percent of the artists found it necessary to have a job other than their art. In New Hampshire, 53 percent of the artists held jobs related to their art, such as teaching, at some time during the year. More than one-third of the artists held jobs unrelated to their art, such as waitressing, during the year. There were some artists, 16 percent, who held both types of jobs at some time during the year.

New Hampshire artists held a variety of arts-related jobs, though the vast majority, 77 percent, taught their art either privately or in some formal educational setting (see Table 3). Art managerial positions made up the next most frequently held arts-related job in both the state and the region, accounting for almost 10 percent of this type of job. Half as many artists held other professional and managerial jobs. The remaining artists who held arts-related jobs worked in sales, clerical, crafts, and service occupations that were not necessarily artistic in nature but were in artistic enterprises, for example, a sales clerk in an art supply store.

# New Hampshire / Table 2

## Educational Attainment of Artists

| | Median Years of Schooling | Percent with Highest Attainment of: | | | | | | | Percent with Specialized Arts Training: | |
| --- | --- | --- | --- | --- | --- | --- | --- | --- | --- | --- |
| | | Less than High School | High School Diploma | Associate's | Bachelor's | Master's | Doctorate | Other | As Part of Formal Education | Outside of Formal Education |
| All Artists | 16.4 | 0.4% | 16.7% | 3.1% | 45.4% | 31.3% | 2.2% | 0.9% | 81.4% | 76.2% |
| By Occupation: Dancers | IS | IS | IS | IS | IS | IS | IS | IS | IS | IS |
| Musicians | 17.8 | 0.0 | 23.8 | 0.0 | 23.8 | 47.6 | 4.8 | 0.0 | 85.7 | 85.7 |
| Actors | 16.0 | 0.0 | 22.2 | 0.0 | 55.6 | 22.2 | 0.0 | 0.0 | 77.8 | 88.9 |
| Theater Production Personnel | 17.3 | 0.0 | 20.0 | 0.0 | 40.0 | 40.0 | 0.0 | 0.0 | 100.0 | 80.0 |
| Writers and Poets | 17.6 | 0.0 | 8.3 | 0.0 | 41.7 | 37.5 | 12.5 | 0.0 | 64.0 | 56.5 |
| Choreographers, Composers, and Playwrights | 19.0 | 0.0 | 0.0 | 0.0 | 16.7 | 83.3 | 0.0 | 0.0 | 100.0 | IS |
| Visual Artists | 16.4 | 0.0 | 15.1 | 1.9 | 45.3 | 35.8 | 0.0 | 1.9 | 96.4 | 74.1 |
| Media Artists | 16.1 | 0.0 | 25.0 | 8.3 | 41.7 | 25.0 | 0.0 | 0.0 | 76.9 | 85.7 |
| Craft Artists | 16.2 | 1.2 | 16.5 | 5.9 | 54.1 | 20.0 | 1.2 | 1.2 | 72.5 | 75.0 |

IS = insufficient sample

Teaching was the most frequently held nonarts-related job. The percentage of the artists teaching at the primary, secondary, or college level was 16.2 percent, slightly higher than in the region. An equal proportion of artists held service jobs, such as waitressing—a larger proportion than regionwide. Fifteen percent of the artists in New Hampshire held professional and technical jobs compared with 19 percent of the artists through-out the region. Craft occupations, including carpentry and masonry, were the next most frequently held nonarts-related jobs. Operatives and laborers, sales and clerical occupations each accounted for almost 11 percent of the nonarts-related jobs held by New Hampshire artists. Nonarts-related managerial jobs were the least likely to be held by the artists in the state. The difference in the distribution of nonarts-related jobs between New Hampshire artists and regionwide artists may simply be a reflection of what kind of jobs were available within the state.

This description of job types tells only what artists do, what kind of jobs they hold, not how they function in the labor force. An examination of the time spent working, on the other hand, tells us much more about how artists work. This "work time" was measured in two ways: by the number of weeks worked overall and as an artist and by the number of hours per week they worked solely as an artist.

Overall New Hampshire artists average one more week of work than artists regionwide. (See Table 4.) They worked one and one-half weeks less in arts-related jobs and more than two weeks less in nonarts-related jobs, but made this up by working almost two weeks more as artists. Writers and poets worked the largest portion of the year, 50 weeks overall, followed by media artists. In the region, visual artists worked the most, followed by writers and media artists. The remainder of the New Hampshire artists, with the exception of actors, worked approximately the same number of weeks overall during 1981. Actors worked the fewest weeks, only 44, in the state and in the region.

In 1981, New Hampshire artists averaged 38 weeks working as artists, almost two weeks more than artists throughout New England. Media artists spent the most time working at their art while choreographers, composers, and playwrights spent the least. Regionwide visual artists worked the most, and choreographers, composers, and playwrights worked the least. Theater production personnel worked the most weeks in arts-related jobs while the media artists worked the least. Throughout the region the choreographers, composers, and playwrights worked the most at arts-related jobs and the actors and craft artists worked the least. With respect to nonarts-related work, the theater production personnel averaged the most weeks while the craft artists averaged the least, or about one-half the weeks. In New England, media artists spent the most time in nonarts-related work while the choreographers, composers, and playwrights spent the least.

# New Hampshire / Table 3

## Distribution of Other Jobs Held by Artists

| Occupation | Job Type Distribution: | |
| --- | --- | --- |
| | Arts-Related | Nonarts-Related |
| Professional and Technical | 3.2% | 14.9% |
| Art Educators | 77.4 | 0.0 |
| Other Educators | 0.8 | 16.2 |
| Art Managerial | 9.6 | 0.0 |
| Other Managerial | 1.6 | 8.1 |
| Sales | 2.4 | 10.8 |
| Clerical | 1.6 | 10.8 |
| *Craft and Kindred Workers | 1.6 | 12.2 |
| Operatives and Laborers | 0.0 | 10.9 |
| Service | 1.6 | 16.2 |

---

*The word "craft" is not used here in the same sense it is used in the text. It is a U.S. Census term that includes various blue collar workers such as carpenters, mechanics, printers, plumbers, and telephone installers.

New Hampshire artists spent more time in a typical week working as artists than did their counterparts regionwide (see Table 5). They spent an average of 35.6 hours per week working as artists whereas artists regionally worked 32.8. Actors in the state and regionwide averaged more than 43 hours per week, more than any other artist. Writers and poets in New Hampshire spent 33 percent more time working at their art than their colleagues regionwide. Musicians worked the fewest hours at their art in the state which was still more than musicians in the region.

The amount of time artists spent working reveals several things. One is that many artists not only worked more than one job during the year but that it was not unusual for them to hold down more than one job at a time. The information on the average number of weeks worked provided in Table 4 shows that artists averaged 38 weeks working at their art, almost 16 weeks in arts-related jobs and more than 9 weeks in nonarts-related jobs. A "total" of more than 52 weeks worked in 1981 and a "total" larger than the average number of weeks worked at all jobs clearly shows that some of these jobs must have occurred simultaneously. The evidence is even stronger when limited to those artists who actually held arts-related and nonarts-related jobs, as indicated by the values in parentheses in Table 4.

New Hampshire artists did not work at other jobs because they preferred them to their art work; they worked primarily for reasons of economic survival. Only 3 percent of the artists who held jobs outside their art did so because they preferred them to their artistic work. More than half the artists (56 percent) worked outside their art because it paid better. Exactly half said they worked at an arts-related or nonarts-related job because there was not enough artistic work available.[4] More than 46 percent identified increased job security as a reason for working outside their art. At the same time, many artists, 40 percent, felt that their outside work complemented their artistic profession.

When work week figures were broken down for men and women artists, another pattern emerged. Overall, female artists averaged significantly fewer working weeks than male artists, 45.9 weeks to 48.3 weeks. The difference of almost two and one-half weeks can be attributed to an eight-week differential in the number of weeks men spent working as artists. Male artists spent 42.4 weeks and female artists spent 34.4 weeks. Women worked two weeks more than men in arts-related jobs and almost four weeks more in nonarts-related jobs. The reasons for these differences are difficult to uncover. There is, however, at least a partial answer to why men worked more weeks overall. Some time during 1981, 36 percent of New Hampshire artists left the labor force, that is, they were neither working nor unemployed. The primary reason given for this exit was family obligations, and even in the 1980s this seems to still fall primarily to women.

As with the number of weeks, the number of hours women worked as artists was much smaller than it was for men. Female

# New Hampshire / Table 4

## Weeks Employed In 1981

|  | Overall | As An Artist | In Arts-Related Jobs* | In Nonarts-Related Jobs* |
|---|---|---|---|---|
| All Artists | 47.0 | 38.0 | 15.8 (29.7) | 9.1 (27.8) |
| **By Occupation:** | | | | |
| Dancers | IS | IS | IS | IS |
| Musicians | 47.5 | 33.0 | 32.9 (38.6) | 9.9 (29.7) |
| Actors | 43.8 | 30.6 | 15.9 (IS) | 9.0 (IS) |
| Theater Production Personnel | 47.3 | 30.4 | 33.9 (38.1) | 15.0 (IS) |
| Writers and Poets | 50.0 | 44.2 | 13.3 (24.5) | 10.3 (41.0) |
| Choreographers, Composers, and Playwrights | 47.3 | 28.3 | 29.0 (IS) | 8.7 (IS) |
| Visual Artists | 47.1 | 38.1 | 16.1 (28.7) | 10.7 (25.7) |
| Media Artists | 49.2 | 46.1 | 5.4 (IS) | 7.8 (IS) |
| Craft Artists | 46.7 | 40.1 | 10.0 (24.2) | 7.6 (24.2) |

*Numbers in parentheses are weeks worked in arts-related and nonarts-related jobs for only those artists who held such jobs.

IS = insufficient sample

The sum of the weeks worked exceeds the overall total if artists held two or more jobs at the same time.

artists worked 30.5 hours during a typical week while the male artists averaged 40.4 hours. The largest differential was among the musicians with the male musicians averaging 40 hours per week, twice the amount of time spent by the female musicians. The smallest differential, almost 6 hours per week, was among the visual artists, 30.8 hours for the female artists to 36.7 for the male artists. Only among the choreographers, composers, and playwrights did the women work more than the men, 27.7 hours versus 15.5 hours, but with only five artists in this group these estimates are likely to be subject to relatively large sampling error and therefore are not very reliable.

Not all New Hampshire artists were employed throughout 1981. Nineteen percent of the artists experienced some unemployment, a proportion somewhat smaller than what was found regionwide for all the artists as well as nationally for all workers.[5] (An artist is unemployed when he or she is neither an employee nor self-employed but is seeking work or employment.) Just under 24 percent of the musicians and visual artists were unemployed at some time during 1981, while approximately 22 percent of the actors, theater production personnel, and writers and poets experienced some unemployment. Unemployment was somewhat less likely among the craft and media artists with almost 16 percent of the craft artists and a little more than 14 percent of the media artists having experienced unemployment. None of the choreographers, composers, and playwrights were unemployed during 1981, though the small sample makes this estimate unreliable.

Those artists who were unemployed averaged 13.6 weeks out of work. Only 17 percent of the unemployed artists in the state received any unemployment compensation. The reasons for this are self-employed artists were not eligible, many of the arts-related and nonarts-related jobs may not have been covered, and some artists may not have worked long enough to establish eligiblity.

In New Hampshire a much higher percentage of people were out of the labor force sometime in 1981 than were out of work. Fully 30 percent of the artists experienced at least one period where they were neither employed nor unemployed. Almost 39 percent indicated they left the labor force to practice their art; nearly 36 percent cited family obligations; 16 percent were in school; 13 percent were ill; and only 3 percent said they believed no work was available.[6]

In some ways the labor market behavior of New Hampshire artists differed considerably from artists regionally. They were less likely to work at jobs outside their art, and they spent more weeks and more hours per week working as artists than the average New England artist. Much of this might also be a reflection of different opportunities available to artists in either their art work or in other employment areas. Dancers, for example, may have relatively few opportunities to perform in the state, so they are more likely to be working as dance teachers or in

# New Hampshire / Table 5

## Hours Working as an Artist in a Typical Week in 1981

| | Total | Performing Artists: | | | | Nonperforming Artists: | | |
| | | Performing | Rehearsing | Practicing | Looking for Work | Creating | Training | Marketing |
|---|---|---|---|---|---|---|---|---|
| **All Artists** | 35.6 | - | - | - | - | - | - | - |
| **By Occupation:** | | | | | | | | |
| Dancers | IS | IS | IS | IS | IS | - | - | - |
| Musicians | 29.6 | 5.6 | 5.5 | 13.3 | 18.8 | - | - | - |
| Actors | 43.4 | 20.3 | 14.1 | 7.7 | 9.3 | - | - | - |
| Theater Production Personnel | IS | IS | IS | IS | IS | - | - | - |
| Writers and Poets | 35.0 | - | - | - | - | 30.6 | 3.1 | 4.0 |
| Choreographers, Composers, and Playwrights | IS | | | | | IS | IS | IS |
| Visual Artists | 33.7 | | | | | 26.8 | 1.8 | 13.6 |
| Media Artists | 36.9 | | | | | 29.6 | 0.7 | 9.8 |
| Craft Artists | 37.8 | | | | | 30.2 | 1.5 | 10.3 |

IS = insufficient sample

some other nonarts-related job than those in Massachusetts or Connecticut where there are greater performance opportunities.

# Income

New Hampshire artists' contributions to their household incomes came from several sources. They earned labor income from their work as artists, in arts-related jobs, and in nonarts-related jobs. They received nonlabor income from returns on investments, interest, dividends, and transfer payments, such as social security, unemployment compensation, and public assistance. They bartered for goods and services.

The average 1981 income for New Hampshire artists' households was almost $24,800 — $2,500 less than the average for artists regionwide. In 1980, the average income for a New Hampshire household was almost $22,075, and the median was $19,674.[7] Inflation accounts for a considerable portion of the income differential between artists' 1981 households and 1980 households in general. It does not, though, provide a full explanation for the 27 percent difference in income. It would, therefore, appear that an average New Hampshire artist's household was slightly better off than the average household in the state but worse off than the average New England artist's household.

Very few of the artists in the state were the sole contributor to their household income. Only 25 percent of the artists belonged to households where they did not share income or living expenses with another person. In the other 75 percent, more than 64 percent had someone besides the artist working full-time (at least 35 hours per week), and more than 23 percent had another household member working part-time. In only a little over 12 percent of these households was the artist the only person working.

Writers and poets and theater production personnel in New Hampshire were members of households with incomes averaging more than $30,000. Regionwide these artists' households received less than that, and it was the actors' households that had the most income. The visual artists' households averaged almost $26,000, more than $1,200 less than their colleagues throughout the region. Musicians and craft artists were members of households with an average income of almost $23,000, about $3,000 less than in the region. Choreographers, composers, and playwrights, and media artists all belonged to households with 1981 incomes of around $20,000. Actors' households had the lowest income of any of the artists in the state — $17,400. This was 53 percent of the regionwide income for actors' households.

The average artist in New Hampshire contributed $13,700 to the household or 55 percent of the income (this does not include in-kind income from bartering). Choreographers, composers and playwrights contributed the largest share of their household income, almost 96 percent, while theater production

personnel contributed the largest dollar amount, almost $22,000. Craft artists were responsible for both the smallest share and smallest dollar contribution to their household income, 47 percent and $10,700 respectively. This pattern of artist contributions was very similar to the regional pattern.

The largest source of income for the average New Hampshire artist was the earnings received from art work. This provided almost $7,000 in income or 51 percent of the average artist's income— almost $600 more than the average artist in New England. New Hampshire artists earned about $3,800 from arts-related work, which was more than $900 less than what was earned regionally. Nonlabor income averaged almost $1,600 in the state as well as regionwide and accounted for almost 12 percent of the average artist's income. Earnings from work not related to his or her art provided approximately $1,500 or less than 11 percent of the average artist's total income.

Among artists there were wide differences in income. Musicians, writers and poets, visual artists, media artists, and craft artists all succeeded in earning more from their art than from other work. Media artists earned the largest proportion of their income from artistic work, 72 percent, while writers and poets earned the largest dollar amount, $11,748. Actors, theater production personnel, writers and poets, and choreographers, composers, and playwrights all earned income from their arts-related work. The actors earned the least number of dollars from working as artists, while the choreographers, composers, and playwrights earned a proportion smaller than any other artist from artistic work.

Bartering, while unconventional, is another source of income for many artists. In New Hampshire, artists received an average value of $201 in goods and services, which was exactly the same as regionwide. Artists who produce a physical product were the most successful at bartering. The craft artists averaged $314 in barter income followed by media and visual artists. Both musicians and theater production personnel, artists who produce a service, received no income from bartering.

Income, of course, is only one-half of the artist's work situation. Expenses is the other. New Hampshire artists spent almost $4,000 in unreimbursed costs (see Table 6), almost $400 more than the average New England artist. These artistic costs were 57 percent of their earnings from their art. So if the average artist grossed $7,000 in earnings he or she would have netted only $3,000. More than half the artists (53 percent) actually spent more producing their art than they earned from it. Media artists spent the most in the state as in the region, almost $7,200, leaving them with net artistic earnings of $1,100. Actors had the smallest net artistic earnings of $84, while writers and poets had the largest net artistic earnings of $8,200. Clearly, many New Hampshire artists subsidized their artistic activities with income from other household members or from working at something other than their art.

A number of differences exist among New Hampshire artists that are related to sex, age, and educational background. (See Table 7.) Women artists received less income from all sources than the men artists. The average woman artist received 46 percent of the income received by the average man artist. The difference between the $9,019 for the women and the $19,680 for men artists was statistically significant. Much of this can be attributed to the difference in what the artists earned from their art. Men averaged $11,834 from working in their art while women artists averaged only $3,166. There was a difference between their art-related earnings too, but it was much less, $4,930 versus $2,961. Neither the men nor women artists earned very much working at jobs not related to his or her art, $1,530 and $1,412 respectively, and the difference was not significant. The same was true for their nonlabor income, men averaged $1,656 while women artists averaged $1,549 in nonlabor income. Even the total household income for the women artists was less than it was for the men, $23,491 versus $26,435 respectively, though the difference was again not significant.

The differences in the amount of time spent working as an artist and in arts-related work explains, in part, these discrepancies. Women artists in New Hampshire worked for an average of 34 weeks at their art while men artists averaged 42 weeks, almost 25 percent more. The men also averaged one-third more hours working as artists in a "typical" week. Working less is only a partial answer though. What is harder to explain is the significant difference in arts-related earnings in favor of the men based on time spent working since women artists actually worked more weeks, 16.7 to 14.6, in arts-related jobs. Unfortunately, no information was collected on the number of hours worked per week at arts-related jobs. Men artists could have worked more hours per week in arts-related activities and, therefore, would have earned more money.,

One of the most revealing ways to look at employment is to look at the hourly wages. New Hampshire artists received an average hourly wage of $5.40 for their work as artists. In comparison, the regionwide wage for artistic work was $6.08 per hour, and the average 1981 wage for production workers in New Hampshire was $6.41,[8] or 19 percent higher. Men had a higher hourly wage than women artists, in fact, it was double the women's wage, $7.34 per hour to $3.67. In only one occupation, acting, did women earn more on an hourly basis, $4.61 versus $2.70. The difference among the craft artists slightly favored men, $4.95 per hour to $4.40.

When artistic costs are taken into account, the "net" wage becomes negative. On average artists in New Hampshire lost 75 cents for every hour they worked as artists. Women fared even worse—actually losing $2.00 per hour while men earned $0.28 per hour working as artists.

Differences in workers' income can also be attributed to differences in their ages. This is no less true for New Hampshire

# New Hampshire / Table 6

## Income and Artistic Costs in 1981

| | Total Household Income | Artist's Income: Total* | As Artist | In Arts-Related Work | In Nonarts-Related Work | Nonlabor | Value of Art Work Bartered | Total Artistic Costs |
|---|---|---|---|---|---|---|---|---|
| All Artists | $ 24,795 (20,000) | $ 13,706 ( 9,900) | $ 6,948 | $ 3,820 | $1,463 | $1,596 | $201 | $3,942 |
| **By Occupation:** | | | | | | | | |
| Dancers | IS | IS | IS | IS | IS | IS | IS | IS |
| Musicians | 22,901 (21,000) | 13,198 (12,067) | 6,860 | 4,604 | 1,462 | 450 | 0 | 3,064 |
| Actors | 17,400 (17,000) | 11,953 (11,000) | 2,854 | 6,602 | 1,898 | 600 | 56 | 2,170 |
| Theater Production Personnel | 31,990 (35,050) | 21,891 (21,050) | 7,248 | 8,012 | 5,930 | 702 | 0 | 1,752 |
| Writers and Poets | 33,944 (24,000) | 21,261 ( 9,700) | 11,748 | 5,202 | 925 | 3,385 | 7 | 3,537 |
| Choreographers, Composers, and Playwrights | 20,250 (16,750) | 19,383 (16,400) | 4,030 | 14,153 | 1,200 | 0 | 167 | 2,245 |
| Visual Artists | 25,914 (21,602) | 13,101 ( 8,000) | 5,853 | 3,757 | 1,470 | 2,442 | 246 | 3,294 |
| Media Artists | 19,875 (15,550) | 11,414 (10,650) | 8,265 | 1,522 | 1,477 | 150 | 273 | 7,165 |
| Craft Artists | 22,721 (19,989) | 10,702 ( 8,466) | 7,247 | 1,534 | 1,109 | 811 | 314 | 5,174 |

*Components of total artist's income may not add exactly to total because of nonresponses to question requesting breakdown of total income.
IS = insufficient sample

artists. Total 1981 household income increased with the artist's age from almost $14,500 for the average artist between the ages of 20 to 29 to a peak $38,200 for artists 50 to 59. It then declined to $15,000 for the oldest artists, 70 or older. The pattern was essentially the same for artistic earnings and arts-related earnings. The artists 20 to 29 earned almost $3,700 from their art while the artists 50 to 59 earned almost $12,700 and those 70 or older earned a little more than $6,100. For arts-related earnings the youngest artists earned $2,300 while the highest earnings were more than $5,700 for the artists 40 to 49. The oldest artists did not earn any arts-related income.

Nonarts-related earnings followed a very different pattern. The artists 20 to 29 earned more than $2,500 from nonarts-related work, but the next two age groups earned less. Nonarts-related earnings increased for people over 50, with the artists 60 to 69 earning almost $3,300 from nonarts-related work. Again the artists 70 or older had no nonarts-related income. Not surprisingly the amount of nonlabor income, which includes social security, increased with an artist's age. Artists 20 to 29 received less than $30 in nonlabor income in 1981, while the oldest artists averaged almost $6,500 in nonlabor income.

The relationship between education and income for New Hampshire artists is less clear than that of age and income. There was a weak but statistically significant positive relationship between the number of years of formal schooling and an artist's total income. Additional years of formal education do seem to lead to additional income. This connection is the strongest in the relationship between schooling and arts-related earnings. When examining the relationship between education and other sources of artist income, artistic, nonarts-related, and nonlabor, the relationship becomes slightly negative indicating that as the amount of formal schooling increases, income decreases. For nonlabor income years of schooling may to some extent be a proxy for age. Younger artists are more likely to have more schooling than their elders who have high nonlabor incomes. But in general, it appears formal education does not strongly influence artistic earnings but does affect arts-related earnings. This may possibly be because of the certification needed to gain entrance into arts-related jobs, such as teaching.

The same relationships were generally reflected in a comparison between income and the highest degree earned by New Hampshire artists. The positive relationship between schooling and the artists' total incomes is illustrated by the fact that beyond the high school level, income rises as higher degrees are earned. Those who stopped at high school averaged almost $14,700 in total income. Artists with associate degrees and artists with baccalaureates averaged approximately $12,000. Artists with master's degrees averaged just over $14,000, and artists with doctorates received more than $30,000. The high school graduates earned $8,800 for their art work, more than all the artists except those with associate degrees ($11,100) and those with doctorates

# New Hampshire / Table 7

## Average 1981 Income by Demographics

|  | Total Household Income | Artists' Income: | | | | |
|---|---|---|---|---|---|---|
|  |  | Total | Arts | Arts Related | Nonarts Related | Nonlabor |
| Sex: Female | $23,491 | $ 9,019 | $ 3,166 | $ 2,961 | $1,412 | $1,549 |
| Male | 26,435 | 19,680 | 11,834 | 4,930 | 1,530 | 1,656 |
| Race: White | 24,893 | 14,066 | 7,128 | 3,880 | 1,480 | 1,643 |
| Nonwhite | IS | IS | IS | IS | IS | IS |
| Age: 20-29 | 14,449 | 8,528 | 3,656 | 2,301 | 2,542 | 29 |
| 30-39 | 22,112 | 11,624 | 6,806 | 2,848 | 1,208 | 762 |
| 40-49 | 29,393 | 15,951 | 8,162 | 5,744 | 991 | 1,273 |
| 50-59 | 38,198 | 23,076 | 12,667 | 5,730 | 1,142 | 4,161 |
| 60-69 | 24,162 | 15,781 | 2,509 | 4,770 | 3,290 | 5,212 |
| 70 + | 14,988 | 12,627 | 6,129 | 0 | 0 | 6,498 |
| Education: Degree: | | | | | | |
| High School | 20,684 | 14,888 | 8,354 | 1,034 | 2,389 | 3,006 |
| Associate's | 32,714 | 12,115 | 11,119 | 500 | 107 | 389 |
| Bachelor's | 23,963 | 11,957 | 6,911 | 2,405 | 1,753 | 1,012 |
| Master's | 26,089 | 14,018 | 5,072 | 7,240 | 882 | 957 |
| Doctorate | 38,400 | 30,700 | 9,820 | 11,360 | 0 | 9,520 |

IS = insufficient sample

($9,800). The pattern for arts-related earnings was more conventional. High school graduates averaged only $1,100 while bachelor's degree holders earned more than twice that, artists with master's degrees earned 7 times as much, and those with doctoral degrees earned 10 times the high school graduates' earnings. There was a weak negative relationship between highest degree and nonarts-related earnings that is attributable to no nonarts-related earnings for artists with doctorates and little variation in this source of earnings for them and all other artists.

# New Hampshire— Endnotes

[1]Department of Commerce, Bureau of Census. *1980 Census of Population and Housing: Provisional Estimates of Social, Economic, and Housing Characteristics.* (Washington D.C.: 1982), Table P-1, p. 6.

[2]Ibid., Table P-3, p. 28.

[3]Ibid., Table P-2, p. 17.

[4]Multiple responses to this question were permitted.

[5]U.S. Department of Labor, Bureau of Labor Statistics. *News,* No. 82-255, July 20, 1982.

[6]An artist could have indicated more than one reason for leaving the labor force since they could have experienced more than one period out of the labor force.

[7]From special tabulations of the U.S. Bureau of Census, 1981 Current Population Survey data tapes in New England.

[8]U.S. Department of Labor, Bureau of Labor Statistics. *Employment and Earnings.* Vol. 29, No. 5, May 1982, p. 120.

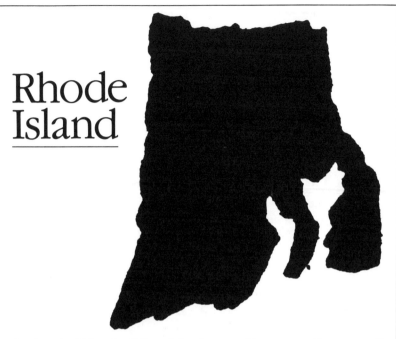

# Rhode Island

Artists in **Rhode Island** had a median age of 35.9 and were 50.0 percent female and 4.3 percent nonwhite.

They averaged 17.6 years of school. Almost 86 percent (85.8) had at least a bachelor's degree. In addition, 91.4 percent received specialized artistic training in school, and 62.3 percent received such training outside of school.

They worked 36.2 weeks as artists in 1981. In addition to their work as artists, 58.1 percent held jobs related to their art for an average of 33.4 weeks and 37.8 percent held jobs not related to their art for 36.4 weeks. Holding more than one job at a time was common. Nevertheless, 29.6 percent were unemployed and 23.9 percent dropped out of the labor force during the year.

They earned $15,817 in income from all sources in 1981. Their household income (including earnings of other household members) was $24,836. However, the income they earned as artists was $5,179. In earning their artistic income, they incurred nonreimbursed costs of $2,661.

# Demographic and Educational Characteristics

The distribution of artistic occupations for the artists who responded to the survey in Rhode Island (see Table 1) differed from that of the region. Visual artists were the largest group in the state as well as the region, but in Rhode Island they made up a little more than one-quarter of the artists while regionwide they were fully one-third of the artists. Musicians were the second largest group in Rhode Island. They accounted for 22 percent of the artists, which was 43 percent higher than their regional representation. Of the remaining artists, dancers, actors, theater production personnel, and choreographers, composers, and playwrights had a somewhat larger proportion in the state than in the region. The writers and poets, media artists, and craft artists were underrepresented relative to all of New England. These differences probably reflect the kind of job opportunities that artists have in Rhode Island relative to opportunities they have in other parts of the region.

The median age of Rhode Island artists in 1981 was 35.9. This was essentially the same as the median age in the region but was more than four years older than the median age of all of Rhode Island residents.[1] An equal number of men and women responded to the questionnaire, indicating that there was a larger proportion of male artists in the state than throughout New England, and that there was a larger proportion of women working as artists than women in the state labor force.[2] Almost 96 percent of the artists were white and 3 percent were black, twice the proportion regionwide. The remainder were either American Indian or of Asian descent, with 1.5 percent of Spanish origin. Table 1 gives the details of the ethnic/racial distribution for each of the artistic occupations in Rhode Island.

Artists in Rhode Island were better educated than artists in New England (Table 2). They averaged 17.6 years of formal schooling, more than a year more than regionwide, and almost 86 percent had earned at least a bachelor's degree, 6 percent more than in the region. Compared to the 15 percent of the adult population, 25 years old and older, in the state who completed four or more years of college,[3] Rhode Island artists were very well educated.

But not all Rhode Island artists were equally well educated. Choreographers, composers, and playwrights in the state and the region had the most formal schooling and, not surprisingly, the greatest proportion with graduate degrees. In formal schooling, writers and poets were next with an average of 18.0 years of schooling and over 27 percent with doctoral degrees, more than any other group of artists in the state. The artists with the least amount of formal schooling in the state were theater production personnel, while regionwide it was dancers and actors.

Not unlike most others in the region, Rhode Island artists'

# Rhode Island/Table 1

## Demographic Characteristics of the Artists

| | Percent by Occupation | Median Age | Percent Who Are: | | Percent Who Are: | | | | | Percent Who Are: |
|---|---|---|---|---|---|---|---|---|---|---|
| | | | Male | Female | Amer. Indian | Asian | Black | White | Other | Hispanic |
| All Artists | 100.0% (n =210) | 35.9 | 50.0% | 50.0% | 0.5% | 0.5% | 2.9% | 95.7% | 0.5% | 1.5% |
| By Occupation: Dancers | 2.0 | IS | IS | IS | IS | IS | IS | IS | IS | IS |
| Musicians | 22.3 | 41.0 | 71.1 | 28.9 | 0.0 | 2.3 | 2.3 | 95.5 | 0.0 | 0.0 |
| Actors | 5.4 | 32.0 | 45.5 | 54.5 | 0.0 | 0.0 | 9.1 | 90.9 | 0.0 | 0.0 |
| Theater Production Personnel | 5.0 | 42.5 | 40.0 | 60.0 | 0.0 | 0.0 | 0.0 | 100.0 | 0.0 | 0.0 |
| Writers and Poets | 10.9 | 38.5 | 45.5 | 54.5 | 4.5 | 0.0 | 0.0 | 90.9 | 4.5 | 0.0 |
| Choreographers, Composers, and Playwrights | 3.0 | 37.5 | 50.0 | 50.0 | 0.0 | 0.0 | 0.0 | 100.0 | 0.0 | 0.0 |
| Visual Artists | 26.2 | 33.1 | 39.6 | 60.4 | 0.0 | 0.0 | 5.7 | 94.3 | 0.0 | 2.0 |
| Media Artists | 5.9 | 29.5 | 83.3 | 16.7 | 0.0 | 0.0 | 0.0 | 100.0 | 0.0 | 0.0 |
| Craft Artists | 19.3 | 34.0 | 41.0 | 59.0 | 0.0 | 0.0 | 0.0 | 100.0 | 0.0 | 2.9 |

IS = insufficient sample

education was not limited to a formal setting. Two-thirds of the artists participated in organized artistic training outside the formal educational environment. This was less than the three-quarters who participated regionwide. On the average, artists started this training at around 14 years of age. The dancers and musicians started their training at a much younger age than the other artists, typically around 8 or 9 years old. More than 90 percent of the actors participated in this type of training, the largest group within the state, while only half the writers and poets had training outside formal school setting.

During 1981, 36 percent of Rhode Island artists participated in artistic training outside the formal educational setting. These artists spent an average of 16 weeks, 11 hours per week, in training during the year. The average cost of the training was $449.

More than 91 percent of Rhode Island artists incorporated artistic training, in some fashion, into their formal schooling. Writers and poets were the least likely to take artistic training as part of their formal schooling; only two-thirds indicated they took any kind of training. Theater production personnel and choreographers, composers, and playwrights were the most likely to have some artistic training while attending school. Almost 48 percent of Rhode Island artists received some artistic training in high school, with almost 9 percent having attended special art school. Of those artists who attended college, three-quarters of them majored in their art and more than 45 percent did so while attending an art school. Only 14 percent of the artists did not study art at all as a part of their undergraduate education. Seventy percent of Rhode Island artists who attended graduate school majored in their art. Thirty-five percent of these artists were attending art schools.

# Labor Market Characteristics

A large number of Rhode Island artists, as well as artists throughout New England, found it necessary to work at jobs other than their art. Only 19 percent of the artists in Rhode Island worked only as artists. This was a much lower percentage than regionwide where almost 25 percent of the artists worked only as artists. In Rhode Island, 58 percent of the artists worked in a job related to their art at some time during 1981, compared to 54 percent in the region. Almost 38 percent held jobs that were not related to their art, while more than 14 percent worked at both arts-related and nonarts-related jobs during the year. Regionwide the comparable percentages were 36 percent and 14 percent, respectively.

The distribution of arts-related jobs held by Rhode Island artists differed from the distribution regionwide (see Table 3). The predominant arts-related job in Rhode Island and New England was teacher, but 8 percent more artists in Rhode Island held this type of job than regionwide. Both professional and technical

# Rhode Island / Table 2

## Educational Attainment of Artists

|  | Median Years of Schooling | *Percent with Highest Attainment of:* | | | | | | | *Percent with Specialized Arts Training:* | |
|  |  | Less than High School | High School Diploma | Associate's | Bachelor's | Master's | Doctorate | Other | As Part of Formal Education | Outside of Formal Education |
|---|---|---|---|---|---|---|---|---|---|---|
| **All Artists** | 17.6 | 0.0% | 12.8% | 1.0% | 39.2% | 39.2% | 7.4% | 0.5% | 91.3% | 67.3% |
| **By Occupation:** | | | | | | | | | | |
| Dancers | IS | IS | IS | IS | IS | IS | IS | IS | IS | IS |
| Musicians | 17.8 | 0.0 | 14.3 | 2.4 | 38.1 | 40.5 | 4.8 | 0.0 | 97.7 | 66.7 |
| Actors | 16.7 | 0.0 | 27.3 | 0.0 | 63.6 | 0.0 | 9.1 | 0.0 | 90.9 | 90.9 |
| Theater Production Personnel | 16.5 | 0.0 | 0.0 | 0.0 | 60.0 | 30.0 | 10.0 | 0.0 | 100.0 | 80.0 |
| Writers and Poets | 18.0 | 0.0 | 0.0 | 0.0 | 40.9 | 31.8 | 27.3 | 0.0 | 66.7 | 50.0 |
| Choreographers, Composers, and Playwrights | 19.5 | 0.0 | 0.0 | 0.0 | 0.0 | 83.3 | 16.7 | 0.0 | 100.0 | 83.3 |
| Visual Artists | 17.0 | 0.0 | 11.8 | 0.0 | 39.2 | 43.1 | 3.9 | 2.0 | 94.1 | 61.5 |
| Media Artists | 17.6 | 0.0 | 16.6 | 0.0 | 33.3 | 50.0 | 0.0 | 0.0 | 90.9 | 75.0 |
| Craft Artists | 17.7 | 0.0 | 18.4 | 2.6 | 28.9 | 44.7 | 5.3 | 0.0 | 92.1 | 68.4 |

IS = insufficient sample

occupations and arts managerial occupations were underrepresented in the state relative to the region. No artists in Rhode Island held sales or clerical jobs in artistic enterprises, while over 3 percent of the artists regionally were so employed. Also, the proportion of artists holding service jobs in an arts establishment, a guard in an art museum, for example, was four times higher in Rhode Island than throughout New England.

The distribution of nonarts-related jobs among Rhode Island artists was very similar to that for the region. The professional and technical occupations accounted for almost 22 percent of the jobs they held, compared to 19 percent for the region, and was the most common type of job. In Rhode Island sales jobs were next in popularity with a 50 percent larger share of the nonarts-related jobs than regionwide. Teaching jobs, other than those in the arts, were next, followed by service, building trades, and managerial occupations not in artistic enterprises. The proportion of artists holding clerical jobs, next in the ranking, was about 25 percent less than the proportion in New England with similar jobs. A small proportion of the artists, both in Rhode Island and the region, held operative and laborer jobs.

But while this describes the kinds of jobs Rhode Island artists held, it does not tell how they functioned in the labor force. This can be better seen by examining the amount of time spent working. This "work time" was measured in two ways: by the number of weeks they worked at all jobs and as an artist and by the number of hours they worked solely as artists.

Artists in the state averaged almost 47 working weeks overall in 1981 (see Table 4), only slightly more than the regionwide average. They spent an average of 36 weeks working as artists, the same as in the region; 19 weeks working in arts-related jobs, 10 percent more than in the region; and almost 14 weeks in nonarts-related jobs, 15 percent more than in the region. The number of weeks Rhode Island artists worked in 1981 varied among artists, but the variation was less than among artists in the region. Media artists worked the most overall and as artists. They were closely followed by theater production personnel. Visual artists, who averaged the most weeks working regionwide, were next with an average of 48.6 weeks overall, almost two weeks more than artists throughout New England. Rhode Island writers and poets worked the fewest weeks overall and as artists. Regionally, writers and poets worked the most weeks and actors the fewest.

Rhode Island artists typically spent 31.5 hours per week working at their art, a little less than artists regionally (Table 5).[4] Actors in the state, as well as in the region, worked the most hours during the week—almost 10 percent more than other artists. Media artists were next, and they too worked 10 percent more hours than their colleagues throughout the region. Following them were visual artists, who worked slightly more in Rhode Island than in the region, theater production personnel, who worked considerably less than those in the region, and craft

# Rhode Island / Table 3

## Distribution of Other Jobs Held by Artists

| Occupation | Job Type Distribution: | |
| --- | --- | --- |
| | Arts-Related | Nonarts-Related |
| Professional and Technical | 4.2% | 21.7% |
| Art Educators | 83.8 | 0.0 |
| Other Educators | 0.0 | 13.6 |
| Art Managerial | 6.7 | 0.0 |
| Other Managerial | 0.0 | 10.9 |
| Sales | 0.0 | 16.5 |
| Clerical | 0.0 | 10.8 |
| *Crafts and Kindred Workers | 1.6 | 11.0 |
| Operatives and Laborers | 0.8 | 4.1 |
| Service | 2.5 | 12.3 |

*The word "craft" is not used here in the same sense it is used in the text. It is a U.S. Census term that includes various blue collar workers such as carpenters, mechanics, printers, plumbers, and telephone installers.

artists who spent about 20 percent less time working as artists than their regional counterparts. Musicians worked the fewest hours, only 25 hours per week.

These findings tell us several things about the artists' working lives. It is clear that in general not only did they hold down more than one job but they did so simultaneously.[5] This is evident because the sum of the weeks worked at all jobs was larger than the total number of work weeks and more than the number of weeks in a year. The reasons why artists held more than one job at a time are complex but seem to be at the very least tied to the need to earn enough income to survive. Although this will be discussed in more detail later, it is important to point out here that most artists did not choose to work at other jobs that were outside their art work. Almost two-thirds of the artists said that they worked other jobs because of better pay. More than half[6] of these artists cited job security and not enough work available for artists as reasons for holding other jobs. Only 6 percent worked outside their art because they preferred it to their artistic work. It should be noted, however, that more than 43 percent felt their "other" job complemented their artistic work.

Another aspect of artists in the labor force that was found when looking at their work time was the difference between the amount of time men and women artists spent working. The typical woman artist in Rhode Island worked significantly fewer weeks than her male counterpart, 44.5 versus 49.3 weeks. This was also true throughout the region. Men artists in the state worked more weeks as artists, 39.0 versus 33.4 weeks, and in nonarts-related jobs 16.1 to 11.1 weeks. There was only a slight difference in the number of weeks men worked in arts-related jobs, 19.9 for men, 17.9 for women. A partial explanation for the difference in the amount of time men and women worked can be found in the fact that almost 40 percent of the Rhode Island artists who were out of the labor force (that is, they were neither employed nor unemployed) some time during 1981. The primary reason given for leaving the labor force was family obligations, such as raising children, a duty still heavily dominated by women in our society.[7]

Unemployment, that is, being out of work but still looking for work, was certainly not foreign to Rhode Island artists during 1981. Almost 30 percent were unemployed at some time during the year. This was almost 50 percent higher than the proportion unemployed throughout New England. The artists who were unemployed in the state averaged almost 16 weeks of being out of work, spread out over an average of two periods. Not all artists had the same chance of being unemployed during 1981. Choreographers, composers, and playwrights and actors were by far the most likely to have been unemployed, with 60 percent of the former and 55 percent of the latter out of work at some point. The artists least likely to have been unemployed in Rhode Island were the media artists—only 17 percent were ever unemployed during 1981.

# Rhode Island / Table 4

## Weeks Employed In 1981

| | Overall | As An Artist | In Arts-Related Jobs* | In Nonarts-Related Jobs* |
|---|---|---|---|---|
| **All Artists** | 46.8 | 36.2 | 18.9 (33.4) | 13.6 (36.4) |
| **By Occupation:** | | | | |
| Dancers | IS | IS | IS | IS |
| Musicians | 46.9 | 35.4 | 26.3 (39.0) | 14.9 (43.6) |
| Actors | 44.5 | 33.8 | 10.6 (IS) | 12.2 (IS) |
| Theater Production Personnel | 49.5 | 39.3 | 19.3 (29.0) | 0.0 (IS) |
| Writers and Poets | 43.5 | 31.7 | 19.0 (30.0) | 13.7 (24.9) |
| Choreographers, Composers, and Playwrights | IS | IS | IS | IS |
| Visual Artists | 48.6 | 39.1 | 15.6 (28.8) | 13.1 (37.1) |
| Media Artists | 50.2 | 46.6 | 11.5 (IS) | 17.4 (IS) |
| Craft Artists | 46.8 | 33.8 | 16.4 (32.8) | 16.4 (41.5) |

*Numbers in parentheses are weeks worked in arts-related and nonarts-related jobs for only those artists who held such jobs.

IS = insufficient sample

The sum of the weeks worked exceeds the overall total if artists held two or more jobs at the same time.

A smaller proportion of artists, almost 24 percent, was out of the labor force rather than unemployed some time during 1981. This was a smaller proportion than regionwide. In identifying the reasons for this behavior an equal proportion of artists indicated they left the labor force because they had family obligations as indicated they left to practice their artistic skills. These reasons were followed by: no work available, attending school, and illness.

The labor market experiences of Rhode Island artists did not differ dramatically from artists regionwide, but they do differ somewhat from those of the typical worker in the state, especially those with equivalent educational backgrounds. The long hours and many jobs held by the artists appear to have been very important for their economic survival.

# Income

The income received by Rhode Island artists came from both labor and nonlabor sources. The sources of the labor income were working as an artist, working in an arts-related job, working in a nonarts-related job, and in-kind income received through bartering a good or service produced by the artist. The nonlabor income came from returns on investments, dividends, interest, and transfer payments such as social security, unemployment compensation, and public assistance. The 1981 average income by source for Rhode Island artists can be found in Table 6 (median values are in the parentheses).

The artists in Rhode Island came from households with an average 1981 income of slightly more than $24,800. This was more than 11 percent less than the regionwide average. In 1980, the average income for a Rhode Island household was $19,127.[8] The difference of 30 percent between the 1980 average for all the state residents and the 1981 artist's average household income cannot be fully explained by inflationary increases over the period. Some of the differences must be attributed to higher than average household incomes for artists in Rhode Island.

In Rhode Island, choreographers, composers, and playwrights' households had the highest total income, $47,400 — almost twice the statewide average and more than 50 percent higher than regionwide. The next two groups of artists, theater production personnel and actors, had household incomes considerably smaller — $33,700 and $31,600 respectively. Following them were the musical performers and media artists with only a $1,500 difference in household incomes. The craft artists, visual artists, and writers and poets in the state were members of households with incomes within about $1,800 of each other and were less than the average incomes in the state. All three belonged to households with incomes much less than the regionwide averages.

Rhode Island artists brought in 64 percent of their house-

# Rhode Island / Table 5

## Hours Working as an Artist in a Typical Week in 1981

| | Total | Performing Artists: | | | | Nonperforming Artists: | | |
|---|---|---|---|---|---|---|---|---|
| | | Performing | Rehearsing | Practicing | Looking for Work | Creating | Training | Marketing |
| All Artists | 31.5 | - | - | - | - | - | - | - |
| **By Occupation:** | | | | | | | | |
| Dancers | IS | IS | IS | IS | IS | - | - | - |
| Musicians | 25.3 | 6.9 | 6.0 | 9.8 | 1.7 | - | - | - |
| Actors | 47.6 | 17.3 | 16.3 | 5.5 | 0.9 | - | - | - |
| Theater Production Personnel | 33.8 | 10.6 | 13.1 | 5.1 | 0.7 | - | - | - |
| Writers and Poets | 22.6 | - | - | - | - | 16.6 | 1.2 | 5.4 |
| Choreographers, Composers, and Playwrights | IS | - | - | - | - | IS | IS | IS |
| Visual Artists | 36.8 | - | - | - | - | 32.2 | 0.4 | 4.2 |
| Media Artists | 39.1 | - | - | - | - | 31.2 | 0.8 | 7.1 |
| Craft Artists | 30.6 | - | - | - | - | 26.8 | 2.1 | 2.2 |

IS = insufficient sample

holds' income in 1981, a higher proportion than regionwide, but clearly other members of the household also helped. Two-thirds of the artists lived in a household where they shared income or living expenses with another person. In slightly more than 11 percent of these households there was no other person working. In almost 27 percent of these households, a second household member was working part-time (less than 35 hours per week), and in 62 percent another member of the household was working full-time (35 hours per week or more). In contrast, during 1981, only 58 percent of the families in Rhode Island had two or more workers.[9]

Actors in Rhode Island provided the largest share of household income, 83 percent, 14 percent more than writers and poets, the next group of artists. Regionwide it was theater production personnel who provided the largest share of their household income, followed by actors. In the state, choreographers, composers, and playwrights contributed the least relatively, only 21 percent, and absolutely, just under $10,000, to the income of their households. In Rhode Island the visual artists and craft artists contributed a larger proportion of the household income than regionwide, but in terms of dollar amounts the Rhode Island visual artists contributed slightly less while the craft artists contributed slightly more.

Unlike artists throughout New England, the largest share of Rhode Island artists' income was not from their work as artists but from their work in arts-related jobs. In 1981, the average artist in the state earned almost $5,200 from his or her art, or almost 33 percent of his or her income, while he or she earned more, almost $5,500, from his or her arts-related work. In comparison, the typical New England artist earned more and a larger share of income, 42 percent, from his or her art and less as well as a smaller share of income, 30 percent, from his or her arts-related work. In Rhode Island this pattern was true for all but the actors and media artists. Both groups of artists earned more and received a larger share of their income from working as artists than from any other source. The actors earned more from working as artists—$18,773. This was 72 percent of their income. No other group of artists had as large a proportion. In both absolute and relative terms writers and poets' artistic work contributed the least to their total income.

The $5,500 earned by Rhode Island artists from their arts-related work accounted for almost 35 percent of their total income. For musical performers, theater production personnel, visual artists, and choreographers, composers, and playwrights, an arts-related income was the most important source. Arts-related earnings accounted for 54 percent of the theater production personnel's income, the highest proportion, while it accounted for only 3 percent of the actors' total income, the lowest proportion. Even though arts-related earnings was not the most important source of income for the craft artists, it was more than their artistic earnings. With the exception of Rhode

# Rhode Island / Table 6

## Income and Artistic Costs in 1981

| | Total Household Income | Artist's Income: Total* | As Artist | In Arts-Related Work | In Nonarts-Related Work | Nonlabor | Value of Art Work Bartered | Total Artistic Costs |
|---|---|---|---|---|---|---|---|---|
| **All Artists** | $ 24,836 (22,001) | $ 15,817 (13,000) | $ 5,179 | $ 5,480 | $4,136 | $ 965 | $122 | $2,661 |
| **By Occupation:** | | | | | | | | |
| Dancers | IS | IS | IS | IS | IS | IS | IS | IS |
| Musicians | 27,624 (25,050) | 18,237 (17,000) | 5,200 | 6,147 | 5,474 | 1,269 | 70 | 1,730 |
| Actors | 31,564 (17,009) | 26,125 (14,009) | 18,773 | 802 | 6,031 | 519 | 20 | 3,577 |
| Theater Production Personnel | 33,708 (33,770) | 23,373 (30,000) | 10,349 | 12,686 | 0 | 338 | 128 | 1,373 |
| Writers and Poets | 20,156 (24,933) | 14,730 (10,000) | 1,137 | 6,029 | 7,196 | 369 | 182 | 1,230 |
| Choreographers, Composers, and Playwrights | 47,400 (35,7000) | 9,983 ( 8,700) | 2,593 | 3,853 | 3,509 | 29 | 167 | 1,746 |
| Visual Artists | 20,847 (18,000) | 13,819 ( 8,532) | 5,078 | 6,304 | 1,860 | 576 | 133 | 4,203 |
| Media Artists | 26,014 (24,167) | 17,926 (13,300) | 8,206 | 2,421 | 6,658 | 642 | 400 | 3,735 |
| Craft Artists | 21,940 (17,300) | 13,631 (12,010) | 2,791 | 4,248 | 4,640 | 1,952 | 82 | 2,741 |

*Components of total artist's income may not add exactly to total because of nonresponses to question requesting breakdown of total income.
IS = insufficient sample

Island actors, arts-related earnings were more important to artists in this state than to artists regionwide.

Earnings received from nonarts-related work were quite a bit more important to artists in Rhode Island than to artists regionwide. In the state, it accounted for 26 percent of their income while regionwide it accounted for only 19 percent. For both writers and poets and craft artists, earnings from nonarts-related work was the largest single source of income. Writers and poets actually earned more from this work than from their artistic and arts-related work combined.

Nonlabor income (rent, interest, social security, and transfer payments) accounted for less than $1,000 for the average Rhode Island artist, or only 6 percent of his or her total income. This was one-third of what the average artist regionwide received. Craft artists averaged the largest nonlabor income, receiving almost $2,000 in 1981, or 14 percent of their income. For all the other artists, nonlabor income accounted for 6 percent or less of their income.

Rhode Island artists were less successful than the average New England artist in bartering for goods and services. The average income from bartering was only $122. The most successful artists in bartering were media artists; the least successful were actors.

Artists incur considerable costs in creating their art. In Rhode Island the typical artist spent almost $2,700, or 51 percent of his or her artistic earnings on artistic costs—a smaller proportion than regionwide. Almost half of the artists in the state (48 percent) spent more in unreimbursed expenses to produce their art than they received in return. Visual artists spent the most, followed by media artists, actors, and craft artists. Regionwide media artists spent the most, followed by craft artists and visual artists. Whatever the source, many of Rhode Island artists clearly used resources other than their earnings from their art to produce it.

Differences in the income of artists in Rhode Island were in part due to differences in sex, age, and educational background (Table 7). Women artists in the state received less income from all sources than did men artists. The average woman artist received 62 percent of the income of the average male, $12,075 versus $19,842. Rhode Island women artists earned less than their men counterparts from their art as well, but not significantly less ($4,604 versus $5,748). Large, significant earning differentials were revealed, however, for arts-related and nonarts-related jobs. In arts-related earnings the average woman artist earned 62 percent of what the average man earned, $4,185 versus $6,775. The differential in nonarts-related earnings was even larger, both in absolute and relative terms. The average woman artist earned $2,761 while the average man artist earned $5,512. Even in nonlabor income the average male artist received significantly more, $1,436 to $488. Total household income also favored men, $26,055 versus $23,553.

# Rhode Island / Table 7

## Average 1981 Income by Demographics

| | Total Household Income | Artists' Income: Total | Arts | Arts Related | Nonarts Related | Nonlabor |
|---|---|---|---|---|---|---|
| **Sex: Female** | $23,553 | $12,075 | $ 4,604 | $ 4,185 | $ 2,761 | $ 488 |
| Male | 26,055 | 19,482 | 5,748 | 6,775 | 5,512 | 1,436 |
| **Race: White** | 24,228 | 15,227 | 4,532 | 5,395 | 4,236 | 995 |
| Nonwhite | 43,983 | 34,130 | 24,926 | 8,090 | 1,080 | 34 |
| **Age: 20-29** | 14,319 | 9,460 | 4,122 | 2,513 | 2,596 | 229 |
| 30-39 | 22,448 | 11,973 | 4,595 | 3,648 | 3,342 | 388 |
| 40-49 | 32,316 | 22,650 | 7,347 | 10,432 | 3,693 | 1,166 |
| 50-59 | 32,065 | 22,971 | 4,610 | 7,668 | 9,700 | 1,264 |
| 60-69 | 41,625 | 32,643 | 4,954 | 10,596 | 7,529 | 9,564 |
| 70+ | IS | IS | IS | IS | IS | IS |
| **Education: Degree:** | | | | | | |
| High School | 24,441 | 16,525 | 6,230 | 1,722 | 5,069 | 3,504 |
| Associate's | IS | IS | IS | IS | IS | IS |
| Bachelor's | 20,928 | 11,907 | 5,972 | 2,736 | 2,781 | 388 |
| Master's | 26,187 | 16,051 | 4,260 | 7,168 | 3,723 | 806 |
| Doctorate | 36,900 | 30,039 | 3,668 | 14,252 | 11,459 | 659 |

IS = insufficient sample

The reasons for these income differences involve a number of factors, most of which are beyond the scope of this report. At least a partial explanation, however, can be found in the amount of time artists spent working. As previously discussed, men artists in Rhode Island worked significantly more weeks overall than women artists, with significant differences in the weeks worked as artists and the weeks worked in nonarts-related jobs. (The small differential in artistic income can be explained by the significant difference in weeks worked as an artist and essentially no difference in the number of hours spent per week working as an artist.) The differential in nonarts-related earnings may also be due to a male-female difference in the number of hours worked but unfortunately this information was not obtained. This same factor, number of hours worked per week, may also explain the arts-related earnings differential, though other factors may be important, too.

One method used to simultaneously adjust for both weeks worked and hours worked per week was to estimate an hourly wage. With the information at hand it was only possible to estimate an hourly wage for artistic work. The hourly wage for Rhode Island artists was $7.94 per hour, compared to $6.08 per hour regionwide. The average wage for a production worker in the state was $6.10 in 1981,[10] or 23 percent less than the artist's average wage. Male artists earned more per hour, though not significantly more, than the female artists, $8.73 versus $6.92. In several artistic occupations, however, there were considerable differences. Men musicians earned 41 percent more per hour than women musicians, $8.09 to $5.73. Men visual artists earned more than twice the hourly wage for women, $16.15 versue $6.80, while female writers had wages almost 10 times male writers and poets, $5.59 versus $0.59. Some of these estimates, especially those for actors and writers and poets, may be overestimated because of the relatively small number of artists in these occupations who responded to the survey. When artistic costs are accounted for, the estimated overall "net" wage becomes $3.02 per hour, or $2.79 for women artists and $3.12 for the men artists. These were greater than the wages regionwide.

Age was also a factor in explaining income differences among Rhode Island artists. Total household income increased with an artist's age from more than $14,300 for artists 20 to 29, to more than $41,600 for artists 60 to 69 (there were not enough responses from artists 70 and older to confidently estimate their income). The income received by the artists themselves followed the same increasing pattern. Artists 20 to 29 averaged under $9,500 in total income while artists 60 to 69 averaged more than $32,600 in 1981. Earnings from working as an artist followed a different pattern. Artists 40 to 49 earned the most from working as an artist, $7,350, while the youngest artists, 20 to 29, and the oldest artists, 60 to 69, earned almost the same from their art, more than $4,100 and almost $5,000 respectively. Earnings from nonarts-related work peaked at $9,700 among artists 40

to 49. The youngest artists earned 34 percent of the oldest artists' nonarts-related earnings which were slightly more than $7,500. Earnings from arts-related work diverged considerably from this age pattern. The artists 40 to 49 and 60 to 69 earned about the same, $10,400 to $10,600, while artists 50 to 59 earned three-quarters of that and the youngest artists earned approximately one-third of that amount. Not surprisingly, the artists 60 to 69 received the most nonlabor income, $9,600, while the youngest artists received the least, just under $230. Clearly the bulk of the nonlabor income was social security or some other source of retirement income.

The formal schooling received by Rhode Island artists was also related to the income they received in 1981. The relationship between education and income raises some interesting questions concerning its value to the artists. In general an artist's income increased with additional years of schooling, a relationship that apparently holds true throughout the work force. This relationship was important for total household income, total income received by an artist, and an artist's arts-related earnings. Where the Rhode Island artists competed directly with nonartists for jobs, (for example, nonarts-related work) there was only weak evidence indicating that more schooling was related to increased earnings. It is possible that artists were underemployed in their nonarts-related work, or possibly the nonarts-related jobs that best fit the artists' needs did not require a great deal of schooling. For artistic earnings and nonlabor income additional schooling was actually related to less income rather than more. The relationship of artistic earnings and education was not strong and may simply have been a reflection of the increased value of the artist's time in alternative activities, such as arts-related work, relative to the time spent working as an artist. For nonlabor income this relationship was very strong.

When comparing the highest degree earned by Rhode Island artists to their income, essentially the same patterns emerged. Total household income for artists with doctorates was 50 percent higher than for artists with only a high school diploma, $36,900 versus $24,100. Artists who stopped at the bachelor's degree came from households with total incomes 13 percent lower than high school graduates, and the households of artists with master's degrees had income 9 percent higher. The pattern was essentially the same for total income received by the artist with the range from $11,900 for artists with bachelor's degrees to $30,000 for holders of doctoral degrees. Artists with bachelor's degrees earned almost $6,000 from their art, about $400 more than artists with high school degrees, and $2,300 more than artists with doctoral degrees. For arts-related earnings, the artists with high school degrees earned 13 percent of what the artists with doctorates earned ($14,252), who earned twice what artists with master's degrees earned. With respect to nonarts-related earnings, the artists holding doctoral degrees earned the most, almost $11,500, followed by the high school

graduates, with less than $5,750, master's degree holders and bachelor's degree holders. Artists in Rhode Island with only high school degrees received much more in nonlabor income than any other group of artists. They received almost $3,700 in 1981, while the next group of artists, those with master degrees received $806. The others received even less. This pattern, along with others, would suggest that a considerable proportion of those artists with high school degrees were older artists. They did not receive more schooling because at the time they entered the labor market schooling was not an important factor in securing a job or working as an artist.

# Rhode Island — Endnotes

[1] Department of Commerce, Bureau of the Census, *1980 Census of Population and Housing: Provisional Estimates of Social, Economic, and Housing Characteristics.* (Washington D.C.: 1982), Table P-1, p. 7.

[2] Ibid., p. 29.

[3] Ibid., p. 18.

[4] U.S. Department of Labor, Bureau of Labor Statistics, *News,* No. 82-255, July 20, 1982.

[5] In May of 1980 4.9 percent of the national work force were multiple jobholders. U.S. Department of Labor, Bureau of Labor Statistics, *News,* No. 81-8, January 14, 1981.

[6] Multiple responses to this question were permitted.

[7] Multiple responses to this question were permitted.

[8] From special tabulations of the U.S. Bureau of the Census, 1981 Current Population Survey data tapes for New England.

[9] *1980 Census,* Table P-3, p. 29.

[10] U.S. Department of Labor, Bureau of the Census. *Employment and Earnings,* Vol. 28, No. 5, May 1982, p. 121.

# Vermont

Artists in **Vermont** had a median age of 37.9 and were 50.0 percent female and 0.9 percent nonwhite.

They averaged 16.6 years of school. A little over 82 percent (82.5) had at least a bachelor's degree. In addition, 88.2 percent received specialized artistic training in school, and 72.5 percent received such training outside of school.

They worked 39.3 weeks as artists in 1981. In addition to their work as artists, 56.9 percent held jobs related to their art for an average of 32.5 weeks and 32.6 percent held jobs not related to their art for 29.5 weeks. Holding more than one job at a time was common. Nevertheless, 20.6 percent were unemployed and 25.8 percent dropped out of the labor force during the year.

They earned $13,843 in income from all sources in 1981. Their household income (including earnings of other household members) was $25,146. However, the income they earned as artists was $6,385. In earning their artistic income, they incurred nonreimbursed costs of $4,137.

# Demographic and Educational Characteristics

The occupational distribution of Vermont artists was similar to that regionwide. Table 1 shows visual artists as the largest group, accounting for almost one-third of the artists. Craft artists were next, comprising almost one-quarter of the artists in the state. This was, however, almost 20 percent more than in the region. Another major difference between Vermont and New England was the proportion of musical performers among Vermont artists—approximately half the regionwide proportion. This probably reflects a relative lack of job opportunities for musicians in Vermont or within a reasonable distance of the state. On the other hand, the proportion of choreographers, composers, and playwrights in Vermont was twice the proportion regionwide.

The median age of Vermont artists is almost 38, making them slightly older than the typical artist in New England and almost ten years older than the typical resident of the state.[1] There were an equal number of male and female respondents to the questionnaire. Because men make up 57 percent of the labor force, this means there was a greater proportion of women among Vermont artists than in the general labor force.[2] Minority artists were underrepresented in the state relative to New England. Essentially all of Vermont artists were white with only a few of Spanish descent.

On the average, Vermont artists were slightly better educated than artists regionwide with an average of 16.6 years of formal schooling. Eighty-five percent earned a minimum of a bachelor's degree, which was slightly greater than the proportion in the region. In comparison only 25 percent of all the residents of Vermont 25 years old and over had four or more years of college.[3] Clearly Vermont artists were well educated relative to the general population of the state.

As shown in Table 2, however, not all Vermont artists were equally well educated. Theater production personnel averaged the most formal schooling and had the largest proportion with graduate degrees. Regionwide they were not as well educated, indicating that in Vermont this group may include a greater proportion of teachers, especially at the college level, than throughout New England. The craft artists in Vermont had the least formal schooling, averaging only 16.1 years.

Almost 90 percent of Vermont artists received artistic training as part of their formal schooling. Over 40 percent of the artists received some artistic training in high school, with about 7 percent attending a special arts high school. Of those who attended college, almost 60 percent majored in their art and over 35 percent did this while attending an art school. Only 20 percent of Vermont artists did not take art courses as part of their undergraduate education. In Vermont almost 62 percent of the

# Vermont / Table 1

## Demographic Characteristics of the Artists

| | Percent by Occupation | Median Age | Percent Who Are: | | Percent Who Are: | | | | | Percent Who Are: |
| --- | --- | --- | --- | --- | --- | --- | --- | --- | --- | --- |
| | | | Male | Female | Amer. Indian | Asian | Black | White | Other | Hispanic |
| All Artists | 100.0% (n = 218) | 37.9 | 50.0% | 50.0% | 0.5% | 0.5% | 0.0% | 99.1% | 0.0% | 1.5% |
| **By Occupation:** | | | | | | | | | | |
| Dancers | 2.3 | IS | IS | IS | IS | IS | IS | IS | IS | IS |
| Musicians | 8.8 | 42.0 | 73.7 | 26.3 | 0.0 | 0.0 | 0.0 | 100.0 | 0.0 | 0.0 |
| Actors | 2.8 | 32.0 | 66.7 | 33.3 | 0.0 | 0.0 | 0.0 | 100.0 | 0.0 | 0.0 |
| Theater Production Personnel | 5.1 | 35.5 | 54.6 | 45.4 | 0.0 | 0.0 | 0.0 | 100.0 | 0.0 | 0.0 |
| Writers and Poets | 11.5 | IS | IS | IS | IS | IS | IS | IS | IS | IS |
| Choreographers, Composers, and Playwrights | 6.0 | 39.0 | 30.8 | 69.2 | 0.0 | 8.3 | 0.0 | 91.7 | 0.0 | 8.3 |
| Visual Artists | 31.3 | 38.8 | 47.1 | 52.9 | 1.5 | 0.0 | 0.0 | 98.5 | 0.0 | 1.6 |
| Media Artists | 8.8 | 37.0 | 68.4 | 31.6 | 0.0 | 0.0 | 0.0 | 100.0 | 0.0 | 0.0 |
| Craft Artists | 23.5 | 30.0 | 38.8 | 61.2 | 0.0 | 0.0 | 0.0 | 100.0 | 0.0 | 2.1 |

IS = insufficient sample

artists with graduate schooling majored in their art with 43 per-
cent of this occurring at art schools.

A large proportion of Vermont artists, almost 73 percent,
participated in artistic training outside of their formal schooling.
This was slightly below the regionwide participation level of 75
percent. The average age for starting this training was 14, with
dancers and musicians typically starting their training at a younger
age. The artistic occupation with the greatest participation in
this type of training was the choreographers, composers, and
playwrights, probably because the group includes a number of
choreographers who are or were dancers. In Vermont, over 34
percent of the artists participated in some form of artistic train-
ing outside formal schooling during 1981. The average artist
spent almost 12 hours per week for 15 weeks in this training and
at an average cost of $340.

# Labor Market Characteristics

Many artists in Vermont, as well as throughout New Eng-
land, found it necessary to hold jobs other than as artists. Only
28 percent of Vermont artists held no other job. Regionwide
almost 25 percent of the artists were "pure" artists. Over half
of the Vermont artists worked in a job related to their art at some
time during 1981. Almost one-third of the artists held a job un-
related to their art, while 17 percent worked at both types of
jobs, arts-related and nonarts-related, at some time during 1981.

The types of arts-related jobs held by Vermont artists were
very similar to those held by artists throughout New England
(see Table 3). Almost 78 percent of the artists who held arts-
related jobs were teachers, either privately or as part of formal
schooling. Nine percent of the artists who held arts-related jobs
worked in arts management. The remainder of the arts-related
jobs were professional and sales jobs that were not artistic in
nature but were in arts enterprises.

The largest proportion of Vermont artists holding nonarts-
related jobs taught at the primary, secondary, or college level.
They accounted for more than one-quarter of the nonarts-related
jobs. In the region, less than 15 percent of the artists who held
nonarts-related jobs taught. Another difference between Ver-
mont and the rest of New England was that none of the artists held
clerical jobs and the proportion having held sales jobs was half
that of the region. Other differences between the state and the
region were a smaller proportion of Vermont artists worked in
professional, technical, and service jobs, and a larger proportion
worked in managerial and building trade jobs. These differences
in nonarts-related jobs held by Vermont artists may simply
reflect differences in job opportunities in the state relative to
the opportunities available in the other New England states. It
would appear that relatively few Vermont artists supplemented
their artistic income by working as a waitress or cook.

# Vermont / Table 2

## Educational Attainment of Artists

| | Median Years of Schooling | Percent with Highest Attainment of: | | | | | | | Percent with Specialized Arts Training: | |
| --- | --- | --- | --- | --- | --- | --- | --- | --- | --- | --- |
| | | Less than High School | High School Diploma | Associate's | Bachelor's | Master's | Doctorate | Other | As Part of Formal Education | Outside of Formal Education |
| All Artists | 16.6 | 0.5% | 11.8% | 3.3% | 44.1% | 34.6% | 3.8% | 1.9% | 88.1% | 72.5% |
| By Occupation: Dancers | IS | IS | IS | IS | IS | IS | IS | IS | IS | IS |
| Musicians | 17.3 | 0.0 | 16.7 | 5.6 | 27.8 | 44.4 | 5.6 | 0.0 | 94.4 | 73.7 |
| Actors | 16.5 | 0.0 | 0.0 | 0.0 | 83.3 | 16.7 | 0.0 | 0.0 | 66.7 | IS |
| Theater Production Personnel | 18.9 | 0.0 | 0.0 | 9.1 | 18.2 | 72.7 | 0.0 | 0.0 | 100.0 | 63.6 |
| Writers and Poets | 17.9 | 4.0 | 0.0 | 4.0 | 28.0 | 48.0 | 16.0 | 0.0 | 80.0 | 56.0 |
| Choreographers, Composers, and Playwrights | 16.4 | 0.0 | 7.7 | 0.0 | 38.5 | 38.5 | 7.7 | 7.7 | 100.0 | 92.3 |
| Visual Artists | 16.4 | 0.0 | 17.9 | 1.5 | 49.3 | 28.4 | 1.5 | 1.5 | 93.8 | 69.7 |
| Media Artists | 17.7 | 0.0 | 0.0 | 5.9 | 35.3 | 52.9 | 5.9 | 0.0 | 72.2 | 72.2 |
| Craft Artists | 16.1 | 0.0 | 16.7 | 4.2 | 52.1 | 22.9 | 0.0 | 4.2 | 86.0 | 79.2 |

IS = insufficient sample

This description of job types, however, tells us only what artists did, not how they did it. To understand further how the artist operates in the labor market, the way in which they spent their time was examined (Tables 4 and 5). This "work time" was measured in two ways: by the number of weeks artists worked at all jobs and only as artists and by the number of hours per week they worked solely at their art.

Artists averaged just over 47 weeks working at all jobs during the year, which was a week longer than the regionwide average. They worked almost 40 weeks as artists, 10 percent more than the average New England artist; they worked more than 18 weeks in arts-related jobs, slightly more than regionwide; and more than 9 weeks in nonarts-related jobs, a third less than regionwide. There was more variation in the number of weeks worked among Vermont artists than among artists regionwide. In Vermont, craft artists worked the largest number of weeks during the year, including 15 percent more weeks in art work and 45 percent fewer weeks in nonarts-related work than artists in the region. They were followed by visual artists, who, regionally, worked the most during the year. In Vermont, choreographers, composers, and playwrights worked the fewest weeks, while regionwide, it was actors.

The typical Vermont artist spent 33.6 hours per week working at his or her art. This was almost an hour per week more than the typical artist regionwide. Craft artists spent more time working at their art than any of the other artists and spent 18 percent more time per week than their counterparts regionally. Visual artists in the state also worked more hours than their colleagues regionwide, 35.8 to 34.6 hours. Choreographers, composers, and playwrights in both the state and the region spent the least amount of time working at their art during the typical week.

These findings tell us several things about the artist's behavior in the labor force. Artists not only held down more than one job but more than likely held them simultaneously. Taken together, the sum of the weeks worked in each type of job is greater than the total number of weeks worked and is more weeks than exist in a year. Therefore, artists must have been worked at several jobs at one time. The evidence for this is even stronger when the number of weeks worked in arts-related jobs and nonarts-related jobs is narrowed to only those who held those jobs (values in parentheses in Table 4). The reasons for Vermont artists holding more than one job were many, but economic survival, as will be discussed later, played a major role.

Vermont artists did not work at jobs outside their art because they preferred them; fewer than 2 percent of the artists who held jobs other than their art said they did so out of personal preference. The majority instead cited economic reasons for working outside their art.[4] Almost 60 percent indicated they did so because the pay was better in the nonarts job. Nearly 50 percent indicated that job security was an important reason, with the same proportion indicating that they felt not enough work

# Vermont / Table 3

## Distribution of Other Jobs Held by Artists

|  | Job Type Distribution: | |
| Occupation | Arts-Related | Nonarts-Related |
| --- | --- | --- |
| Professional and Technical | 5.7% | 16.6% |
| Art Educators | 77.9 | 0.0 |
| Other Educators | 1.6 | 25.7 |
| Art Managerial | 9.0 | 0.0 |
| Other Managerial | 1.6 | 16.6 |
| Sales | 1.6 | 6.0 |
| Clerical | 0.0 | 0.0 |
| *Crafts and Kindred Workers | 2.4 | 15.2 |
| Operatives and Laborers | 0.0 | 7.5 |
| Service | 0.0 | 12.1 |

*The word "craft" is not used here in the same sense it is used in the text. It is a U.S. Census term that includes various blue collar workers such as carpenters, mechanics, printers, plumbers, and telephone installers.

was available to support themselves as artists. In addition, over 40 percent of the artists with either an arts-related job or a non-arts-related job felt their other work complemented their artistic work.

Looking at the number of hours that artists worked at their art one might deduce that some artists were more committed to art than others since some artists worked many more hours (Table 5). But this is not necessarily, nor even likely, the case. Instead, work hours probably reflect the income-generating activities that were available to artists at the time. If an actor could not find steady employment, for example, he would have to spend more time working at something else. What is more clearly shown by the examination of work hours is that artists spent a lot of time working. If a writer who worked 27 hours a week writing and had a 15 hour-a-week job as a part-time teacher, it would mean he or she would be working at least a 42-hour work week.

When the amount of time spent working was broken down into men artists and women artists a distinct pattern surfaced. In Vermont, as in the region, men artists worked significantly more weeks overall than women. Men averaged 49.5 total working weeks while women averaged 44.6 total working weeks. This five-week differential can be attributed to the more than 7 additional weeks men worked as artists, 42.9 weeks as opposed to 35.4 weeks. Both men and women artists worked more of the year as artists than comparable artists regionwide.

Men artists in Vermont also worked more in arts-related jobs, 19.0 weeks versus 17.5 weeks for women. Women worked a little longer in nonarts-related jobs, 8.4 weeks versus 8.1 weeks, but the differences were not significant. A possible reason for this discrepancy in work time may be attributed to the fact that more than 36 percent of all the artists in Vermont said they left the labor force some time during 1981 (that is, they were neither employed nor unemployed) due to family obligations. Even in 1981, family obligations were more likely to keepwomen artists from working than men artists.

Women artists in Vermont not only worked fewer weeks during 1981 but they worked significantly fewer hours as artists than their male counterparts. Women averaged 29.5 hours per week working in their art, while men averaged 37.4 hours per week. The largest differential was 16 hours between the male and female visual artists and craft artists. Only among the theater production personnel did the women work more hours than the men, but with only eight artists in this occupation the estimates of hours worked are likely to be subject to relatively large sampling error and therefore not reliable.

Many Vermont artists were unemployed during 1981. Almost 21 percent (essentially the same proportion as artists in the region and nationally for all workers[5]) had at least one period of unemployment during the year. (Unemployment occurs when an artist is not working as an employee nor is self-employed but when he or she is seeking work.) Choreographers,

# Vermont / Table 4

## Weeks Employed In 1981

|  | Overall | As An Artist | In Arts-Related Jobs* | In Nonarts-Related Jobs* |
|---|---|---|---|---|
| **All Artists** | 47.1 | 39.3 | 18.1 (32.5) | 8.2 (29.5) |
| **By Occupation:** | | | | |
| **Dancers** | IS | IS | IS | IS |
| **Musicians** | 44.4 | 30.1 | 31.3 (43.3) | 3.2 (IS) |
| **Actors** | IS | IS | IS | IS |
| **Theater Production Personnel** | 43.3 | 38.0 | 22.5 (35.3) | 9.5 (IS) |
| **Writers and Poets** | 47.7 | 42.2 | 22.4 (37.3) | 15.8 (36.8) |
| **Choreographers, Composers, and Playwrights** | 38.7 | 22.1 | 19.4 (28.0) | 6.1 (IS) |
| **Visual Artists** | 48.3 | 43.7 | 15.0 (30.5) | 7.8 (34.5) |
| **Media Artists** | 46.7 | 41.9 | 11.5 (20.4) | 10.3 (IS) |
| **Craft Artists** | 49.4 | 43.6 | 14.0 (31.9) | 5.8 (19.7) |

*Numbers in parentheses are weeks worked in arts-related and nonarts-related jobs for only those artists who held such jobs.

IS = insufficient sample

The sum of the weeks worked exceeds the overall total if artists held two or more jobs at the same time.

composers, and playwrights were the most likely to be unemployed, with almost 42 percent unemployed sometime during 1981. They were closely followed by media artists (approximately 38 percent) and theater production personnel (little more than 36 percent) unemployed during the year. The craft artists were by far the least likely to be unemployed, with only 6 percent of them having an unemployment spell during 1981. This pattern differs somewhat from the regional unemployment patterns discussed earlier although sample size problems among the dancers and actors in Vermont prevent a direct comparison. The average unemployed artist was unemployed for 11.6 weeks during the year, and almost 40percent received unemployment insurance.

Aside from being unemployed, some artists dropped out of the labor force altogether—approximately 26 percent left the labor force some time during 1981. (Out of the labor force means an artist was unemployed but not seeking work.) Almost 42 percent of the artists who left the labor force during 1981 did so to practice their art and, as discussed above, more than 36 percent of those who left the labor force at some time during the year did so because they had family obligations.[6] Other reasons cited by artists were illness, no work available, and school.

Artists in Vermont do not differ very much from the artists throughout the region in their labor market behavior, but they do differ from the general worker in the state, especially when compared to those with similar educational backgrounds. They were much more likely to hold more than one job and work longer hours.

# Income

Vermont artists received income from a number of different sources. They received labor income from work as artists, from arts-related jobs, and from nonarts-related jobs. They received nonlabor income from returns on investments, interest, dividends, and transfer payments, such as social security, unemployment insurance, and public assistance. Artists also received in-kind income through trading a good or service they produced for a good or service produced by someone else. Table 6 provides information on the average 1981 income received by Vermont artists from these sources (median values are in the parentheses).

Vermont artists belonged to households with an average 1981 income of $25,146. In 1980, the average income for a Vermont household was $18,922.[7] One year of inflation explains some of this income difference, but not all of it. It would therefore appear that Vermont artists were members of households with above average incomes. But despite this, their average household income was below that of artists regionwide, by $2,150.

Very few Vermont artists had no one sharing living expenses with them. Over three-quarters of the artists (76.7 percent)

# Vermont/Table 5

## Hours Working as an Artist in a Typical Week in 1981

| | Total | Performing Artists: | | | | Nonperforming Artists: | | |
| --- | --- | --- | --- | --- | --- | --- | --- | --- |
| | | Performing | Rehearsing | Practicing | Looking for Work | Creating | Training | Marketing |
| All Artists | 33.6 | - | - | - | - | - | - | - |
| **By Occupation:** | | | | | | | | |
| Dancers | IS | IS | IS | IS | IS | - | - | - |
| Musicians | 23.1 | 6.8 | 7.0 | 8.2 | 1.1 | - | - | - |
| Actors | IS | IS | IS | IS | IS | - | - | - |
| Theater Production Personnel | 30.1 | 3.8 | 15.5 | 3.8 | 0.8 | - | - | - |
| Writers and Poets | 27.0 | - | - | - | - | 22.3 | 0.1 | 4.0 |
| Choreographers, Composers, and Playwrights | 18.1 | | | | | IS | IS | IS |
| Visual Artists | 35.8 | - | - | - | - | 30.1 | 1.2 | 4.2 |
| Media Artists | 32.1 | - | - | - | - | 25.1 | 1.2 | 5.5 |
| Craft Artists | 42.3 | - | - | - | - | 33.4 | 1.1 | 7.6 |

IS = insufficient sample

shared their income or living expenses with another person. The artist was the sole supporter in only 12 percent of these households. Almost 56 percent of the artists had other household members who worked full-time and almost 33 percent had other household members who worked part-time. In 1979, only 58 percent of the families in Vermont had two or more workers.[8]

There was considerable variation in household incomes among artists. The households of the media artists, choreographers, composers, and playwrights, and theater production personnel had 1981 incomes within $1,000 of each other with media artists having the highest household income. Regionally, media artists and theater production personnel had average household incomes about equal but almost $4,000 less than the same artists in Vermont. Craft artists and writers and poets were members of households with incomes about $4,000 less than the previous occupations but almost $3,000 more than the households of musical performers and visual artists. This is similar to the regionwide ranking with some minor differences.

In Vermont, the average artist brought in approximately 55 percent of his or her household income, approximately the same proportion as regionwide. Musicians were responsible for the largest share of their household income, 65 percent, while the choreographers, composers, and playwrights, and writers and poets contributed the smallest proportion, only 33 percent, and the smallest dollar amount, almost $10,000. Theater production personnel in the state contributed the largest dollar amount, more than $19,000 on average.

Vermont artists earned more from their art work than from any other kind of work they did. In 1981, the average Vermont artist earned almost $6,400, or 46 percent of his or her total labor income. This was equal to the earnings of the average New England artist. An additional 27 percent, or $3,800, of his or her income came from arts-related work, a somewhat smaller share and dollar amount than regionwide. Nonarts-related work accounted for another $1,800, or 13 percent of his or her income, which was less than the regionwide average.

Not all the state's artists earned more from their art than from other work. Craft artists were the most successful. They earned more than $11,500, or three-quarters of their income, from their art. Choreographers, composers, and playwrights were the least successful, earning only $1,600, or 15 percent of their income, from their art. Only two other occupational groups, visual artists and media artists, earned more from their art than from the combined earnings of working at an arts-related job and a nonarts-related job.

Nonlabor income accounted for an average of almost $1,900, or 14 percent, of the Vermont artist's income. This was 21 percent more than received by artists regionally. For the theater production personnel in the state, this nonlabor income, for example, rent, interest, dividends, and transfer payments, made up more than 40 percent of their income. It ac-

# Vermont/Table 6

## Income and Artistic Costs in 1981

| | Total Household Income | Artist's Income: Total* | As Artist | In Arts-Related Work | In Nonarts-Related Work | Nonlabor | Value of Art Work Bartered | Total Artistic Costs |
|---|---|---|---|---|---|---|---|---|
| All Artists | $ 25,146 (20,000) | $ 13,843 (10,000) | $ 6,385 | $3,791 | $1,789 | $1,872 | $321 | $4,137 |
| By Occupation: | | | | | | | | |
| Dancers | IS | IS | IS | IS | IS | IS | IS | IS |
| Musicians | 23,311 (18,154) | 15,102 (12,000) | 4,846 | 7,884 | 2,179 | 435 | 587 | 2,945 |
| Actors | IS | IS | IS | IS | IS | IS | IS | IS |
| Theater Production Personnel | 30,238 (29,008) | 19,147 (16,100) | 3,742 | 5,294 | 2,286 | 7,825 | 318 | 1,138 |
| Writers and Poets | 25,442 (20,033) | 16,367 (15,600) | 3,418 | 6,198 | 3,683 | 3,068 | 110 | 2,249 |
| Choreographers, Composers, and Playwrights | 30,558 (14,000) | 9,977 (10,000) | 1,622 | 5,104 | 1,240 | 2,011 | 23 | 2,436 |
| Visual Artists | 23,048 (20,000) | 12,240 ( 8,600) | 6,430 | 3,225 | 1,191 | 1,377 | 312 | 3,938 |
| Media Artists | 31,278 (20,500) | 14,609 (10,990) | 6,634 | 2,394 | 3,661 | 1,920 | 218 | 4,975 |
| Craft Artists | 26,139 (20,041) | 15,132 ( 9,222) | 11,523 | 1,834 | 794 | 742 | 520 | 7,601 |

*Components of total artist's income may not add exactly to total because of nonresponses to question requesting breakdown of total income.
IS = insufficient sample

counted for 20 percent or less of the income of the other artists.

Many Vermont artists engaged in bartering. They received on the average $310 worth of goods and services. Vermont artists received 59 percent more income from bartering than did artists regionally. Musicians were the most successful in bartering in Vermont and one of the least successful groups regionwide. They were followed by craft artists, who were the only other artistic occupation to receive more than the average for the state. In Vermont, only the choreographers, composers, and playwrights, and writers and poets had barter income less than the regionwide average.

Artists surveyed in this study frequently had more expenses than income from their art. Vermont artists showed the same tendency. They spent an average of $4,100, or 65 percent of their artistic income in 1981 to produce their art. This then made the artists' net income only $2,300. Looking at it another way, the majority of the artists (54 percent) spent more in unreimbursed expenses to produce their art than they received in income from it. Not surprisingly craft artists spent the most to produce their art, but they also had the highest net income. Most of the artists, however, were clearly using other financial resources, such as nonarts income or other household members, to at least partially support their artistic endeavors.

In general, women artists received less income from all sources than men artists with the exception of nonlabor income (see Table 7). The average woman artist received 70 percent of the income of the average man artist, $11,400 versus $16,345. Much of this can be attributed to a $4,500 difference in artistic earnings. Male artists earned $8,571 and female artists earned $4,034. Male artists also earned $1,300 more from arts-related work, $4,439 versus $3,149, and from nonarts-related work, $1,867 versus $1,743. Female artists received $900 more in nonlabor income, $2,380 versus $1,456. The only advantage female artists had was being a member of a household with more total income, $26,151 versus $23,962.

A complete examination of the reasons for these income differences is beyond the scope of this report, but it is apparent that some of the difference can be explained by the amount of time spent working. As previously mentioned, women artists in Vermont worked significantly fewer weeks overall primarily because they worked fewer weeks at their art. Women artists worked fewer weeks in arts-related jobs, but only slightly less, possibly explaining the small differential in arts-related income. They worked slightly more weeks in nonarts-related jobs but earned slightly less. Without information on the number of hours worked, it is not possible to determine whether the amount of time spent working was important or some other factor, such as a difference in the types of nonarts-related jobs held by the male and female artists, caused the differences.

An hourly wage is another way of looking at how much artists earned. With the information from the survey, it was only

# Vermont / Table 7

## Average 1981 Income by Demographics

*Artists' Income:*

| | Total Household Income | Total | Arts | Arts-Related | Nonarts-Related | Nonlabor |
|---|---|---|---|---|---|---|
| **Sex: Female** | $26,151 | $11,400 | $4,035 | $3,149 | $1,743 | $2,380 |
| **Male** | 23,962 | 16,345 | 8,571 | 4,439 | 1,867 | 1,456 |
| **Race: White** | 25,003 | 14,006 | 6,445 | 3,853 | 1,782 | 1,924 |
| **Nonwhite** | IS | IS | IS | IS | IS | IS |
| **Age: 20-29** | 16,456 | 8,719 | 4,510 | 2,151 | 1,869 | 189 |
| **30-39** | 21,454 | 12,720 | 6,061 | 3,351 | 1,900 | 1,507 |
| **40-49** | 33,780 | 19,090 | 9,658 | 5,717 | 1,848 | 1,850 |
| **50-59** | 34,131 | 15,168 | 4,496 | 5,595 | 2,364 | 2,458 |
| **60-69** | 23,889 | 12,144 | 4,334 | 491 | 0 | 7,499 |
| **70+** | 19,479 | IS | IS | IS | IS | IS |
| **Education: Degree:** | | | | | | |
| **High School** | 23,874 | 9,396 | 7,191 | 1,599 | 651 | 64 |
| **Associate's** | 27,678 | 14,938 | 3,543 | 1,664 | 4,075 | 5,656 |
| **Bachelor's** | 23,888 | 12,358 | 6,224 | 2,848 | 1,721 | 1,515 |
| **Master's** | 26,269 | 16,931 | 7,132 | 5,651 | 1,472 | 2,731 |
| **Doctorate** | 28,256 | 18,134 | 1,098 | 7,107 | 7,572 | 2,358 |

IS = insufficient sample

possible to estimate an hourly wage for art work. Vermont artists earned $5.19 as artists, compared to the average of $6.08 region-wide. The average wage for production workers in Vermont for 1981 was $6.79,[9] or 30 percent higher than the artists' average wage. Overall, there was very little difference between the wages for men and women artists, $5.30 and $5.06, respectively. But in several specific occupations there were considerable differences. The men craft artists worked for a wage more than double that of women craft artists, $8.52 versus $3.65. The male visual artist's wage was 40 percent higher than the female wage, $5.17 versus $3.64. Male musicians also received a higher wage than female musicians, $7.81 versus $5.53. Women writers and poets earned more than the men writers on an hourly basis, $5.04 versus $2.69. For the other artistic occupations, there were too few artists to estimate their wage. When artistic costs are subtracted, the "net" hourly wage of all artists is $0.17. For men, it is $1.36; for women, it is minus $0.03.

Vermont artists' income also varied with their age. Total household income increased with age from almost $16,500 for artists 20 to 29 to more than $34,100 for artists 50 to 59, and then declined to almost $19,500 for artists 70 or older. The pattern for labor income earned by the artists was essentially the same. Artistic income and arts-related income reached a peak for artists 40 to 49, at almost $19,750 and $5,720, respectively, and declined with age until the artists 70 and older earned less than one-third the peak earnings and considerably less than artists just starting their careers. Peak earnings from nonarts-related work occurred later in life, 50 to 59. None of the artists 60 or older earned any nonarts-related income. This differs considerably from the behavior of artists regionwide, especially those 60 to 69, who, on the average, earned almost $2,650 from nonarts-related work. Not surprisingly, the amount of nonlabor income, which includes social security, received by the artist increased with age from almost $190 for the artist 20 to 29, to $7,500 for the artist 60 to 69, or 62 percent of this group's total income.

Vermont artists, like artists regionwide, were very well educated, but the relationship between their education and their income raises questions concerning its value. In general, the more formal schooling completed by the artist, the higher his or her income. Artists' arts-related earnings, nonarts-related earnings, and nonlabor income increased significantly with additional years of formal schooling. But this was not true for artistic earnings and total household income. In fact there was weak evidence that the artist's earnings from his or her art may actually decrease with additional years of schooling. This may simply be a reflection of the increased value of the artist's time in alternative activities, such as teaching, relative to working at his or her art.

The relationship between education and earnings generally held true when comparing income and the highest degree earned by the artists. The artist who stopped his or her schooling after

high school had a household income that averaged $23,900, while the artist with a doctoral degree had a household income that averaged $28,300. There was a greater difference in total income earned by artists. High school graduates earned approximately $9,400, while people holding doctoral degrees earned $18,100. All artists earned approximately $7,000 from working as artists except for those with doctorates who only earned $1,100. For the high school graduate, his or her art income accounted for 77 percent of his or her income while it was only 6 percent of the doctorate's income. Artists with bachelor's and master's degrees earned 50 percent and 42 percent, respectively, of their incomes from working at their art. Arts-related work accounted for 17 percent of the high school graduate's income; 23 percent of the income of artists with bachelor's degrees; 33 percent of the income of artists with master's degrees; and 39 percent of the income of those with the doctorates. Except for the artists with doctoral degrees, the average artist earned less than 15 percent of his or her income from working at a nonarts-related job, 7 percent for high school graduates, 7 percent for master's degree holders, and 14 percent for bachelor's degree holders.

# Vermont — Endnotes

[1]Department of Commerce, Bureau of the Census. *1980 Census of Population and Housing: Provisional Estimates of Social, Economic, and Housing Characteristics.* (Washington D.C.: 1982), Table P-1, p. 8.

[2]Ibid., Table P-3, p. 30

[3]Ibid., Table P-2, p. 19.

[4]Multiple responses to this question were permitted.

[5]U.S. Department of Labor, Bureau of Labor Statistics. *News,* No. -255, July 20, 1982.

[6]Multiple responses to this question were permitted.

[7]Special tabulations of the U.S. Bureau of the Census, 1981 Current Population Survey data tapes in New England.

[8]*1980 Census,* Table P-3, p. 30.

[9]U.S. Department of Labor, Bureau of Labor Statistics., *Employment and Earnings,* Vol. 29, No. 5, May 1982, p. 121.

# Appendices

# Appendix A

## Survey Methodology

The survey instrument was drafted by the authors. It was evaluated by staff members of the New England Foundation for the Arts, the Massachusetts Council of the Arts and Humanities, and 18 artists who serve on an advisory panel to the Council. A revised version of the questionnaire incorporated changes recommended by its critics and was mailed to Massachusetts artists. The same questionnaire, with minor changes to correct typesetting errors and to insert the appropriate calendar year, was mailed to artists in the other five New England states. The questionnaire is reproduced in Appendix B.

A problem in surveying artists living in any state or region is getting a random and representative sample. There is no single organization whose roster or mailing list that contains all known artists, for example. Although this situation may be true for other professionals as well, it is usually possible to draw representative samples based upon populations reported in each state or area in the United States Census. This task is also made difficult because of two characteristics inherent in the Census treatment of artistic occupations.

First, the occupations that are categorized as "artistic" do not correspond to other definitions. Second, the Census requests a person's primary occupation on its form. Many artists hold nonartistic jobs as well, and the nonartistic jobs are often better paying. It becomes unclear which job such persons would list on the Census form. It probably means that the new or financially unsuccessful artist is likely to list an alternative occupation if he has one.

Despite these shortcomings and because there is no better reference, the 1970 Census was used as the basis for distributing questionnaires among the six New England states and among artistic fields within states. Detailed tabulations on the distribution of New England artists from the 1980 Census were not then and are still not available. Because of reasons noted above, however, the Census distribution of artistic disciplines was not followed exactly. The types of occupations classified by the Census as artistic but not included in this survey are architects, radio and television announcers, and a few occupations in the Census "not elsewhere classified" artistic category, such as acrobats and translators. Announcers, acrobats, and translators were excluded because these occupations were considered to be only peripheral to that of artist. While this argument could also be made for excluding architects, they were excluded primarily because their job market is quite different from the job market for artists with similar skills.

Added to the occupations to be surveyed was that of craft artist. Excluded from the artistic occupations by the Census, craft artists produce and sell their product in ways analogous to visual artists. Furthermore, many artists describe themselves as possessing skills of both the crafts artist and the visual artist. Based on their relative appearance in organizations that have memberships comprising both craft artists

and visual artists, craft artists were sampled at one-third to two-thirds the sampling rate of visual artists, depending on the state.

Because of anticipated sample size problems, all artists in small states (Maine, New Hampshire, and Vermont) and artists in fields where the Census reported few artists (primarily dance) were oversampled. Sampling by artistic field was simplified because every mailing list used was either for a specific field or identified artists by field. But some ambiguity arose because of differences between field and occupation. For example, it usually was not possible to determine in advance how many names on a dance mailing list were choreographers as opposed to dancers. Also, because artists were asked to identify their occupation on the questionnaire, it is to be expected that some may have listed occupations other than these indicated by the mailing list.

For all states the same procedure was followed to obtain mailing lists of artists. Among the organizations and sources solicited for mailing lists were unions and membership organizations, performing and repertory organizations, artistic periodicals and directories, art schools and guilds, and art departments of colleges and universities (for both faculty and alumni), and regional, state and local artist councils. A full list of organizations which contributed mailing lists may be found in Appendix C. Some lists contained names within only one state; others covered all of New England. The major factor in selecting lists was establishing an adequate sample of artists in each field in each state.

The strategy for obtaining lists called for initially contacting national artist organizations, followed by regional, state, and local artist groups. The intention was to obtain lists that would reflect the various kinds and size of organizations to which New England artists belonged, for example, art medium groups as well as the more general "umbrella" arts organizations, artist unions and other labor-related groups within the arts, and arts organizations with open membership and those with more selected membership criteria. Major New England arts training institutions were also contacted for lists of graduates.

Library resources were used to locate New England artists for sampling, including artist directories. In addition, the catalogues of more than 50 New England colleges and universities offering courses in the arts were used to sample for academic artists.

One primary source of New England artists was a computerized mailing list provided by the New England Foundation for the Arts, prepared with the assistance of the New England state art commissions and councils.

The questionnaire mailing occurred in 1981 in Massachusetts and in 1982 in the other New England states. Because of the regional scope of the questionnaire distribution, it was not possible to provide advance publicity to all artists receiving the questionnaire, although attempts were made in some states. A second negative factor affecting the response rate is the length of the questionnaire. It is four pages in length and contains 39 questions. It takes a conscientious person at least a half-hour to complete. Nevertheless, the questionnaire was completed and returned by 3,096 artists in New England. Overall, the response rate was 17.3 percent. Among states, it ranged from a low of 15.6 percent in Rhode Island to a high of 23.7 percent in Maine. More detail on the response to the questionnaire mailing may be found in Table A-1.

Although the data derived from the questionnaire responses form the core of this study, no survey instrument can elicit all relevant information from its subjects. To fill in gaps and to pursue some topics in greater depth, personal interviews with about 100 artists were held

throughout New England. Most of these interviews were conducted in group sessions of from five to ten artists. Artists were nominated for these interviews so that there would be a diversity of occupations, career stages, ages, and degrees of success. Obviously, the information derived from these interviews is not quantitative in nature. It was very helpful, however, in filling out the part of the narrative where quantitative data do not reveal the whole story.

On the questionnaire, each artist assigned himself to an artistic occupation when he answered the first question. If an artist held more than one artistic occupation, he was asked to rank them in terms of income (highest first). All artists naming more than one artistic occupation were classified by the first one listed. To the selection, the artist was given a menu of fifty-two artistic occupations, listed on the back of the questionnaire, to choose from. If none of them adequately described his skills, he was asked to write his own description. The occupations named by the artists were reduced to nine by grouping related skill areas under the same occupational title. Four of the nine, dancers, musicians, actors, and theater production personnel, are occupations in the performing arts. The other five occupations, writers and poets, choreographers, composers and playwrights, visual artists, crafts artists, and media artists, involve artistic skills that culminate in the production of a tangible product, for example, a play, sculpture, or film.

In several cases there was considerable diversity within occupational groups. This can be seen by examining Table A-2. To cite one instance, "musician" is further broken into nine suboccupations. In the information on artists was not broken down beyond the nine occupations. However, a knowledge of the composition of any occupational category may be important in interpreting the information. For example, characteristics of the theater production personnel category will be heavily influenced by the characteristics of artistic directors, who constitute 52 percent of this group. Furthermore, artistic directors may have less in common with artists within other suboccupations in their group than with other artists within dominant suboccupations such as writers, painters, and photographers.

Another factor, not directly observable in the occupational classes reported in the text that may influence the responses of artists is the existence of multiple occupational skills among artists. Of the 3,027 respondents, 44 percent reported possessing a second artistic occupation, 17 percent reported possessing a third artistic occupation, and 5 percent reported possessing a fourth artistic occupation. An indication of the relationships among artistic occupations is shown in Table A-3, which cross tabulates the occupations listed first and second. Most such relationships can be seen to be cases where one is capitalizing on complementary skills, such as dancer-choreographer. Multiple occupational skills within the same overall occupational group are possible under this classification system. Examples would be string-player—keyboard player (musician) and writer-poet.

# Table A-1

## Response to Questionnaire Mailing

| | Connecticut | Maine | Massachusetts | New Hampshire | Rhode Island | Vermont | Total |
|---|---|---|---|---|---|---|---|
| 1. Number sent | 4,658 | 1,280 | 8,000 | 1,182 | 1,355 | 1,178 | 17,653 |
| Returned, address unknown | 2 | 1 | 5 | 0 | 0 | 0 | 8 |
| Returned, not currently artists | 57 | 21 | 47 | 18 | 12 | 7 | 162 |
| 2. Net number sent | 4,599 | 1,258 | 7,948 | 1,164 | 1,343 | 1,171 | 17,483 |
| 3. Total response | 813 | 312 | 1,281 | 244 | 215 | 231 | 3,096 |
| 4. Received and coded* | 786 | 298 | 1,281 | 234 | 210 | 218 | 3,027 |
| 5. Response rate (4 - 2) | 17.1% | 23.7% | 16.1% | 20.1% | 15.6% | 18.6% | 17.3% |

*A deadline prevented all those returned from being analyzed in time for the study.

181.

# Table A-2

## Breakdown of Surveyed Artists by Occupational Subgroups

| Occupational Group | Occupational Subgroups | Percent of Occupational Group |
|---|---|---|
| Dancer | Dancer | 100% |
| Musician | Conductor | 16 |
| | Keyboard Instrumentalist | 15 |
| | Fretted Instrumentalist | 6 |
| | Percussionist | 6 |
| | String Player | 17 |
| | Brass Player | 12 |
| | Woodwind Player | 12 |
| | Singer | 13 |
| | Other Musician | 3 |
| Actor | Actor | 75 |
| | Mime | 7 |
| | Puppeteer | 6 |
| | Broadcaster / Announcer | 12 |
| Theater Production Personnel | Artistic Director | 52 |
| | Technical Director | 4 |
| | Production Manager | 6 |
| | Stage Manager | 7 |
| | Set / Property Designer | 8 |
| | Lighting Designer | 6 |
| | Costume Designer | 8 |
| | Makeup Designer | 2 |
| | Property Technician | 2 |
| | Lighting Technician | 1 |
| | Carpenter | 1 |
| | Other Theater Production | 4 |
| Writer | Writer | 65 |
| | Poet | 34 |
| | Other Writer | 1 |
| Choreographer, Composer, and Playwright | Choreographer | 34 |
| | Composer | 45 |
| | Playwright | 21 |
| Visual Artist | Painter | 49 |
| | Sculptor | 19 |
| | Graphic Artist | 17 |
| | Graphic Designer | 9 |
| | Conceptual Artist | 1 |
| | Architect | 5 |

# Table A-2 (continued)

| Occupational Group | Occupational Subgroups | Percent of Occupational Group |
|---|---|---|
| **Media Artist** | Photographer | 76% |
| | Filmmaker | 18 |
| | Video Artist | 6 |
| **Craft Artist** | Ceramist | 26 |
| | Stained Glass Artist | 7 |
| | Glassblower | 2 |
| | Enamelist | 1 |
| | Metalsmith | 10 |
| | Woodworker | 9 |
| | Leatherworker | 1 |
| | Fiber Artist | 35 |
| | Papermaker | 1 |
| | Printer / Binder / Typographer | 4 |
| | Other Craft Artist | 3 |

Note: Percentages do not always add to 100 due to rounding.

# Table A-3

## Multiple Occupational Skills Among New England Artists

*Percent With Second Occupation of:*

| First Occupation | Dancer | Musician | Actor | Theater Production Personnel | Writer and Poet | Choreographer, Composer, and Playwright | Visual Artist | Media Artist | Craft Artist | No Second Occupation |
|---|---|---|---|---|---|---|---|---|---|---|
| Dancer | 9.5% | 4.8% | 4.8% | 4.8% | 2.4% | 38.1% | 4.8% | 0.0% | 0.0% | 31.0% |
| Musician | 0.7 | 58.1 | 1.4 | 0.7 | 2.1 | 7.4 | 1.2 | 0.2 | 1.4 | 26.9 |
| Actor | 1.0 | 8.8 | 17.6 | 13.7 | 6.9 | 2.9 | 2.9 | 2.0 | 1.0 | 43.1 |
| Theater Production Personnel | 0.9 | 3.5 | 11.4 | 31.6 | 3.5 | 11.4 | 7.0 | 0.9 | 3.5 | 26.3 |
| Writer and Poet | 0.0 | 1.9 | 1.0 | 1.9 | 23.1 | 4.9 | 4.9 | 3.9 | 1.9 | 56.5 |
| Choreographer, Composer, and Playwright | 12.1 | 22.0 | 6.6 | 11.0 | 5.5 | 5.5 | 3.3 | 1.1 | 0.0 | 33.0 |
| Visual Artist | 0.1 | 1.5 | 0.6 | 0.1 | 1.9 | 0.4 | 27.1 | 3.3 | 9.1 | 55.9 |
| Media Artist | 0.0 | 1.5 | 0.0 | 1.0 | 3.0 | 1.0 | 10.8 | 11.3 | 2.5 | 69.0 |
| Craft Artist | 0.2 | 0.7 | 0.4 | 1.3 | 2.4 | 0.4 | 15.5 | 1.8 | 10.1 | 67.2 |

# Appendix B

## Survey Questionnaire

---

# ARTISTS AND JOBS QUESTIONNAIRE

Dear Artist:

You are one of approximately 8,000 artists who have been selected to receive this questionnaire. In it, we are asking questions about your work as artists because little is known about your overall work experiences. As a result, public policy has often ignored or been irrelevent to the special problems that artists face in the work place. Your responses to this survey will enable the sponsoring agencies to improve and refine programs for artists. *Please be advised that in no way can your responses be identified.* To insure anonymity, please do not write your name on the questionnaire or on the return envelope. Return of the enclosed card, signifying that you have completed and returned the questionnaire, ensures that you will not receive a questionnaire in a follow-up mailing.

As you complete the questionnaire, some questions may strike you as odd, irrelevent, or needlessly specific. While we have tried to limit the economic jargon and the detailed definitions, it is necessary to collect this information in forms that will be compatible with existing studies of other professions. Please bear with us.

We are interested in you, regardless of whether you work full time at your art or only occasionally. It is essential to the success of this survey that a substantial response be recorded. What you have to tell us is important.

We hope that you will fill out the enclosed questionnaire as completely as possible and return it to us promptly. A return envelope is provided for your convenience. If you are unable to complete part of this questionnaire, please indicate why this is so. Please do not hesitate to call any of us (collect) if you have any questions relating to this survey.

| **Neil Alper** | **Paula McCabe** | **Gregory Wassall** |
|:---:|:---:|:---:|
| Assistant Professor | Research Assistant | Assistant Professor |
| Northeastern University | Northeastern University | Northeastern University |
| (617) 437-2839 | (617) 437-2610 | (617) 437-2196 |

---

## Part I: OCCUPATION

**1** From the enclosed list (**see back page**) please select the discipline and job type that best describes your artistic occupation. If you have more than one artistic occupation please list them according to their artistic importance to you, with the most important artistic occupation first. Next to each occupation please rank it in terms of the income received in 1981 with a "1" assigned to the artistic occupation with the highest income. Please do not list any arts-related jobs such as teaching or management of an artistic organization.

| Discipline | Job Type | Rank by Income (if more than one) |
|---|---|---|
| _____ | _____ | _____ |
| _____ | _____ | _____ |
| _____ | _____ | _____ |
| _____ | _____ | _____ |

**2** Are you a member of any unions or professional organizations, such as Actors' Equity, The American Federation of Musicians, or the League of New Hampshire Craftsmen?

_____ YES (please list) _____  _____ NO

_____

_____

_____

The next two questions apply to any non-artistic jobs you held in 1981. The first one refers to *arts-related* occupations which include teaching or coaching in your artistic discipline, or in arts administration, such as management, clerical work, usher, ticket taker, etc. The second one refers to *non-arts related* occupations including any job other than artistic or arts-related.

**3** Did you work in an *arts-related* occupation (or occupations) in 1981?

_____ YES (please describe) _____  _____ NO

_____

_____

**4** Did you work in a *non-arts related* occupation (or occupations) in 1981?

_____ YES (please describe) _____  _____ NO

_____

_____

**5** Do you look on your artistic job as your principal profession?

_____ YES  _____ NO: my principal profession is

_____

185.

## Part II: EDUCATION AND TRAINING

**6** What is the highest grade (in years) of formal schooling that you completed? (Please circle)

| ELEMENTARY | HIGH SCHOOL | COLLEGE | GRADUATE SCHOOL |
|---|---|---|---|
| 8 or less | 9, 10, 11, 12 | 13, 14, 15, 16 | 17, 18, 19, 20 or more |

**7** What is the *highest* degree (diploma) you have earned?

High School _____    Bachelors _____

G.E.D. _____    Masters _____

Associates _____    Doctorate _____

Other (specify) _____

**8** At what age did you begin your artistic training? ___

**9** *As part* of your high school and/or college training, did you: (check all those that apply)

| | At the Secondary School Level | At the Undergraduate College Level | At the Graduate Level |
|---|---|---|---|
| Attend a specialized arts school/college? | ___ | ___ | ___ |
| Receive specialized arts training as a major field of study? | ___ | ___ | ___ |
| Receive specialized arts training but *not* as a major field of study? | ___ | ___ | ___ |
| Not receive any specialized arts training? | ___ | ___ | ___ |

**10** In addition to the above, have you ever participated in any *organized* study, training or classes to improve your abilities in your profession?

_____ YES _____ NO (Go to question 11)

10a. Did any of this occur in 1981?
_____ YES _____ NO

10b. If yes, how much time, on the average, did you spend in such study, training or classes?
_____ Hours per week _____ Weeks in 1981

**11** During 1981 did you participate in any CETA (Comprehensive Employment and Training Act) program?

_____ NO (Go to question 12)

_____ YES, in my artistic profession

_____ YES, in some other field

11a. If yes, what kind of program(s)?

_____ Classroom training

_____ On-the-job work experience

_____ Public Service Employment (PSE)

_____ Other (Specify major program activity)
_____

**12** Prior to 1981 had you participated in any government-supported employment or training program?

_____ YES, in my artistic profession _____ NO

_____ YES, in some other field

## Part III: EMPLOYMENT AND UNEMPLOYMENT IN 1981

In answering the questions that follow please use the definition of employment provided by the U.S. Department of Labor.

*"A person is employed during a week if he/she either worked for as little as one hour for pay or worked as a self-employed person for pay or in anticipation of receiving pay." According to the Department of Labor, a self-employed visual artist (for example) is employed whenever working at his/her art, as long as it is anticipated that the art will be sold. The performing artist is employed if paid for performing or rehearsing but not for unpaid self-imposed practice.*

Use of the above definition is necessary to draw comparisons between artists and other professions. We recognize that it does not completely capture the work experiences of artists.

**13** Using the above definition of employment:
(Include full-time and part-time work. The total number of weeks may be greater than 52 if you held more than one job at a time.)

How many weeks in 1981 were you employed? ___

How many weeks in 1981 did you work as an artist? _____

How many weeks in 1981 did you work in a job(s) related to the arts, e.g., teaching, coaching, arts administration, ushering, etc.? _____

How many weeks in 1981 did you work in a job(s) not related to the arts? _____

**14** For how many weeks in 1981, if any, were you actively working at your art *but were not "employed" according to the above definition?* _____ weeks.

**15** If you held a job(s) other than work as an artist, approximately how many different *employers* did you work for in 1981:
In an arts-related job(s)? _____
In a non-arts related job(s)? _____

**16** If you held a job(s) other than work as an artist any time during 1981, what were your reasons for taking the job? (Check all that apply.)

___ The pay is better than your earnings as an artist

___ The job security is better than your artist profession

___ Not enough work as an artist was available

___ You like this kind of work more than your artist work

___ The work complements your work as an artist

___ Other reasons (specify) _____

**17** Was there any time during 1981 when you were *not* employed but willing to work and looking for work?

_____ YES _____ NO (Go to question 18)

17a. If yes, for about how many weeks were you not employed but looking for work? _____

17b. Approximately how many different times did this occur? _____

17c. For how many of these times were you able to collect unemployment insurance? _____

**18** Was there any time in 1981 that you were both *not* employed and not looking for and not available for work?

_____ YES _____ NO (Go to question 19 or 20)

18a. If yes, was it because:
___ You believed there was no work available and weren't looking for a job.

___ You had family obligations, such as raising children.

___ You were in school.

___ You were in ill health (but not on paid sick leave).

___ You were practicing or sharpening your artists skills voluntarily.

___ You had other reasons.

**NON-PERFORMING ARTISTS: PLEASE GO TO QUESTION 20**

**19** How many hours did you spend in the following activities during a typical week in 1981? (Note: there are 168 hours in a week)

_____ Performing
_____ Participating in organized rehearsals
_____ Self-imposed practice and taking lessons
_____ Looking for work

**PERFORMING ARTISTS: PLEASE GO TO QUESTION 21**

**20** How many hours did you spend in the following activities during a typical week in 1981? (Note: there are 168 hours in a week)

_____ Creating your art
_____ Receiving artistic training
_____ Exhibiting or marketing your art

**21** How do you look for employment in non-artistic fields? (Check all that apply)

I never seek work in a non-artistic field _____
Want ads _____ Private employment agency _____
Friends or relatives _____
Student placement office _____
Business associates _____
Public employment office _____
Other (specify) _____

**22** How do you look for employment in your artistic field? (Check all that apply)

Not applicable _____
Want ads _____
Friends or relatives _____
Business associates _____
Private employment agency _____
Booking agent _____
Student placement office _____
Public employment office _____
Other (specify) _____

**23** If as an artist you produce a tangible product, how do you market the art you produce? (Check all that apply)

Not applicable _____
Shows and fairs _____
Consignment in showroom/shop or gallery _____
Advertisements _____
Own or share showroom/shop _____
Representative/agent _____
Other _____

## Part IV: INCOME AND EXPENSES

IN ANSWERING THE QUESTIONS BELOW, PLEASE REMEMBER THAT YOUR RESPONSE IS CONFIDENTIAL.

**24** What was the total income in 1981 (before taxes) of _all_ members of your household, including yourself? Include wages, salaries, interest, dividends, social security and retirement benefits, welfare benefits, and income from sale of art works.

$ _____ income in 1981

**25** What percentage of your total household income was earned by you?
_____ %

**26** Please indicate what percentage of _your_ income was derived from: (Note that the four percentages must sum to 100)

Work as an artist _____ %.
Employment in your arts related job(s) _____ %.
Employment in your non-arts related job(s) _____ %.
Non-labor income sources (e.g., interest, dividends, rent) _____ %.

**27** For how many _weeks_ in 1981 did you receive income from your work as an artist? _____ weeks

**28** If during 1981 you exchanged any of your artistic work directly for goods or services rather than selling it, what was your estimate of the value of the goods and services you received? $ _____

**29** In the table below, please estimate your annual costs during 1981 of working as an artist, using the categories provided and adding any that are necessary. Please list only those costs for which you are not reimbursed by an employer.

| TYPE OF COST INCURRED | $ AMOUNT (1981) |
|---|---|
| Organized study, training & classes | $ _____ |
| Travel | $ _____ |
| Publicity/Marketing | $ _____ |
| Duplication & reproduction costs (portfolio, etc.) | $ _____ |
| Insurance (instruments, art works, etc.) | $ _____ |
| Rental of work, performance, loft space | $ _____ |
| Agent's fees and commissions | $ _____ |
| Musical instrument purchase, repair & upkeep & supplies | $ _____ |
| Clothing and costumes, make-up | $ _____ |
| Copyright fees | $ _____ |
| Music, books & research materials | $ _____ |
| Visual art raw material and supplies for visual arts work | $ _____ |
| Tools for artistic trade & costs of upkeep | $ _____ |
| Other | $ _____ |
| TOTAL COSTS | $ _____ |

## Part V: DEMOGRAPHICS

**30** What is your age? _____
**31** What is your sex? _____
**32** What is your race? American Indian _____
Asian _____ Black _____ White _____
Other _____
**33** Are you of Spanish/Hispanic origin or descent?
_____ YES _____ NO
**34** Are you currently living with a spouse or other person with whom you share in income and living expenses? _____ YES _____ NO (Go to ques. 35)
34a. If yes, is he/she:
Working full-time (at least 35 hours per week) _____
Working part-time (between 1 and 35 hours per week) _____ Not working _____
**35** How many children are there currently in your household:
Of pre-school age (kindergarten or less)? _____
In primary or secondary school (1st through 12th grades)? _____
In college? _____

**36** Did either of your parents ever work as an artist?
Mother _____ YES _____ NO
Father _____ YES _____ NO
**37** Are you a veteran? _____ YES _____ NO
**38** What is the zip code of your current residence? _____
**39** Did you live at your current residence five years ago? _____ YES _____ NO
39a. If you did not live in Connecticut five years ago, in what state (or country) did you live? _____

Thank you very much for completing this questionnaire. If there are any important aspects of your labor market experiences that your feel are not discussed above, please comment on them in the space provided below.

_____
_____
_____
_____

List of disciplines and job types for Question 1

## DISCIPLINE

Ballet
Ethnic/Folk/Jazz dance
Modern Dance
Band (not including jazz or popular) music
Chamber music
Choral music
Contemporary (including experimental and electronic) music

Ethnic/Folk music
Jazz
Popular (including rock) music
Solo/Recital
Symphonic
Opera
Literature
Theatre (including classical, contemporary, experimental)
Mime

Musical theatre
Puppet
Theater for young audiences
Visual arts
Architecture/Design
Crafts
Photography
Media arts
Community arts
Folk arts

## JOB TYPE

Choreographer
Dancer
Composer
Conductor
Brass player
Fretted instrument player
Keyboard instrumentalist
Percussionist
String player
Singer
Woodwind player
Actor
Mime
Puppeteer
Artistic director
Technical director
Set/Property designer
Costume designer

Lighting designer
Makeup designer
Carpenter
Property technician
Wardrobe technician
Lighting technician
Production manager
Stage manager
Broadcaster/Announcer
Writer
Poet
Playwright
Architect/Designer
Graphic designer
Graphic artist
Painter
Sculptor
Conceptual artist

Performance artist
Inter-media artist
Photographer
Film maker
Video artist
Ceramist
Glassblower
Stained glass artist
Mosaic artist
Enamelist
Metalsmith
Leather worker
Fiber artist
Woodworker
Papermaker
Printer/Binder/Typographer

NOTE: *If none of the above is applicable, please write your own description of your job type and discipline in question 1.*

# Appendix C

## Sources for Names and Addresses of New England Artists

### General

Actors Equity
African-American Master Artists in Residence Program (Northeastern University, Boston)
Alice James Poetry Cooperative
American Craft Council
American Dance Guild
American Federation of Musicians:

| | |
|---|---|
| Local 634 | Associated Musicians' of Keene, (NH) |
| Local 9-535 | Boston Musicians' Association (MA) |
| Local 351 | Burlington Musicians' Association (VT) |
| Local 400 | Hartford Musicians' Association (CT) |
| Local 234-486 | New Haven Federation of Musicians (CT) |
| Local 220 | Northampton Federation of Musicians (MA) |
| Local 364-409 | Portland-Lewiston Musicians' Association (ME) |
| Local 198-457 | Providence Federation of Musicians (RI) |

American Federation of Television and Radio Artists
American Society of Magazine Photographers
American Society of Picture Professionals
Artisan's Society of ASA, BBW
Artists Equity Association, Inc.
Artists Foundation
Arts Extension Service, University of Masschusetts at Amherst
Art New England
Association of Independent Video and Filmmakers
Boston Ballet
Boston Film Video Foundation, Inc.
Boston Lyric Opera Company
Boston Mime Theatre
Boston Musica Viva
Boston Repertory Theatre
Boston Shakespeare Company
Boston Symphony Orchestra
Boston Visual Artist's Union
Cambridge Arts Council
Cape Cod Symphony
The Christmas Store (Cambridge, MA)
Connecticut Commission on the Arts
Connecticut Film Festival
Connecticut Poetry Society
Connecticut State Department of Education
Connecticut State Library

Connecticut Writers League
The CRT's Craftery Gallery (Hartford, CT)
*Dance Magazine*
Directors Guild of America
Elma Lewis School of Fine Arts, (Boston, MA)
Farmington Valley Arts Center (Avon, CT)
Foundation for the Community of Artists
Franklin County Arts Council (MA)
Groton Center for the Arts (MA)
Guilford Handcrafts (CT)
The Handweavers Guild of America, Inc.
The Hartman Theatre
Haystack Mountain School of Crafts
Institute for Movement Exploration (Hartford, CT)
Joy of Movement Center (Cambridge, MA)
The League of New Hampshire Craftsmen
Maine Department of Educational and Cultural Services
Maine State Commission on the Arts and Humanities
M.I.T. Center for Advance Visual Studies
Mattapan Arts Council (Boston, MA)
Meet The Composer
Merrimac Regional Theatre (MA)
Micah Publication
Mission Hill Arts Council (Boston, MA)
Museum of the National Center of Afro-American Artists
Mystic Art Association (CT)
National Art Education Association
National Center of Afro-American Artists
National Dance Association
National Endowment for the Arts
New England Poetry Club
New England Theatre Conference
New Hampshire Commission on the Arts
New Hampshire Department of Education
New Hampshire Media Foundation, Inc.
North Berkshire Arts Council (MA)
P.E.N., New England
Poets and Writers, Inc.
Professional Photographers of America
Quinnebauga Valley Council for the Arts (MA)
Real Artways, Inc. (Hartford, CT)
Rhode Island State Council on the Arts
Rhode Island State Department of Education
South Berkshire Arts Council (MA)
Screen Actors Guild
Society of Stage Directors and Choreographers, Inc.
Theatre by The Sea (Portsmouth, NH)
Trinity Square Repertory Company (Providence, RI)
Vermont State Department of Education
Worcester Crafts Center
Worcester Office of Cultural Affairs

## Schools, Colleges and Universities (Alumni Lists)

Art Institute of Boston
Boston Conservatory of Music and Dance
Boston University, School for the Arts
Brown University, School for the Arts (RI)
Emerson College
New England Conservatory of Music
Portland School of Art (ME)
School of the Museum of Fine Arts (Boston)
University of Bridgeport (CT)
University of Connecticut, School of Fine Arts
University of Maine at Orono, School of Performing Arts
University of New Hampshire, Department of Arts
Yale School of Drama
Yale School of Music

## Directories

*Arts Directory 1980: A Working Directory of Artists, Artisans and Cultural Resources in Vermont,* published by the Vermont State Department of Education.
*Directory of American Poets and Writers (1980-1981),* published by Poets and Writers, New York.
*Who's Who in American Art,* published by R.R. Bowker Company, New York.
In addition, faculty in artistic majors were sampled from college catalogs throughout the region. These included 12 in Connecticut, 2 in Maine, 22 in Massachusetts, 7 in New Hampshire, 5 in Rhode Island, and 4 in Vermont.